Steidl
Fall/Winter 2020/2021

Steidl
Fall/Winter 2020/2021

Steidl Now

steidl.de	Your first stop for all our books and imprints! Every order at steidl.de with free worldwide delivery
Fall/Winter 2020/2021 book catalogue	Steidl's crystal ball—a preview of our books to come
Steidl Magazine No. 3	Hot off the press! Receive your free copy with every order at steidl.de and discover our newest titles and behind-the-scenes secrets
letters@steidl.de	Your thoughts on anything and everything Steidl—we'd love to hear them
hellosteidl@steidl.de	Email Gerhard Steidl that question you've always wanted to ask him and get a personal response! Best questions printed in *Steidl Magazine*
shop@steidl.de	Questions and queries for our online shop? Complaints or compliments? Let us know here
Podcasts	Check in at the Steidl Hotel on Apple Podcasts, Spotify and steidl.de for our new podcast featuring Mark Peterson and his upcoming book *White Noise*
Social media	Check out #SteidlScreenTests and interviews with our artists on Instagram @steidlverlag Facebook @SteidlInternational Twitter @SteidlVerlag YouTube Steidl

Illustration by Paloma Tarrio Alves / Steidl

This catalogue is not for sale · © 2020 for this publication by Steidl Publishers, Germany · © 2020 for the images by the artists · © 2020 for the texts by the authors
Production and printing by Steidl, Düstere Str. 4, 37073 Göttingen, Germany · Phone +49 551 49 60 60 · Fax +49 551 49 60 649 · mail@steidl.de · steidl.de
All rights reserved · Printed in Germany by Steidl · ISBN 978-3-95829-793-7

Contents

Steidl

Düstere Str. 4
37073 Göttingen
Germany
T +49 551 4 960 60
F +49 551 4 960 649
E mail@steidl.de
steidl.de

Sales

Matthias Wegener
T +49 551 4 960 616
F +49 551 4 960 649
E mwegener@steidl.de

Susanne Schmidt
T +49 551 4 960 612
F +49 551 4 960 649
E sschmidt@steidl.de

Submissions

Paloma Tarrío Alves
E submissions@steidl.de

Catalogue / Editorial

Holger Feroudj
T +49 551 49060 621
E holger@steidl.de

Export Management / Shipping

Jan Menkens
T +49 551 4 960 618
F +49 551 4 960 617
E jmenkens@steidl.de

Production

Bernard Fischer
T +49 551 4 960 633
F +49 551 4 960 634
E bfischer@steidl.de

Public Relations / Press

Claudia Glenewinkel
T +49 551 4 960 650
F +49 551 4 960 644
E cglenewinkel@steidl.de

Germany, Austria and Switzerland

Steidl Verlag
Claudia Glenewinkel
Düstere Str. 4
37073 Göttingen
Germany
T +49 551 4 960 650
F +49 551 4 960 644
E presse@steidl.de

USA and Canada

Monika Condrea
91 Saratoga Ave.
Brooklyn, NY 11233
USA
T +1 646 226 6828
E monika.condrea@gmail.com

All other territories

Steidl Verlag
Claudia Glenewinkel
Düstere Str. 4
37073 Göttingen
Germany
T +49 551 4 960 650
F +49 551 4 960 644
E presse@steidl.de

Steidl Comte

Düstere Str. 4
37073 Göttingen
Germany
T +49 551 4 960 60
F +49 551 4 960 649
E mail@steidl.de

Edition 7L Paris

Caroline Lebar
7, rue de Lille
75007 Paris
France
T +33 1 44 502 200
F +33 1 44 502 205
E caroline.lebar@karllagerfeld.com

Steidl Dangin

Pascal Dangin
E pascaldangin@studiodangin.com

Steidl David Zwirner

Doro Globus
525 West 19th Street
New York, NY 10011
T +1 212 7 272 070
F +1 212 7 272 072
E doro@davidzwirner.com
www.davidzwirner.com

Steidl Miles

Peter Miles Studio
650 East 6th Street, Apt. 1
New York, NY 10009
T +1 212 3 587 991
E email@petermilesstudio.com

Verlag

Steidl GmbH & Co. OHG
Düstere Straße 4
37073 Göttingen
T +49 551 4 960 60
F +49 551 4 960 649
E mail@steidl.de
steidl.de

Vertrieb

Matthias Wegener
T +49 551 4 960 616
F +49 551 4 960 649
E mwegener@steidl.de

Susanne Schmidt
T +49 551 4 960 612
F +49 551 4 960 649
E sschmidt@steidl.de

Auslieferungen

Deutschland

Steidl
Düstere Str. 4
37073 Göttingen
T +49 551 49 60 60
F +49 551 49 60 49
E bestellung@steidl.de

Österreich

Mohr-Morawa
Sulzengasse 2
A-1232 Wien
T +43 1 680 140
F +43 1 687 130
E bestellung@mohrmorawa.at

Schweiz

AVA
Centralweg 16
CH-8910 Affoltern am Albis
T +41 44 7 624 200
F +41 44 7 624 210
E avainfo@ava.ch

Außendienst

Deutschland

Schleswig-Holstein, Hamburg, Bremen, Niedersachsen

Bodo Föhr Verlagsvertretungen
Lattenkamp 90
22299 Hamburg
T +49 40 51493667
F +49 40 51493666
E bodofoehr@freenet.de

Berlin, Mecklenburg-Vorpommern, Brandenburg

Vera Grambow
Liselotte-Herrmann-Straße 2
10407 Berlin
T +49 30 40 048 583
F +49 30 4 212 246
E berliner-verlagsvertretungen
@t-online.de

Sachsen-Anhalt, Sachsen, Thüringen

Thomas Kilian
Vor dem Riedtor 11
99310 Arnstadt
T +49 362 85 493 310
F +49 362 85 493 310
E thomas.c.kilian@web.de

Nordrhein-Westfalen Hessen, Rheinland-Pfalz, Saarland, Luxemburg

Benedikt Geulen
Meertal 122
41464 Neuss
T +49 2131 1 255 990
F +49 2131 1 257 944
E benedikt.geulen@t-online.de

Ulrike Hölzemann
Dornseiferstr.67
57223 Kreuztal
T +49 2732 55 83 44
F +49 2732 55 83 45
E u.hoelzemann@buerofuerbuecher.de

Baden-Württemberg

Tilmann Eberhardt
Verlagsvertretungen
Ludwigstr. 93
70197 Stuttgart
T +49 711 615 28 20
F +49 711 615 31 01
E Tilmann.Eberhardt@gmail.com

Bayern

Günter Schubert
Brunnenstraße 20a
85598 Baldham
T +49 8106 377 23 97
F +49 8106 377 23 98
E guenterschubert@t-online.de

Österreich

Jürgen Sieberer
Arnikaweg 79/4
1220 Wien
T +43 285 45 22
F +43 285 45 22
E juergen.sieberer@mohrmorawa.at

Manfred Fischer
Am Pesenbach 18
4101 Feldkirchen
T +43 664 / 811 97 94
F +43 7233 / 20050
E manfred.fischer@mohrmorawa.at

Schweiz

Giovanni Ravasio
Verlagsvertretungen
Klosbachstr. 33
CH-8032 Zürich
T +41 44 260 61 31
F +41 44 260 61 32
E g.ravasio@bluewin.ch

Artbook | D.A.P.

75 Broad Street
Suite 630
New York, N.Y. 10004
USA
T +1 212 627 1999
F +1 212 627 9484
E orders@dapinc.com
www.artbook.com

Trade Sales Representatives

New York & Key Accounts

Jamie Johnston
T +1 212-627-1999
F +1 212-627-9484
E jjohnston@dapinc.com

USA — West Coast / Southwest

Ellen Towell
Karel/Dutton Group
3145 Geary Blvd. #619
San Francisco CA 94118
T +1 415-668-0829
F +1 415-668-2463
E hkarel@comcast.net

Lise Solomon
Albany CA
T +1 510-528-0579
F +1 510-900-1088
E lise.solomon@sonic.net

Dory Dutton
Karel/Dutton Group
Corrales NM
T +1 818-269-4882
F +1 480-247-5158
E dory.dutton
 @valleyvillageemail.com

Southern California

Mark O'Neal
T + 1 562 587 0956
F + 1 877 847 1619
E oneal.mark@gmail.com

Midwest

Stu Abraham
Minneapolis MN
T +1 952-927-7920
F +1 952-927-8089
E stu@aabookreps.com

John Mesjak
Sycamore IL 60178
T +1 815-899-0079
F +1 815-261-4114
E john@aabookreps.com

Sandra Law
T + 1 630 352 8640
F + 1 952 927 8089
E. sandra@aabookreps.com

Emily Johnson
St. Paul MN
T +1 952 927 7920
F +1 952 927 8089
E emily@aabookreps.com

New England / Southeast / Mid-South

Zachary Goss
T + 1 774 644 7374
E zgoss@dapinc.com

Mark Pearson
CT, RI, MA, NH, VT, ME,
VA, NC, SC, GA, FL
T 617-480-1709
F 800-478-3128
E mpearson@dapinc.com

Mid-Atlantic

Chesapeake & Hudson, Inc.
Michael Gourley, Bill Hoar, Janine
Jensen, Steve Straw, Ted Wedel
T +1 800-231-4469
F +1 800-307-5163
E office@cheshud.com

National Accounts

Artbook | D.A.P.
Jane Brown
Los Angeles CA
T +1 323-969-8985
F +1 818-243-4676
E jbrown@dapinc.com

Gift Reps

Aesthetic Movement

New York & Mid-Atlantic

Gus Anagnopoulos
T +1 718-797-5750
F +1 718-797-4944
E gus@aestheticmovement.com

Aesthetic Movement
Chicago & Midwest

Alison Grant
T +1 773-951-8754
F +1 773-435-6691
E ali@aestheticmovement.com

Aesthetic Movement
Atlanta & Southern States

Laura Jane Turner
T +1 404-749-5005
F +1 404-521-4372
E laura@aestheticmovement.com

Artbook | Gift
Los Angeles & West Coast

Tricia Gabriel
T +1 323-969-8985
F +1 323-662-7896
E triciagabriel@gmail.com

Canada

Ampersand Inc.
Toronto On & East Coast

Saffron Beckwith
T +1 416-703-0666
F +1 866-849-3819
E saffronb@ampersandinc.ca

Ampersand Inc.
Vancouver BC & West Coast

Ali Hewitt
T +1 604-448-7165
F +1 888-323-7118
E alih@ampersandinc.ca

Ampersand Inc.
Ottawa & Quebec

Jenny Enriquez
T +1 416-703-0666
F +1 866-849-3819
E jennye@ampersandinc.ca

Interart S.A.R.L.

1, rue de l'Est
75020 Paris
T +33 1 43 493 660
F +33 1 43 494 122
E info@interart.fr

Responsable distribution:
Laurence H'Limi
E laurence@interart.fr

Responsable diffusion:
Pierre Samoyault
E pierre@interart.fr

Représentants:
Blanche Pilven
E blanche@interart.fr

Emerick Charpentier
E emerick@interart.fr

Margot Rietsch
E margot@interart.fr

Assistante commerciale:
Marylaure Perre
E marylaure@interart.fr

Service commande:
E commercial@interart.fr
www.dilicom.net

Head Office / Export Sales Department: Thames & Hudson Ltd.

181a High Holborn
London WC1V 7QX
T +44 20 78 455 000
F +44 20 78 455 050
Sales and Marketing Department:
F +44 20 78 455 055
E sales@thameshudson.co.uk
E export@thameshudson.co.uk

UK

Christian Frederking
Group Sales Director
E c.frederking@thameshudson.co.uk

Andrius Juknys
Head of Distributed Books
T +44 (0)20 7845 5000
F 020 7845 5055
E a.juknys@thameshudson.co.uk

Mark Garland
Manager, Distributed Books
T +44 (0)20 7845 5000
F 020 7845 5055
E m.garland@thameshudson.co.uk

Ellen Morris
Distributed Sales Coordinator
T +44 (0)20 7845 5000
F 020 7845 5055
E e.morris@thameshudson.co.uk

Ben Gutcher
T +44 (0)20 7845 5000
E b.gutcher@thameshudson.co.uk
Head of UK Sales

Dawn Shield
T +44 (0)20 7845 5000
E d.shield@thameshudson.co.uk
London

David Howson
T +44 (0)20 7845 5000
E d.howson@thameshudson.co.uk
London & South East

Karim White
T +44 (0)7740 768 900
E k.white@thameshudson.co.uk
Northern England, Scotland & Ireland

Mike Lapworth
T +44 (0)7745 304 088
E mikelapworth@sky.com
The Midlands & East Anglia

Ian Tripp
T +44 (0)7970 450 162
E iantripp@ymail.com
Wales & Southwestern Counties

Trade: Thames & Hudson (Distributors) Ltd. (distribution and accounts)

Littlehampton Book Services
Faraday Close
Durrington, Worthing
West Sussex BN13 3RB
United Kingdom
T +44 190 382 8501

Key Accounts

Michelle Strickland
T +44 (0)20 7845 5000
E m.strickland@thameshudson.co.uk
Senior Key Accounts Manager

Alice Corrigan
T +44 (0)20 7845 5000
E a.corrigan@thameshudson.co.uk
Key Accounts Manager

Gift

Poppy Edmunds
T +44 (0)20 7845 5000
E p.edmunds@thameshudson.co.uk
Sales Manager

Jamie Denton
T +44 (0)7765 403 182
E jamesdenton778@btinternet.com
South, Southeastern Counties/Gift

Victoria Hutton
T +44 (0)7899 941 010
E victoriahuttonbooks@yahoo.co.uk
London/Gift

Colin MacLeod / Jill Macleod
T +44 (0)7710 852 197 /
 +44 (0)7885 720 175
E colinmacleodsw@gmail.com
Wales & Southwestern Counties/Gift

For all other UK enquiries please contact:

Ellen McDermot
Thames & Hudson Ltd
T +44 (0)20 7845 5000
E sales@thameshudson.co.uk

Europe

Austria, Germany, Switzerland

Michael Klein
T +49 931 17405
E mi-klein@t-online.de

Belgium & Luxembourg

Rosita Stankute
Export Sales Department
Thames & Hudson Ltd
E r.stankute@thameshudson.co.uk

Eastern Europe

Sara Ticci
T +44 7952 919 866
E sara.ticci@niledanube.com

Eastern Mediterranean, Bulgaria, Romania

Stephen Embrey
T +44 (0)7952 919 866
E steve.embrey@niledanube.com

France

Interart S.A.R.L.
T +33 1 43 49 36 60
E commercial@interart.fr

Ireland

Karim White
T +44 (0)7740 768 900
E k.white@thameshudson.co.uk

Netherlands

Van Ditmar b.v.
E th@vanditmar.audax.nl

Scandinavia, Baltic States, Russia and the CIS

Per Burell
T +46 (0) 70 725 1203
E p.burell@thameshudson.co.uk

Spain, Italy and Portugal

Natasha Ffrench
E n.ffrench@thameshudson.co.uk

Africa

Africa (excluding South)

Ian Bartley
E i.bartley@thameshudson.co.uk

South Africa, Swaziland, Lesotho, Namibia and Botswana

Jonathan Ball Publishers
66 Mimetes Road
Denver
Johannesburg, 2094
South Africa
www.jonathanball.co.za

Brunette Mokgotlhoa
E Brunette.Mokgotlhoa
 @jonathanball.co.za

The Near and Middle East

Stephen Embrey
T +44 (0)7952 919 866
E steve.embrey@niledanube.com

Asia and Far East

North East Asia

Thames & Hudson Asia
Units B&D 17/F
Gee Chang ong Centre
65 Wong Chuk Hang Road
Aberdeen
Hong Kong
T +852 2 553 9289
F +852 2 554 2912

Katherine Lee
Managing Director
E Katherine_lee@asiapubs.com.hk

China, Hong Kong, Macau and Korea

Zita Chan
Regional Sales Manager
E zita_chan@asiapubs.com.hk

Taiwan

Helen Lee
E helen_lee@asiapubs.com.hk

Japan

Sian Edwards
E s.edwards@thameshudson.co.uk

South East Asia

APD Singapore PTE Ltd
52 Genting Lane
#06-05, Ruby Land Complex
Singapore 349560
T (65) 6749 3551
F (65) 6749 3552
E customersvc@apdsing.com

Malaysia

APD Kuala Lumpur
Nos. 22, 24 & 26 Jalan SS3/41
47300 Petaling Jaya
Selangor Darul Ehsan
T (603) 7877 6063
F (603) 7877 3414
E liliankoe@apdkl.com

Indian Subcontinent

Roli Books
Kapil Kapoor
T +91 11 2921 0886
F +91 11 2921 7185
E kapilkapoor@rolibooks.com

Pakistan and Sri Lanka

Stephen Embrey
T f+44 (0)7952 919866
E steve.embrey@niledanube.com

Australasia

Australia, New Zealand, Papua New Guinea & the Pacific Islands
Thames & Hudson Australia Pty Ltd
11 Central Boulevard
Port Melbourne Victoria 3207
T +61 (03) 9646 7788
E enquiries@thameshudson.com.au

The Americas

Central & South America, Mexico and the Caribbean
Natasha Ffrench
Export Sales Department
Thames & Hudson Ltd
E n.ffrench@thameshudson.co.uk

For countries not mentioned above, please contact:

Export Sales Department
Thames & Hudson Ltd
T +44 (0)20 7845 5000
F +44 (0)20 7845 5055
E exportsales@thameshudson.co.uk

Steidl Berlin
Bildband Berlin UG
Immanuelkirchstraße 33
10405 Berlin
Germany
T +49 30 4737 7014

Steidl Göttingen
Buchhandlung Calvör
Jüdenstraße 23
37073 Göttingen
Germany
T +49 551 484800

Steidl East Hampton
Linde Gallery
25 A Newtown Lane
East Hampton, NY
11937 USA
T +1 6316045757

Steidl Hong Kong
Asia One
8 Fung Yip Street, Chai Wan
Hong Kong
China
T +852 2 8 892 320

Steidl Johannesburg
MAKER
At House Villa
75 4th Road
Kew
Johannesburg 2090
South Africa
T +27 11 447 6680
www.makerstudio.co.za

Steidl Lisbon
Stet
Rua Acácio de Paira, 20A
1700-111 Lisboa
Portugal
T +35 1 936 250 198

Steidl Los Angeles
Rosegallery
Bergamot Station Arts Center
Gallery G5
2525 Michigan Avenue
Santa Monica, CA 90404
USA
T +1 3102648440

Steidl Ljubljana
Galerija Fotografija
gallery and bookshop
Levstikov trg 7
Ljubljana/Slovenia
T/F +38 612511529
M +38 641664357
www.galerijafotografija.si

Steidl Madrid
La Fabrica
Verónica 13
28014 Madrid
Spain
T +34 912985537

Steidl Moscow
The Lumiere Brothers
Center of Photography
Red October, Bolotnaya emb., 3, b.1
119072 Moscow
Russia
T +7 4952289878
www.lumiere.ru

Steidl Paris
Librairie 7L
7, rue de Lille
75007 Paris
France
T +33 1 42920358

Steidl Rome
s.t. foto libreria galleria
Via Bartolomeo d'Alviano 2A
00176 Roma
Italy
T +39 338 4094647

Steidl San Diego
Museum of Photographic Arts
Museum Store
1649 El Prado
San Diego, CA 92101
USA
T +1 6192387559231

Steidl Shanghai
Le Monde de SHC
1, Tao Jiang Road
Xuhui District
Shanghai
China
T 021-33568808
E books@shcshanghai.com

Steidl Tokyo
POST / limArt co., ltd
2-10-3-1F Ebisuminami
Shibuya-ku
150-0022 Tokyo
Japan
T +81 3 3713 8670
www.post-books.info

steidl.de
For detailed information on all our
books, artists and related events
please visit us at steidl.de

Le Monde de SHC, Shanghai

William Eggleston

Gilles Peress

Mary Ellen Mark

Ed Clark

Damien Hirst

Hans/Jean Arp

Richard Serra

Anish Kapoor

Steidl Book Culture

To receive these special editions at reduced introductory prices, please pre-order directly at Steidl with Susanne Schmidt, sschmidt@steidl.de. Orders must be received by 31 August 2020; payment and delivery follow by September 2020.

Special Editions

A special edition is often an expanded or embellished form of a book—perhaps with extra images, a hardcover and dust jacket instead of a softcover, or an artist's print. This season, our special editions are different. They are not reincarnations of pre-existing publications; they are the original and only forms of these books.

For the artists who conceived them, these projects are inherently special—exceptionally ambitious, intricate, sweeping in scope. From *The Outlands*, William Eggleston's "last definitive pass of my early work shot on Kodachrome," almost wholly unpublished until now; to *Whatever You Say, Say Nothing*, Gilles Peress' long-awaited documentary of the Northern Ireland conflict; and Mary Ellen Mark's *Book of Everything*, more than 50 years' work in nearly 600 photographs.

The resulting books are particularly demanding on our bookmaking know-how and imagination, and greatly fulfilling. We hope they find a special place in libraries, collections, and your bookshelves.

● available
● coming soon
● previously announced

William Eggleston

THE OUTLANDS

A few weeks ago I was in Los Angeles working on my next Steidl book called *The Outlands*. These volumes represent the last definitive pass of my early work shot on Kodachrome, the same body that formed the basis of my first book, *William Eggleston's Guide*. We did this work in my son William's studio with editor Mark Holborn, and my other son Winston. William has a large screen setup that allows projection just like what John Szarkowski and I would view so many years ago from slide carousels.

Together we reviewed images that I haven't seen in more than 40 years—all from Memphis and environs, with very much pure use of color, and of a vanishing world at the time. Revelatory images, never published or seen, that I look forward to sharing. All of these images are very much on my mind right now, just as if they were taken yesterday or today.

William Eggleston

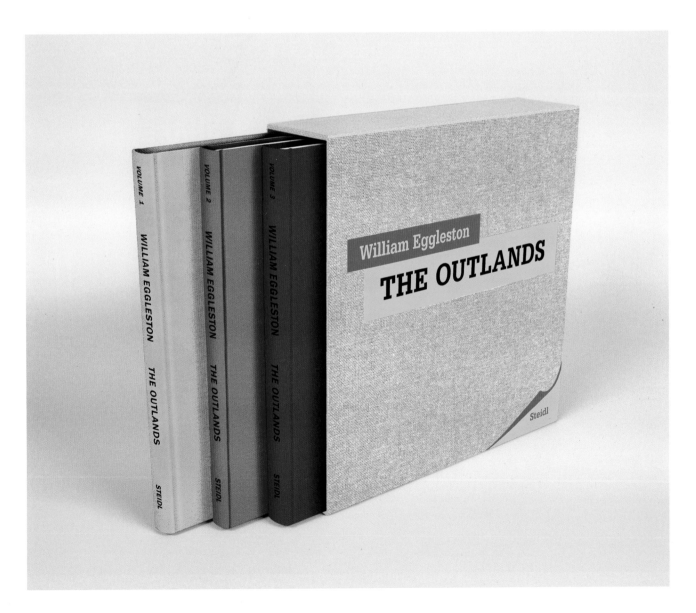

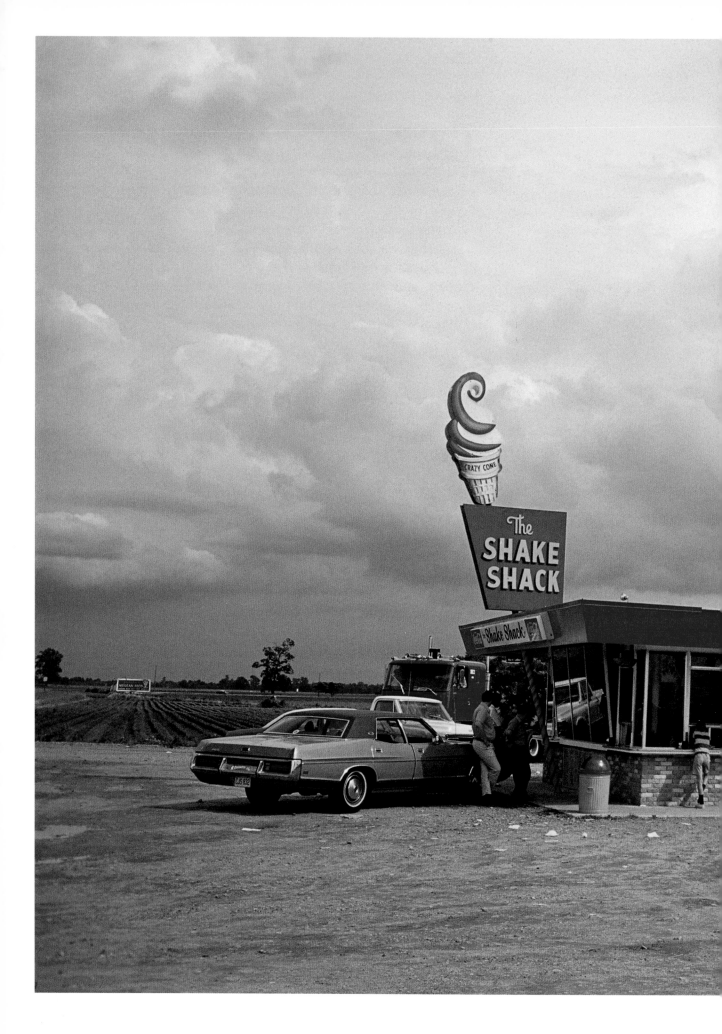

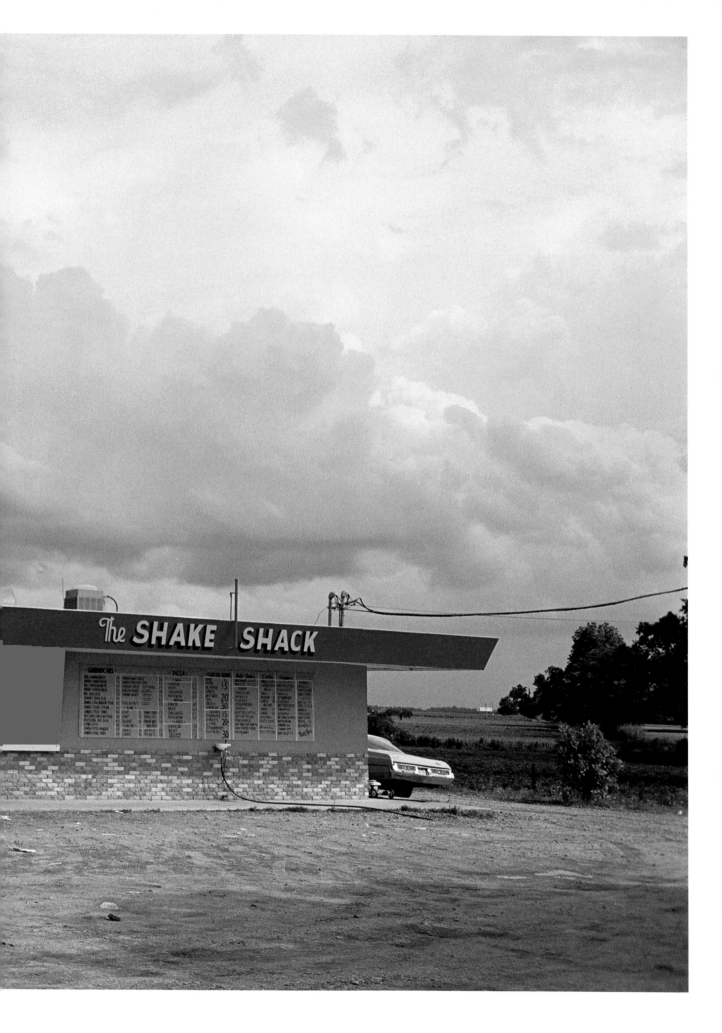

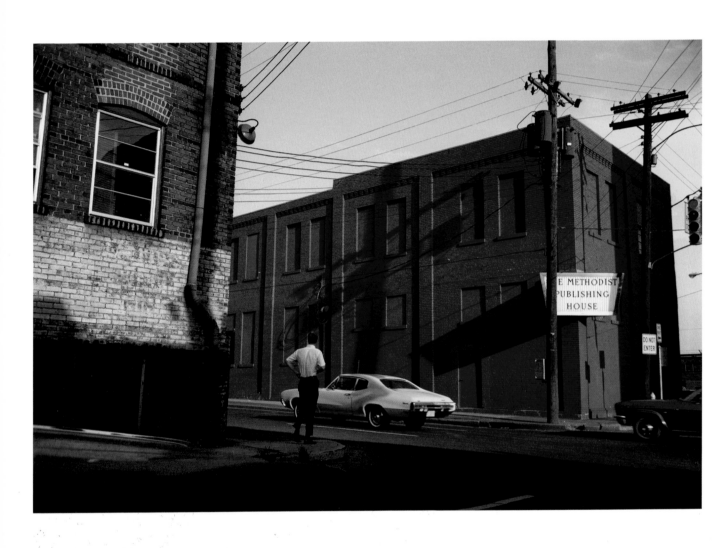

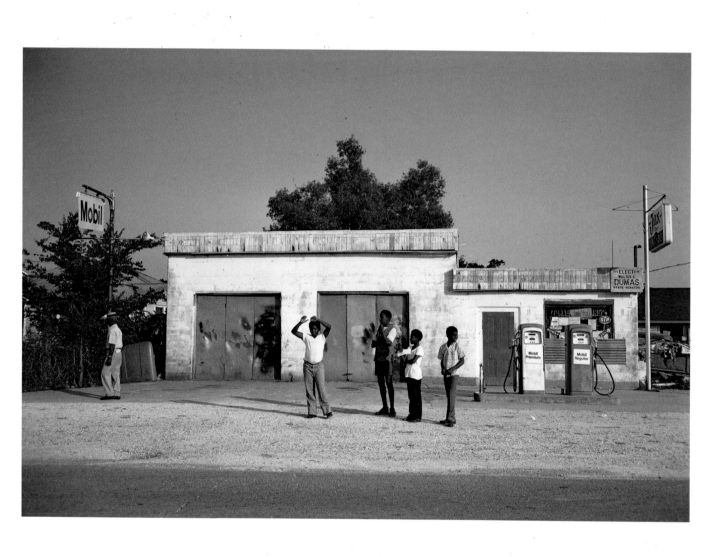

Born in Memphis in 1939, William
Eggleston is regarded as one of the
greatest photographers of his generation
and a major American artist who has
fundamentally changed how the urban
landscape is viewed. He obtained his first
camera in 1957 and was later profoundly
influenced by Henri Cartier-Bresson's
The Decisive Moment. Eggleston introduced
dye-transfer printing, a previously
commercial photographic process, into the
making of artists' prints. His exhibition
"Photographs by William Eggleston" at the
Museum of Modern Art in New York in 1976
was a milestone. He was also involved in
the development of video technology in
the seventies. Eggleston is represented
in museums worldwide, and in 2008 a
retrospective of his work was held at
the Whitney Museum of American Art in
New York and at Haus der Kunst in Munich
in 2009. Eggleston's books published by
Steidl include Chromes (2011), Los Alamos
Revisited (2012), The Democratic Forest
(2015), Election Eve (2017), Morals
of Vision (2019), Flowers (2019) and
Polaroid SX-70 (2019).

● William Eggleston
The Outlands

Edited by Mark Holborn, William Eggleston III
and Winston Eggleston
Texts by Mark Holborn and William Eggleston III
Book design by Gerhard Steidl and Duncan Whyte
12.4 × 12.6 in. / 31.5 × 32 cm

Vol. 1
224 pages
128 color photographs

Vol. 2
224 pages
137 color photographs

Vol. 3
252 pages
130 color photographs

Four-color process
Three clothbound hardcovers in a slipcase

€ 380.00 / £ 340.00 / US$ 450.00
Introductory price until 31 August 2020:
€ 280.00 / £ 240.00 / US$ 350.00
ISBN 978-3-95829-265-9

INTRODUCTORY PRICE
SAVE $100
ORDER BEFORE 31 AUGUST 2020
PAY AND RECEIVE BY SEPTEMBER 2020

The publication of William Eggleston's *Chromes* by Steidl in 2011
marked the beginning of the examination of the entire prolific output
of this extraordinary artist in a range of books including *Los Alamos
Revisited* (2012) and the ten-volume *The Democratic Forest* (2015).
The three volumes of *The Outlands* are drawn from the same source,
the photographs Eggleston made on color transparency film from 1969
to 1974 that formed the basis for the *Chromes* volumes and for John
Szarkowski's seminal exhibition of Eggleston's work at the Museum
of Modern Art in New York in 1976 with the accompanying book
William Eggleston's Guide. However, with the exception of a couple of
alternate versions, none of the photographs in *The Outlands* has been
published previously.

The result is revelatory. Starting at almost the exact point on
the same street in suburban Memphis where Eggleston famously
photographed the tricycle, the work follows a route through the back
roads to old Mississippi where he was raised. What is disclosed is
a sublime use of pure color hovering in semi-detachment from the
forms he records. At the time, Eggleston was photographing a world
that was already vanishing. Today, this final installment of his color
work offers a view of a great American artist discovering the range of
his visual language and an unforgettable document of the Deep South
in transition.

*Eggleston does not make judgments. He neither praises nor
condemns the bright American promise. But to say that he merely
observes it is not right either. An element of deep feeling—a kind
of permanent expression painted on his face—emerges unseen
in his sidewalks and night tables and billboard stanchions.*
Alexander Nemerov

Slipcase

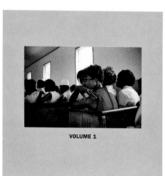

Vol. 1

Vol. 2

Vol. 3

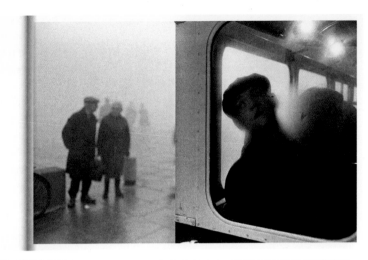

THE FIRST DAY

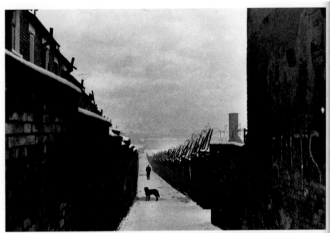

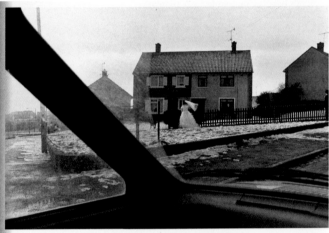

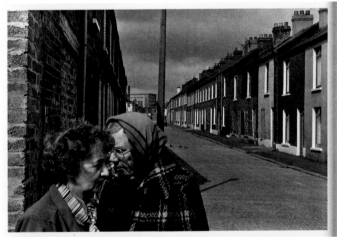

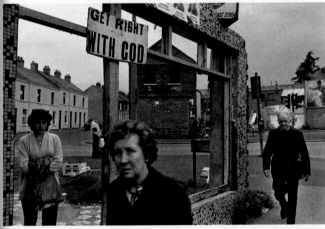

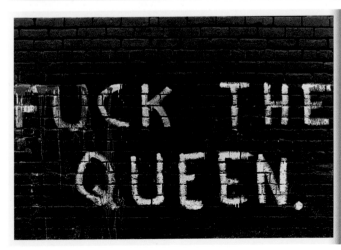

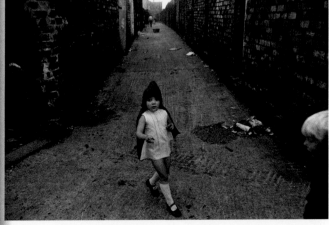

Born in 1946 in Neuilly-sur-Seine,
Gilles Peress moved to New York in 1974
and began a series of interrelated
projects that push the formal and
conceptual possibilities of photography to
interrogate the structure of history and
the nature of intolerance. The resulting
cycle of interlocking narratives in books
and on walls encompasses eight monographs
and has been widely exhibited (at the
Museum of Modern Art and MoMA PS1, New
York, and Centre Pompidou in Paris,
among others) and collected.

● Gilles Peress
Whatever You Say, Say Nothing

Concept and book design by Gilles Peress
with Karina Eckmeier
Packaging and typography by Yolanda Cuomo Studio

Vol. 1: Whatever You Say, Say Nothing
552 pages
14.8 × 10 in. / 37.5 × 25.5 cm
504 black-and-white and 8 color photographs
Tritone and four-color process
Hardcover

Vol. 2: Whatever You Say, Say Nothing
504 pages
14.8 × 10 in. / 37.5 × 25.5 cm
444 black-and-white and 23 color photographs
Tritone and four-color process
Hardcover

Each copy accompanied by Annals of the North
904 pages
7.8 × 10.2 in. / 19.7 × 26 cm
210 black-and-white and 23 color photographs
and 83 illustrations
Duotone and four-color process
Softcover

Two hardcovers and a softcover, housed in a tote bag

€ 280.00 / £ 250.00 / US$ 350.00
Introductory price until 31 August 2020:
€ 225.00 / £ 195.00 / US$ 250.00
ISBN 978-3-95829-544-5

In 1972, at the age of 26, Gilles Peress photographed the British Army's massacre of Irish civilians on Bloody Sunday. In the 1980s he returned to the North of Ireland, intent on testing the limits of visual language and perception to understand the intractable conflict. *Whatever You Say, Say Nothing*, a work of "documentary fiction," organizes a decade of photographs across 22 fictional "days" to articulate the helicoidal structure of history during a conflict that seemed like it would never end—where each day became a repetition of every other day like that day: days of violence, of marching, of riots, of unemployment, of mourning, and also of "craic" where you try to forget your condition.

Held back for 30 years and now eagerly anticipated, this ambitious publication takes the language of documentary photography to its extremes, then challenges the reader to stop and resolve the puzzle of meaning for him or herself. Accompanying each copy is *Annals of the North*, a text-and-image almanac to *Whatever You Say, Say Nothing*, also published separately by Steidl this season.

In a series of remarkable projects over the past half-century, Gilles Peress has creatively transformed photography's tradition of engaged reportage. The most sustained project is the richly textured and deeply moving body of work that he patiently developed during the Troubles—the decades of bitter conflict that devastated Northern Ireland in the wake of Bloody Sunday in 1972. Now Peress has ambitiously shaped that work into two extraordinary books—Whatever You Say, Say Nothing and Annals of the North—that possess the gripping immediacy and epic sweep of a novel by Tolstoy. Peter Galassi

INTRODUCTORY PRICE
SAVE $100
ORDER BEFORE 31 AUGUST 2020
PAY AND RECEIVE BY SEPTEMBER 2020

Tote bag

Vol. 1

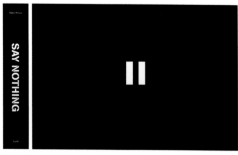
Vol. 2

Annals of the North

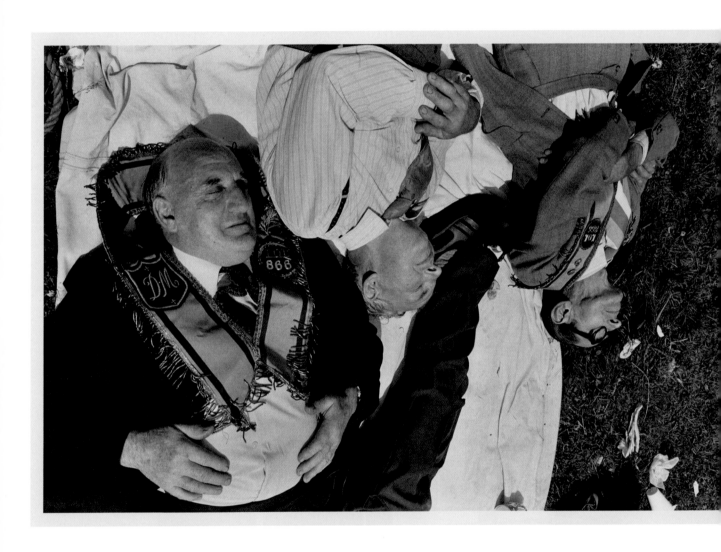

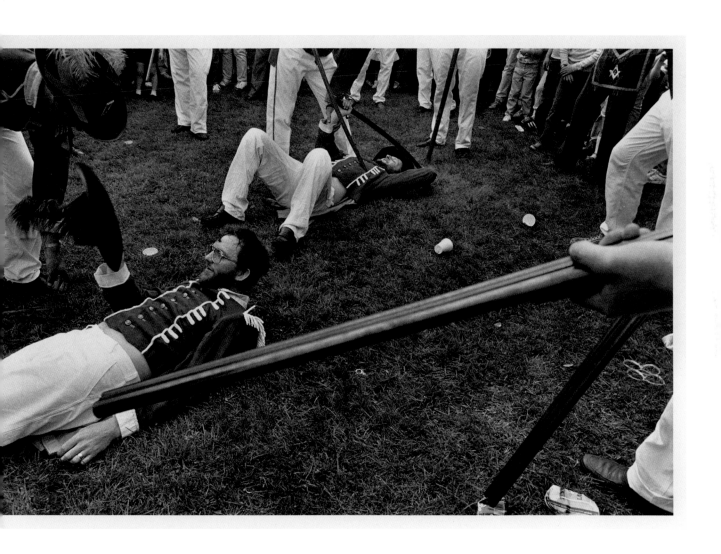

DAYS OF STRUGGLE

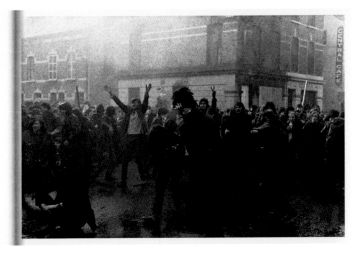

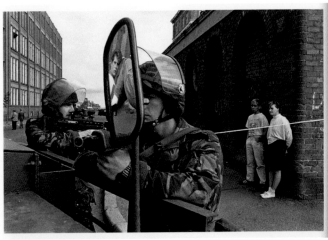

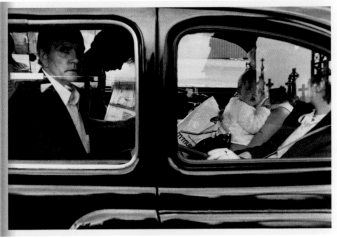

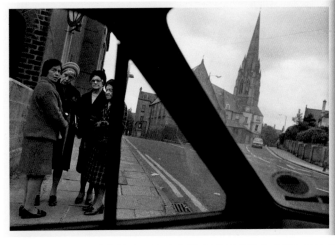

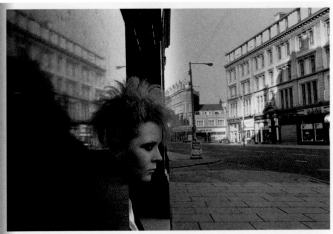

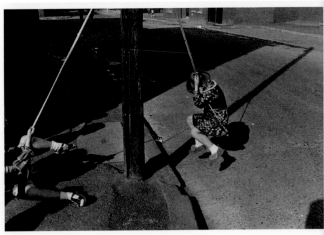

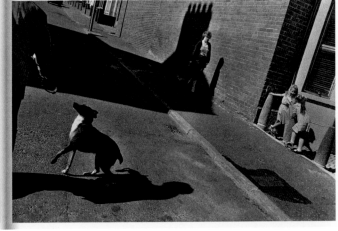

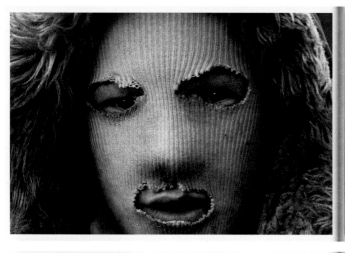
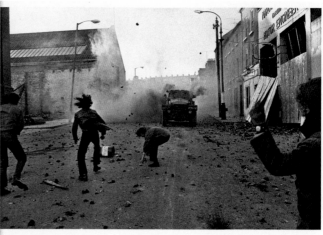
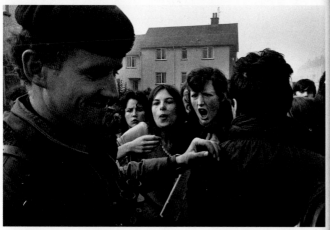
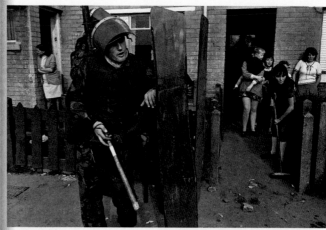
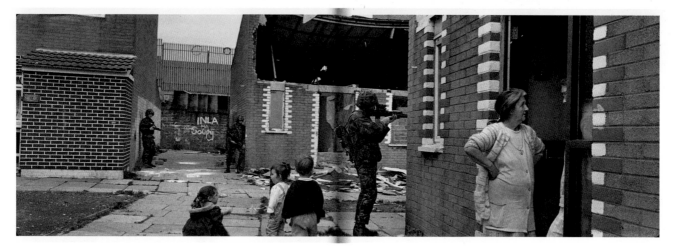
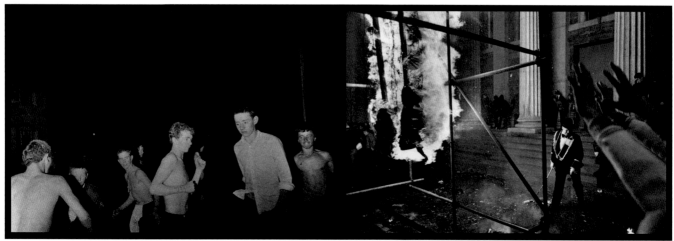

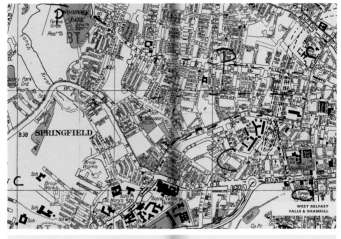

Once upon a time, on a warm October night an older Frenchman. His back hurt, his heart "Let me talk to you about my friends." This is in New York, I went to see a friend of mine. ached, and as he poured me a whiskey he said. what he told me:

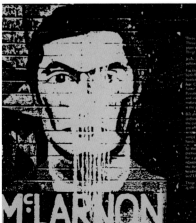

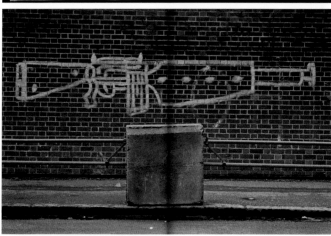

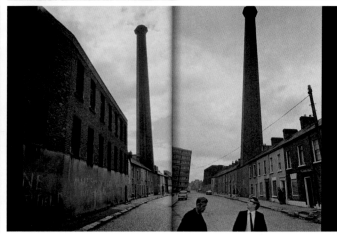

Born in 1946 in Neuilly-sur-Seine,
Gilles Peress moved to New York in 1974
and began a series of interrelated
projects that push the formal and
conceptual possibilities of photography to
interrogate the structure of history and
the nature of intolerance. The resulting
cycle of interlocking narratives in books
and on walls encompasses eight monographs
and has been widely exhibited (at the
Museum of Modern Art and MoMA PS1, New
York, and Centre Pompidou in Paris,
among others) and collected.

Chris Klatell is a writer and lawyer based
in New York. He writes frequently about
photography, including collaborations with
Donovan Wylie (A Good and Spacious Land,
2017, and Lighthouse, Steidl 2020), Jim
Goldberg (Candy, 2017) and Zoe Strauss
(Commencement, 2020).

An almanac to the world of *Whatever You Say, Say Nothing* by Gilles Peress, also published by Steidl this season, *Annals of the North* combines essays, stories, photographs, documents and testimonies to open up for the reader the complicated and contradictory storylines that emerged from the conflict in the North of Ireland. Weighed down by 800 years of colonization but only the size of Connecticut (with half its population), the North provides a remarkably intimate stage set. Interweaving text and image, *Annals of the North* examines the multifaceted struggle between Irish Republicans / Nationalists, Protestant Unionists / Loyalists, and the imperial British to explore broader themes of empire, retribution, and betrayal, as well as the tense dialectic between the ordinary demands of everyday life and intense, periodic explosions of violence. Wide-ranging yet deeply personal and political, alternately dense and humorous, legal and literary, *Annals of the North* is an almanac, not an academic history of the North of Ireland, offering a multiplicity of entry points into the North, and, by extension, into the geopolitics of the twentieth century and their impact on the people trapped in the gears of the machine.

Annals of the North *is about a time and a place, and about a group of people—friends, families, victims, soldiers, lovers, thinkers and spies—but it is also a book about another book.*
Gilles Peress and Chris Klatell

Gilles Peress and Chris Klatell
Annals of the North

Edited by Gilles Peress and Chris Klatell
Photographs by Gilles Peress
Texts by Chris Klatell, Gilles Peress, Chris
Klatell with Pauline Vermare, and others
Concept and book design by Gilles Peress with
Karina Eckmeier
Typography by Yolanda Cuomo Studio
904 pages
7.8 × 10.2 in. / 19.7 × 26 cm
210 black-and-white and 23 color photographs and 83
illustrations
Duotone and four-color process
Softcover

€ 50.00 / £ 45.00 / US$ 65.00
ISBN 978-3-95829-793-7

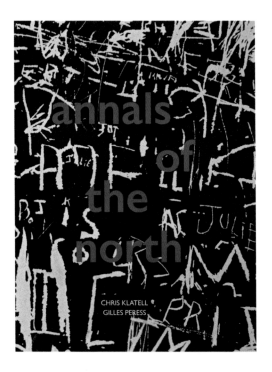

MARY

ELLEN

MARK

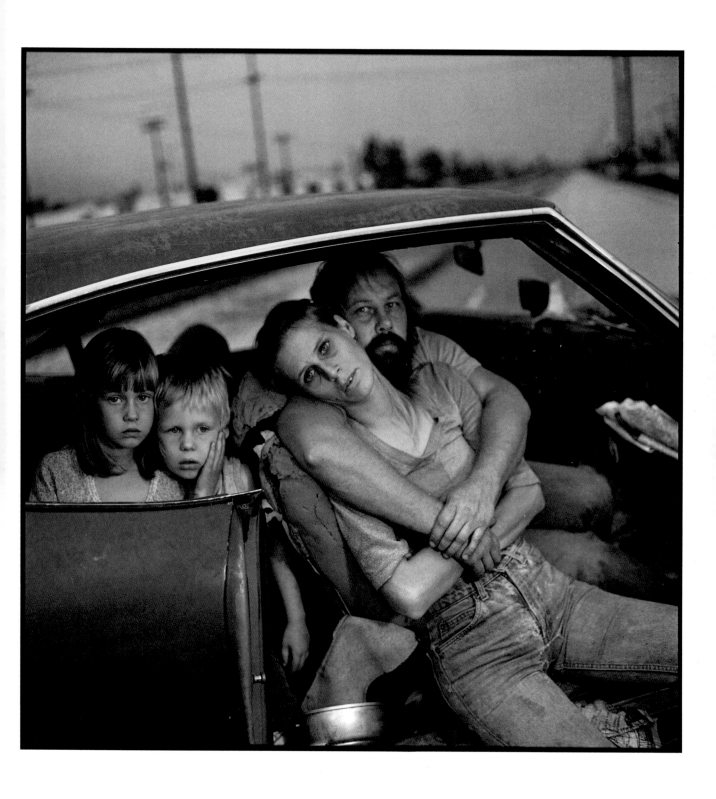

THE BOOK OF EVERY THING

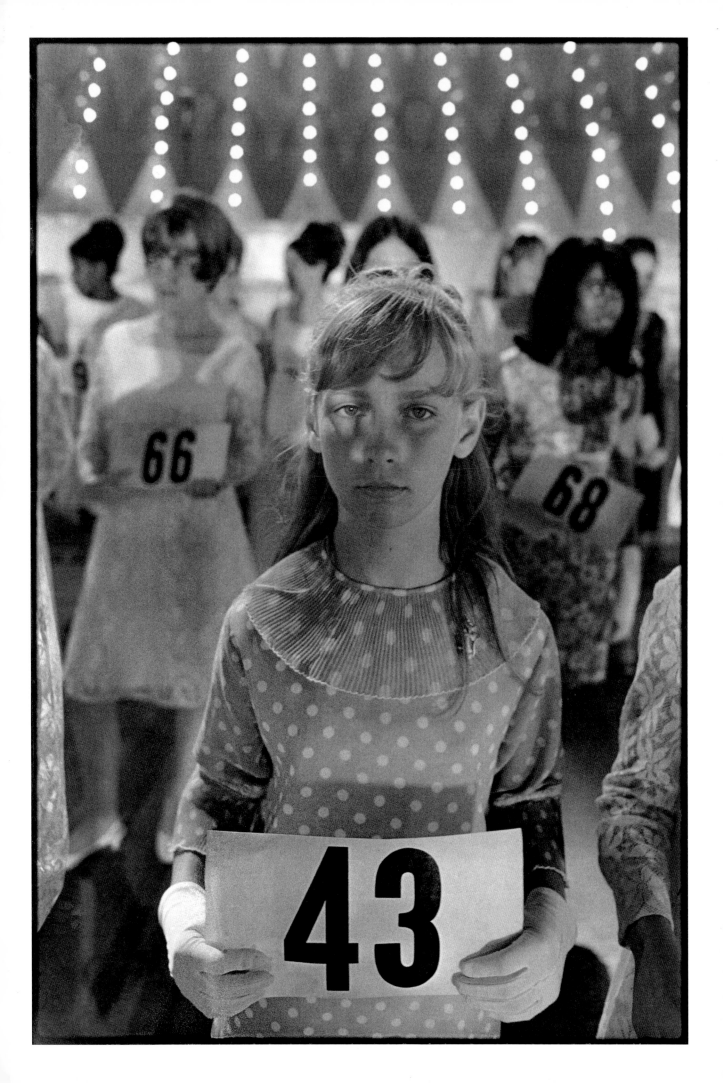

VOL. 1

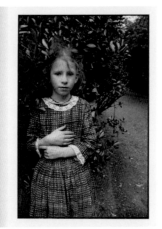

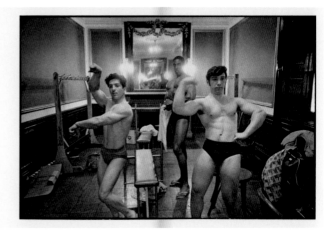

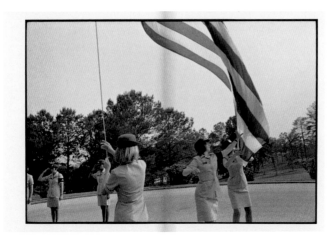

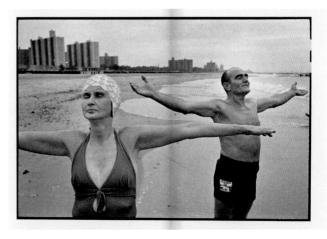

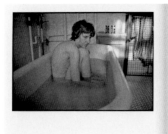

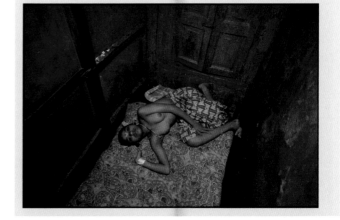

VOL. 2

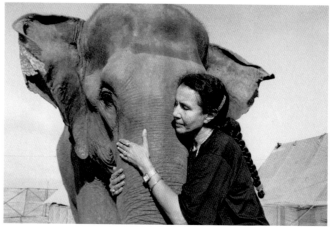

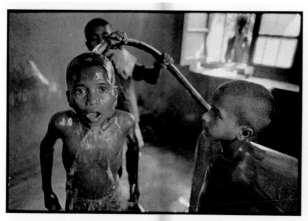

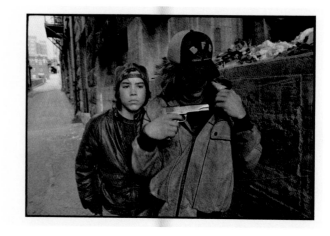

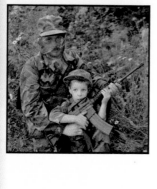

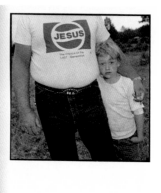

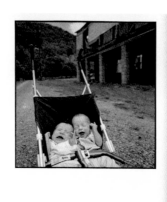

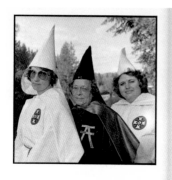

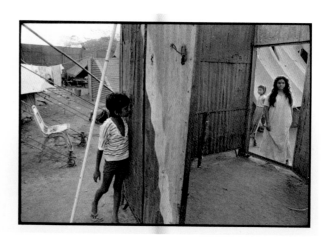

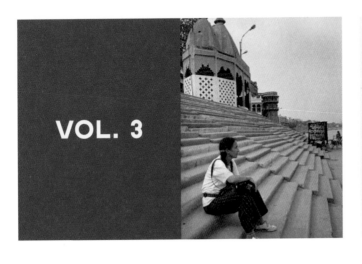

VOL. 3

The images of Mary Ellen Mark (1940-2015) are icons of documentary photography. Her 20 books include Ward 81 (1979), Falkland Road (1981) and Indian Circus (1993). Her last book Tiny: Streetwise Revisited (2015) is a culmination of 32 years documenting Erin Blackwell (Tiny), who was featured in Martin Bell's 1985 film Streetwise and Mark's 1988 book of the same name. Mark's humanistic work has been exhibited and published in magazines worldwide.

Conceived and edited by film director Martin Bell, Mary Ellen Mark's husband and collaborator for 30 years, the *Book of Everything* celebrates in 563 images and diverse texts Mark's extraordinary life, work and vision. From 1963 to her death in 2015, Mark told brilliant, intimate, provocative stories of characters whom she met and engaged with—often in perpetuity. There was nothing casual or unprepared about Mark's approach; she unfailingly empathized with the people and places she photographed.

For this comprehensive publication Bell has selected images from Mark's thousands of contact sheets and chromes—from over two million frames. These include her own now iconic choices, those published once and since lost in time, as well as some of her as yet unpublished preferences. Bell complements these with a few selections of his own. Along with Mark's pictures made in compelling, often tragic circumstances, the *Book of Everything* includes recollections from friends, colleagues and some of those she photographed. Mark's own thoughts reveal doubts and insecurities, her ideas about the individuals and topics she depicted, as well as the challenges of the business of photography.

I became a photographer because photography found me. Once I started to take pictures there was no choice. That was just what I was and what I wanted to do and what I wanted to be. Mary Ellen Mark

Mary Ellen Mark
The Book of Everything

Edited by Martin Bell
Texts by Mary Ellen Mark, Martin Bell and others
Book design by Atelier Dyakova
9.6 × 12.7 in. / 24.5 × 32.2 cm

Vol. 1
292 pages
160 black-and-white and 35 color photographs

Vol. 2
228 pages
122 black-and-white and 12 color photographs

Vol. 3
360 pages
220 black-and-white and 14 color photographs

Tritone and four-color process
Three clothbound hardcovers in a slipcase

€ 250.00 / £ 230.00 / US$ 295.00
Introductory price until 31 August 2020:
€ 150.00 / £ 135.00 / US$ 195.00
ISBN 978-3-95829-565-0

INTRODUCTORY PRICE
SAVE $100
ORDER BEFORE 31 AUGUST 2020
PAY AND RECEIVE BY SEPTEMBER 2020

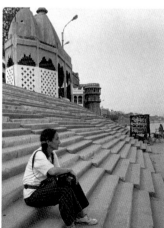

Slipcase front Slipcase back

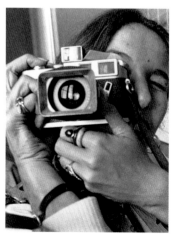

Vol. 1

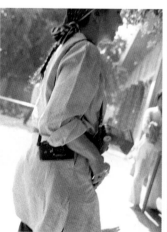

Vol. 2

Vol. 3

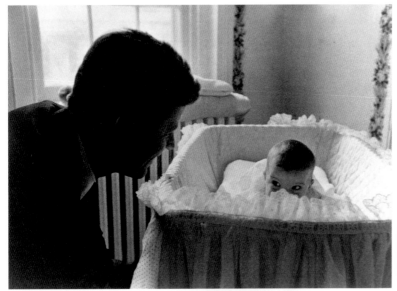

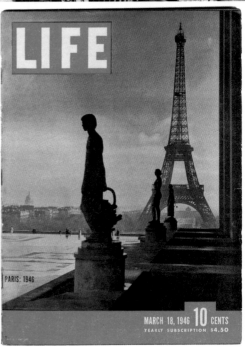

PARIS: 1946

LIFE

MARCH 18, 1946 **10** CENTS
YEARLY SUBSCRIPTION $4.50

Born in 1911 in Nashville, Tennessee,
was a quintessential and prolific
American photojournalist. Clark began
assisting staff photographers at the
daily Nashville Tennessean in 1929, and
worked for the paper until 1942. He was
hired as a stringer for Life in 1936,
the publication's inaugural year, and
began his long tenure as a full-time Life
staff photographer in 1942. In his work
for Life over the next 20 years, Clark
held posts in Nashville, Paris, Moscow,
London, Hollywood and Washington, D.C.
He received a wide range of assignments,
from political figures and events, to
Hollywood's celebrities, to charming
human interest stories. Working in both
the United States and Europe, Clark
covered some of the most important
subjects of his time, including the post-
war rebuilding of Germany and France and
the desegregation of schools in Arkansas.
In 1962 he was forced to leave Life due
to failing eyesight, yet in 1980 advances
in ocular surgery restored Clark's vision
and he returned to making photographs
in later years. He died in 2000 at the
age of 88. Today Clark's archive is held
by the Meserve-Kunhardt Foundation in
Pleasantville, New York.

● Ed Clark
On Assignment
1931–1962

Edited by Keith F. Davis and Peter W. Kunhardt, Jr.
Text by Keith F. Davis
Book design by Duncan Whyte, Gerhard Steidl and
Peter W. Kunhardt, Jr.
9.8 × 11.4 in. / 25 × 29 cm

Vol. 1: Plates and illustrated timeline
344 pages
319 black-and-white and 18 color photographs

Vol. 2: Personal scrapbooks
328 pages
161 color images

Tritone and four-color process
Two hardcovers in a slipcase

€ 165.00 / £ 150.00 / US$ 185.00
Introductory price until 31 August 2020:
€ 135.00 / £ 125.00 / US$ 145.00
ISBN 978-3-95829-506-3

Drawn from Ed Clark's extensive personal archive of photographs,
negatives, contact sheets and scrapbooks, these two volumes reveal
the work of a key figure from the golden age of American photojour-
nalism. From the pageantry of politics to the rhythms of small-town
life, from movie stars to the working class, Clark covered the defining
personalities and events of his age.

Ed Clark is one of the twentieth century's most fascinating and
important "unknown" photographers. A gifted photojournalist, Clark
began his career in 1929 with The Tennessean newspaper in Nashville,
and went on to work for 22 years for Life magazine. He photographed
many of Life's most important assignments during the period of the
magazine's greatest cultural impact; Clark's images helped shape
a nation's sense of itself and the world. His vast range of subjects
includes the Nuremberg war crimes trials, the conflict over civil
rights in the late 1940s and early '50s, Hollywood stars and the movie
industry of the '50s, the people and arts of the Soviet Union, and the
White House during the Eisenhower and Kennedy administrations.
Through Clark's eyes, we witness some of the central episodes and
themes of the post-war world.

The days were never long enough for me while on assignment. I still
love holding a camera, looking through the lens to see what I can see.
Ed Clark

Co-published with the Meserve-Kunhardt Foundation

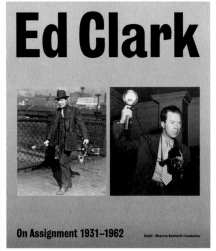

Vol. 1: Plates and illustrated timeline Vol. 2: Personal scrapbooks Slipcase

Pharmacy® London

Pharmacy® London

Pharmacy® London

Pharmacy® London

Pharmacy® London

Damien Hirst

Damien Hirst

Damien Hirst

Damien Hirst

Damien Hirst

Vol. 1
Barking
& Dagenham
Barnet
Bexley

Vol. 2
Brent
Bromley
Camden

Vol. 3
City of London
Croydon
Ealing

Vol. 4
Enfield
Greenwich
Hackney
Hammersmith
& Fulham

Vol. 5
Haringey
Harrow
Havering

Steidl
Other Criteria

Steidl
Other Criteria

Steidl
Other Criteria

Steidl
Other Criteria

Steidl
Other Criteria

Pharmacy®
London

Damien
Hirst

Vol. 6

Hillingdon
Hounslow
Islington
Kensington
& Chelsea

Steidl
Other Criteria

Pharmacy®
London

Damien
Hirst

Vol. 7

Kingston
Upon Thames
Lambeth
Lewisham
Merton

Steidl
Other Criteria

Pharmacy®
London

Damien
Hirst

Vol. 8

Newham
Redbridge
Richmond
Upon Thames

Steidl
Other Criteria

Pharmacy®
London

Damien
Hirst

Vol. 9

Southwark
Sutton
Tower Hamlets
Waltham Forest

Steidl
Other Criteria

Pharmacy®
London

Damien
Hirst

Vol. 10

Wandsworth
Westminster

Steidl
Other Criteria

Pharmacy® London Damien Hirst

Steidl. Other Criteria

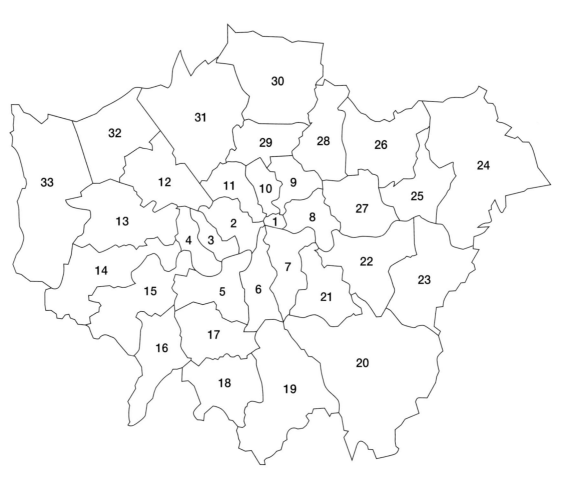

London Boroughs

1. City of London
2. City of Westminster
3. Kensington and Chelsea
4. Hammersmith and Fulham
5. Wandsworth
6. Lambeth
7. Southwark
8. Tower Hamlets
9. Hackney
10. Islington
11. Camden
12. Brent
13. Ealing
14. Hounslow
15. Richmond
16. Kingston upon Thames
17. Merton
18. Sutton
19. Croydon
20. Bromley
21. Lewisham
22. Greenwich
23. Bexley
24. Havering
25. Barking and Dagenham
26. Redbridge
27. Newham
28. Waltham Forest
29. Haringey
30. Enfield
31. Barnet
32. Harrow
33. Hillingdon

Vol. 1, screen-printed clothbound hardcover

Vol. 2, screen-printed clothbound hardcover

Vol. 3, screen-printed clothbound hardcover

Vol. 4, screen-printed clothbound hardcover

Vol. 5, screen-printed clothbound hardcover

Vol. 6, screen-printed clothbound hardcover

Vol. 7, screen-printed clothbound hardcover

Vol. 8, screen-printed clothbound hardcover

Vol. 9, screen-printed clothbound hardcover

Vol. 10, screen-printed clothbound hardcover

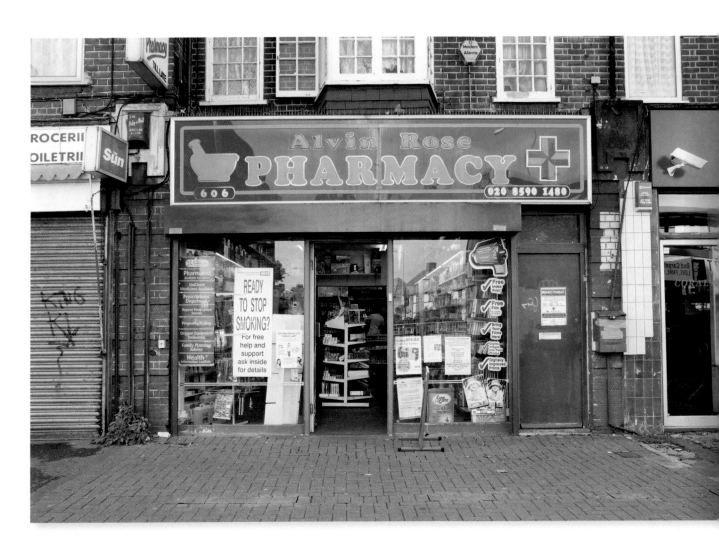

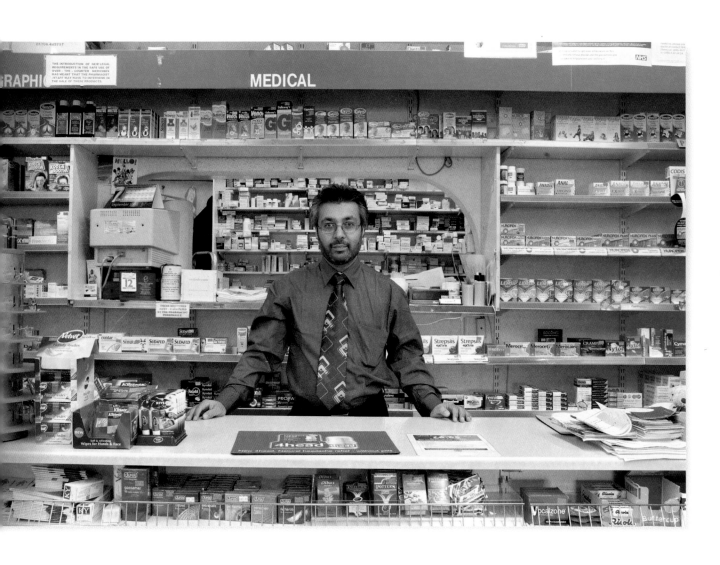

Pharmacy® London

Damien Hirst

Steidl. Other Criteria

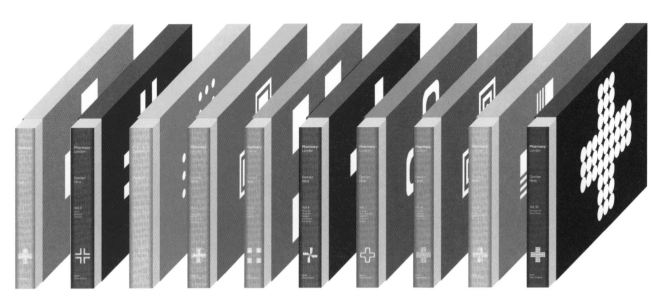

10 hardcover books
in individual cardboard sleeves

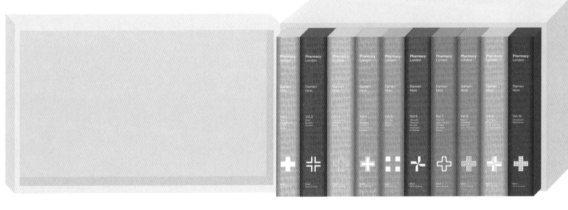

Stored in a wooden crate (open)

Limited edition
of 750 sets

Signed and numbered
by Damien Hirst

Pharmacy® London

Damien-Hirst

Wooden crate (closed)

Born in Bristol in 1965, British artist Damien Hirst employs a varied practice of installation, sculpture, painting and drawing to explore the relationships between art, religion, science, life and death. Iconic works include The Physical Impossibility of Death in the Mind of Someone Living (1991) and For the Love of God (2007). Hirst won the Turner Prize in 1995.

In 2005 Damien Hirst began photographing every dispensing pharmacy in the Greater London area. Shooting both the individual pharmacists behind their counters and the exterior views of the city's 1,832 chemists, the project has taken over a decade to complete. The images are brought together in their entirety in this extraordinary ten-volume artist's book, which presents a portrait of the city through the people and places that prescribe the medicines we take on a habitual and daily basis.

Hirst's career-long obsession with the minimalist aesthetics employed by pharmaceutical companies—the cool colors and simple geometric forms—first manifested in his series of "Medicine Cabinets," conceived in 1988 while still at Goldsmiths College. For his 1992 installation *Pharmacy* Hirst recreated an entire chemist within the gallery space, stating: "I've always seen medicine cabinets as bodies, but also like a cityscape or civilization, with some sort of hierarchy within it. [*Pharmacy*] is also like a contemporary museum. In a hundred years it will look like an old apothecary." *Pharmacy London* similarly embodies the artist's realization of an "idea of a moment in time." The publication also, however, reads as a distilled expression of Hirst's continuing belief in the near-religious role medicine plays in our society.

What's always got me is that people's belief in their drugs is so unquestionable. Damien Hirst

Damien Hirst
Pharmacy London

Limited edition of 750 sets
Signed and numbered by Damien Hirst

Book design by Jason Beard
3,800 pages
17.3 × 11.6 in. / 44 × 29.4 cm
3,565 color photographs
Four-color process
Ten screen-printed clothbound hardcovers
in individual cardboard sleeves,
all housed in a wooden crate

Vol. 1
Barking & Dagenham, Barnet, Bexley
340 pages

Vol. 2
Brent, Bromley, Camden
416 pages

Vol. 3
City of London, Croydon, Ealing
324 pages

Vol. 4
Enfield, Greenwich, Hackney, Hammersmith & Fulham
420 pages

Vol. 5
Haringey, Harrow, Havering
344 pages

Vol. 6
Hillingdon, Hounslow, Islington, Kensington & Chelsea
420 pages

Vol. 7
Kingston upon Thames, Lambeth, Lewisham, Merton
380 pages

Vol. 8
Newham, Redbridge, Richmond upon Thames
340 pages

Vol. 9
Southwark, Sutton, Tower Hamlets
436 pages

Vol. 10
Wandsworth, Westminster
380 pages

€ 1,500.00 / £ 1,300.00 / US$ 1,750.00
Introductory price until 31 August 2020:
€ 1,250.00 / £ 1,150.00 / US$ 1,450.00
ISBN 978-3-86930-991-0

INTRODUCTORY PRICE
SAVE $300
ORDER BEFORE 31 AUGUST 2020
PAY AND RECEIVE BY SEPTEMBER 2020

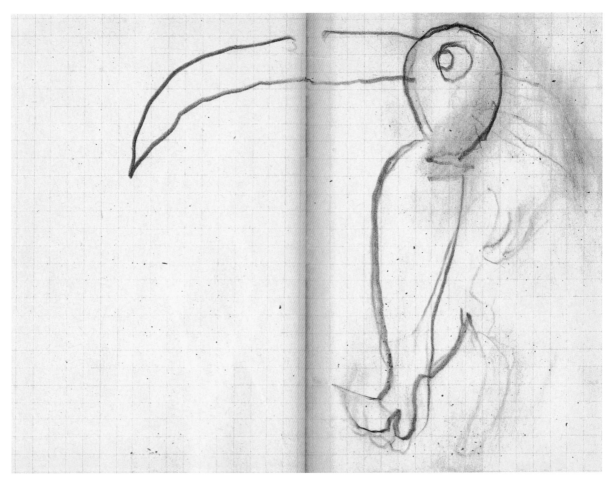

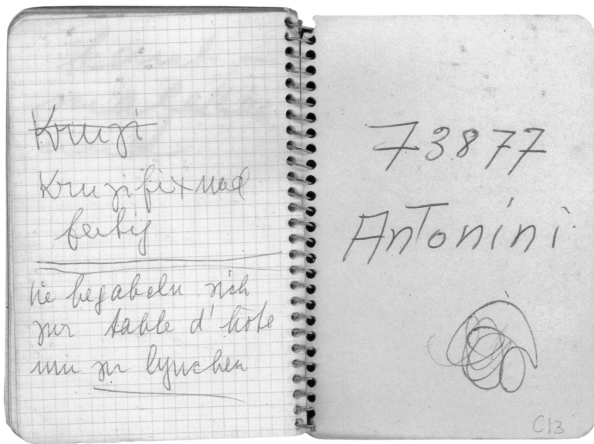

Vol. 1

Vol. 2

Vol. 3

Vol. 4

Vol. 5

Vol. 6

Vol. 7

Vol. 8

Vol. 9

Vol. 10

Vol. 11

Vol. 12

Vol. 13

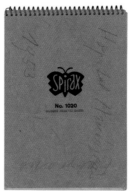

Vol. 14

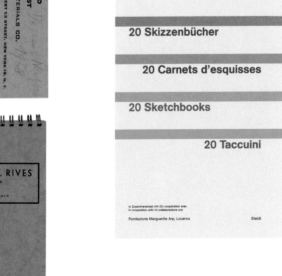

Vol. 15

Vol. 16

Vol. 17

Vol. 18

Vol. 19

Vol. 20

Reader

Hans / Jean Arp

Herausgegeben von / Edité par / Edited by / A cura di
Rainer Hüben & Roland Scotti

20 Skizzenbücher

20 Carnets d'esquisses

20 Sketchbooks

20 Taccuini

In Zusammenarbeit mit / En coopération avec
In cooperation with / In collaborazione con

Fondazione Marguerite Arp, Locarno Steidl

Born in 1886 in Strasbourg, the German-French artist and poet Hans/Jean Arp is one of the most important sculptors of the twentieth century. He co-founded Dada in Zurich in 1916 and later participated in Surrealist circles in Paris as well as the artists' group Abstraction-Création.

Hans / Jean Arp's diverse visual oeuvre—primarily consisting of sculptures, reliefs, drawings, collages and prints—is world-renowned, yet his sketchbooks remain relatively unknown. *Twenty Sketchbooks* seeks to remedy this by reproducing as meticulous facsimiles 20 of Arp's small sketchbooks and spiral-bound pads, made between 1950 and 1966 and today held at the Fondazione Marguerite Arp-Hagenbach, located in Arp's last atelier in Locarno, Switzerland.

This publication allows us for the first time to "hold" Arp's sketchbooks in our hands and thereby gain new insight into his working processes. Some sketches reveal themselves as drafts for fully realized artworks, yet the majority are exploratory works in themselves. *Twenty Sketchbooks* contains over 400 sketches as well as written notes by the artist. The 20 volumes, each produced at its original size, are presented in a handmade box following the design of the carton in which they were found in Arp's archive.

As I work, friendly, strange, evil, inexplicable, mute, or sleeping forms arise. Hans Arp

Co-published with the Fondazione Marguerite Arp-Hagenbach, Locarno

● Hans / Jean Arp
Twenty Sketchbooks

Limited edition of 1,000 boxed sets

Edited by Rainer Hüben and Roland Scotti
Text by Rainer Hüben
4.1 × 12 × 7.1 in. / 10.5 × 30.5 × 18 cm
20 softcover books and a reader,
housed in an archive box
Tritone and four-color process

€ 185.00 / £ 175.00 / US$ 195.00
Introductory price until 31 August 2020:
€ 145.00 / £ 135.00 / US$ 150.00
ISBN 978-3-95829-336-6

INTRODUCTORY PRICE
SAVE $45
ORDER BEFORE 31 AUGUST 2020
PAY AND RECEIVE BY SEPTEMBER 2020

Vol. 1
46 pages
4.7 × 7.1 in. / 12 × 18 cm
22 color facsimiles

Vol. 2
66 pages
3.9 × 5.5 in. / 10 × 14 cm
30 color facsimiles

Vol. 3
48 pages
4.1 × 5.9 in. / 10.5 × 15 cm
19 black-and-white facsimiles

Vol. 4
66 pages
4.1 × 5.8 in. / 10.5 × 14.7 cm
31 black-and-white facsimiles

Vol. 5
56 pages
3.9 × 6 in. / 10 × 15.3 cm
27 black-and-white facsimiles

Vol. 6
54 pages
4.1 × 5.8 in. / 10.5 × 14.7 cm
25 color facsimiles

Vol. 7
66 pages
4.1 × 5.8 in. / 10.5 × 14.8 cm
29 color facsimiles

Vol. 8
54 pages
4.1 × 5.8 in. / 10.5 × 14.8 cm
22 color facsimiles

Vol. 9
52 pages
4.1 × 5.8 in. / 10.5 × 14.8 cm
18 black-and-white facsimiles

Vol. 10
82 pages
2.6 × 4.3 in. / 6.5 × 11 cm
25 black-and-white facsimiles

Vol. 11
96 pages
3 × 4.7 in. / 7.6 × 12 cm
18 color facsimiles

Vol. 12
52 pages
4.1 × 5.8 in. / 10.5 × 14.7 cm
12 black-and-white facsimiles

Vol. 13
66 pages
3.8 × 5.3 in. / 9.6 × 13.5 cm
26 color facsimiles

Vol. 14
88 pages
2.9 × 4.1 in. / 7.3 × 10.5 cm
3 color facsimiles

Vol. 15
68 pages
2.9 × 4.1 in. / 7.3 × 10.5 cm
9 color facsimiles

Vol. 16
70 pages
3.9 × 5.8 in. / 10 × 14.8 cm
33 color facsimiles

Vol. 17
80 pages
3.5 × 5.3 in. / 9 × 13.5 cm
34 color facsimiles

Vol. 18
28 pages
4.1 × 5.9 in. / 10.3 × 15.1 cm
11 black-and-white facsimiles

Vol. 19
42 pages
5.8 × 4.1 in. / 14.8 × 10.3 cm
9 black-and-white facsimiles

Vol. 20
28 pages
4.1 × 5.8 in. / 10.5 × 14.8 cm
3 black-and-white facsimiles

Reader in English, German, French and Italian
6.7 × 11 in. / 17 × 28 cm
128 facsimiles

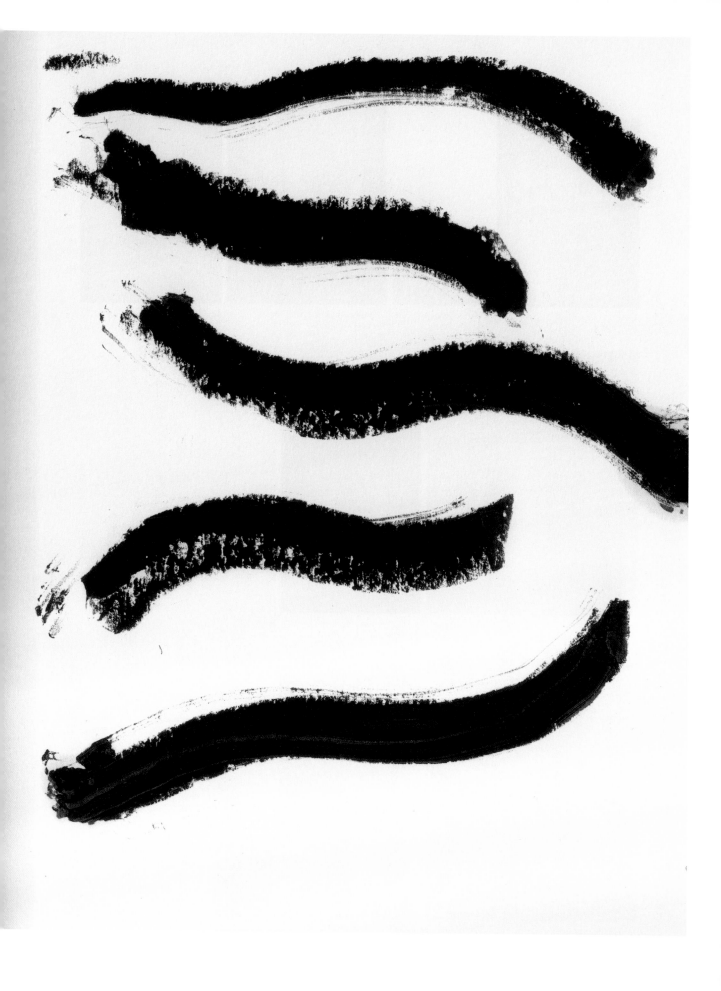

Richard Serra, Wake, 2003 53

Machu Picchu steps
Peru, 1972

Afangar, Videy Island
Iceland, 1989

Basalt columns: Svartifoss
Iceland, 1989

Saqqara pyramid
Egypt, 1990

Schunnemonk Fork
Storm King Art Center, 1991

Snake Eyes and Boxcars
Geyserville, CA, 1993

Wake
2003

Torqued Ellipses
Guggenheim Bilbao, Spain, 2005

Promenade
Grand Palais, Paris, 2008

East-West/West-East
Qatar, 2014

Richard Serra was born in San Francisco in 1938. Since the 1960s he has exhibited extensively throughout the world. In addition, Serra has created a number of site-specific sculptures in public and private venues in both North America and Europe. Serra's books at Steidl include Sculpture 1985-1998 (1999), The Matter of Time (2005), Te Tuhirangi Contour (2005), Notebooks (2011), Early Work (2014) and Vertical and Horizontal Reversals (2015). He lives in New York and Nova Scotia.

● Richard Serra
Notebooks Vol. 2

Limited edition of 1,000 boxed sets
signed and numbered by Richard Serra

Machu Picchu steps, Peru, 1972
8.4 × 10.6 in. / 21.3 × 27 cm
44 pages
Leatherbound hardcover

Afangar, Videy Island, Iceland, 1989
6 × 4 in. / 14.6 × 9.4 cm
152 pages
Leatherbound hardcover

Basalt columns: Svartifoss, Iceland, 1989
10.5 × 14 in. / 25 × 33 cm
32 pages
Halfbound hardcover

Saqqara pyramid, Egypt, 1990
8.3 × 10.8 in. / 21 × 27.5 cm
44 pages
Halfbound hardcover

Schunnemonk Fork, Storm King Art Center, 1991
12.5 × 14.4 in. / 31.8 × 36.5 cm
88 pages
Clothbound hardcover

Snake Eyes and Boxcars, Geyserville, CA, 1993
8.1 × 10.6 in. / 20.6 × 27 cm
136 pages
Leatherbound hardcover

Wake, 2003
9.8 × 12.2 in. / 25 × 31 cm
48 pages
Softcover

Torqued Ellipses, Guggenheim Bilbao, Spain, 2005
12.5 × 14.4 in. / 31.8 × 36.5 cm
52 pages
Clothbound hardcover

Promenade, Grand Palais, Paris, 2008
13.8 × 8.3 in. / 35.1 × 21 cm
84 pages
Softcover

East-West/West-East, Qatar, 2014
4 × 5 in. / 9.5 × 12.5 cm
84 pages
Leatherbound

10 facsimile books housed
in a wooden crate
15.1 × 11.6 × 7.9 in. / 38.5 × 29.5 × 20 cm
764 pages total
Tritone

€ 850.00 / £ 780.00 / US$ 950.00
Introductory price until 31 August 2020:
€ 600.00 / £ 550.00 / US$ 750.00
ISBN 978-3-86930-975-0

Throughout his career, the renowned American sculptor Richard Serra has kept a large number of notebooks which by now fill an entire library in his studio. Contained within them are delicate sketches of his travels, of landscapes, architecture and of other ideas, some of which the artist developed into mature sculptures and drawings. Serra has personally selected ten of his notebooks, two of which he made in Iceland in 1989 and the latest from Qatar in 2014, which are reproduced here in facsimile.

Edition certificate, signed and numbered by Richard Serra

Model for a Sound Building

78

Università Monte St Angelo Metro Station

67, **178**, **179**, **180**, 290, 390, 445

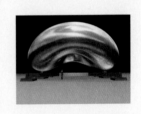

Dome Coil

125, **258**, 356, 424

Cloud Gate

38, 155, **271**, **272**, 370, 443, 495

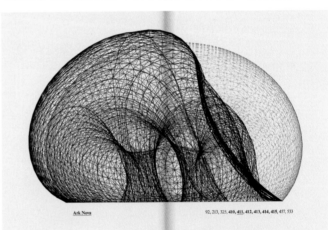

Orbit

121, 253, **349**, **350**, **351**, **352**, **353**, **354**, 425, 454, 525

Ark Nova

92, 213, 325, **410**, **411**, 412, 413, **414**, **415**, 457, 533

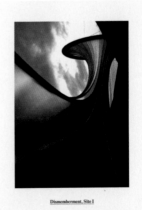

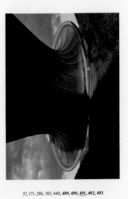

Ark Nova

92, 213, 325, 410, **457**, 458, 533

Dismemberment, Site I

57, 171, 286, 383, 440, **489**, **490**, **491**, **492**, **493**

This publication brings together for the first time Anish Kapoor's architectural projects and ideas that span the last 40 years. These are concepts that continue to inform all areas of Kapoor's artistic output, many of which have been realized in works that confound the distinctions between art and architecture, pushing architecture into radical new territory.

Kapoor's projects renegotiate the relationship not only between art and architecture but also between the very sense of space within ourselves and that of the external world. The forms he presents to us create spaces that blur the duality of subject and object, of interior and exterior. Monochrome fields of color, mirrored surfaces and fathomless voids all destabilize our place in the world. The more than 2,000 sketches, models, renderings and plans in this book show the journey of these forms to how they might exist in reality as well as the spaces they inhabit or create, both outside and within us.

For a long time before—even from the pigment pieces—I'd been thinking of my work as potential architecture. I've always been convinced by the idea that to make new art you have to make new space.
Anish Kapoor

● Anish Kapoor
Make New Space
Architectural Projects

Edited by Anish Kapoor Studio
Book design by Brighten the Corners
6.9 × 9.4 in. / 17.5 × 24 cm

Vol. 1
600 pages
1,053 color photographs and images

Vol. 2
588 pages
1,053 color photographs and images

Four-color process
Two hardcover books in a sleeve

INTRODUCTORY PRICE
SAVE $100
ORDER BEFORE 31 AUGUST 2020
PAY AND RECEIVE BY SEPTEMBER 2020

€ 250.00 / £ 200.00 / US$ 300.00
Introductory price until 31 August 2020:
€ 180.00 / £ 150.00 / US$ 200.00
ISBN 978-3-95829-420-2

Archi tectural Projects Anish Kapoor

Steidl

Sleeve

Vol. 1

Make new space

Architectural Projects
Anish Kapoor

Vol. 2

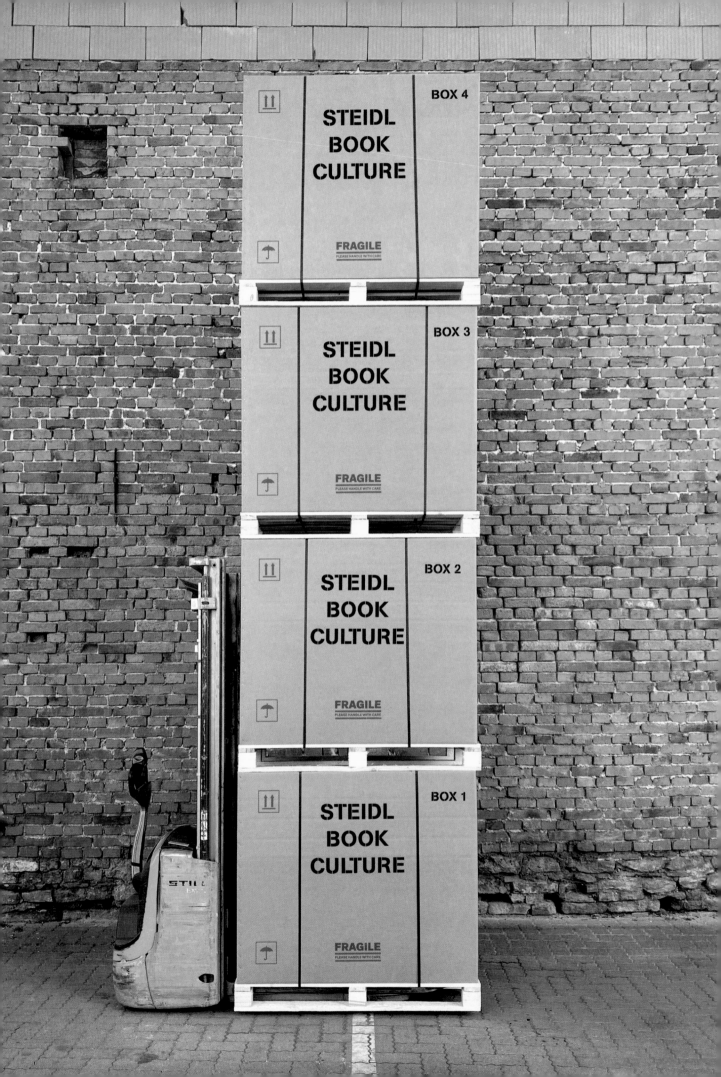

Steidl Book Culture 2006–2020

At the beginning of 2006, I had the idea to hold back 50 copies of each Steidl book to be made in the coming years, a little like how winemakers put aside their finest vintages for future release. Since then I've continued the tradition, carefully tucking away these book bottles, waiting for the right moment to release them all together to the light of day.

That moment has now come. I hope individuals and institutions all over the world enjoy savoring the different flavors of these books, the yield of 15 years. There are just 50 sets to be had; when they're gone, the Steidl cellar is empty again. But remember: the best is yet to come.

Gerhard Steidl

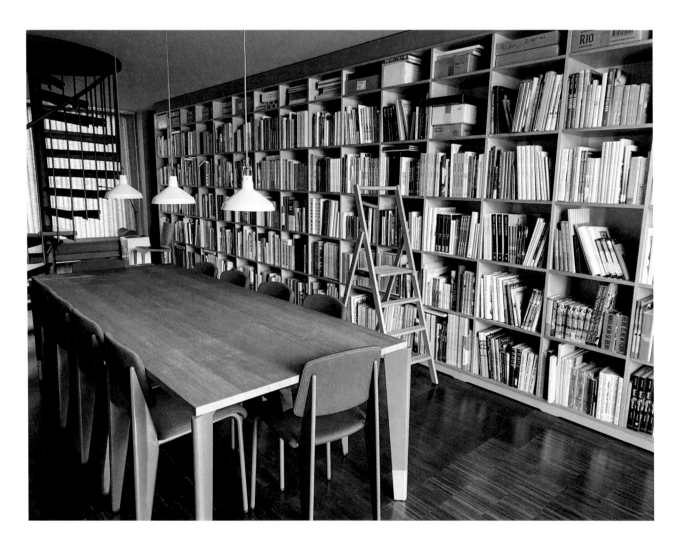

Steidl artists, authors and editors, 2006–2020

A-chan, Berenice Abbott, Adel Abdessemed, Bryan Adams, Robert Adams, Jörg Adolph, Shahidul Alam, Miles Aldridge, Manuel Álvarez-Bravo, Dirk Alvermann, Francis Alÿs, Laurie Anderson, Steffen Appel, Nobuyoshi Araki, Hans/Jean Arp, Julie Ault, Richard Avedon, Martina Bacigalupo, Francis Bacon, Peter Badge, Olle Bærtling, David Bailey, Matthew Bakkom, John Baldessari, Catherine Balet, Balthus, Lewis Baltz, François-Marie Banier, Tina Barney, Fabien Baron, Adam Bartos, Daniela Baumann, Noah Baumbach, Valérie Belin, Kristine Bell, Lead Belly, Jerry Berndt, Joseph Beuys, Werner Bischof, Jürgen Bischoff, Daniel Blaufuks, Barbara Bloom, Erwin Blumenfeld, Koto Bolofo, Alessandra Borghese, Guy Bourdin, Louise Bourgeois, Joachim Brohm, Philip Brookman, Adam Broomberg, Daniel Brush, Berlinde De Bruyckere, Yul Brynner, Christoph Büchel, Brigitta Burger-Utzer, Balthasar Burkhard, Marie Burki, René Burri, Edward Burtynsky, Harry Callahan, Sophie Calle, David Campany, Tina Campt, Robert Capa, William Carter, Henri Cartier-Bresson, Germano Celant, Theseus Chan, Oliver Chanarin, Clément Chéroux, William Christenberry, Joshua Chuang, Yukari Chikura, Ed Clark, Brian Clarke, Langdon Clay, Maude Schuyler Clay, Chuck Close, Grace Coddington, John Cohen, Lynne Cohen, Stéphanie Cohen, Bob Colacello, Ernest Cole, Teju Cole, Hannah Collins, Papo Colo, Joan Colom, Michel Comte, Lauren Cornell, Margaret Courtney-Clarke, Thibaut Cuisset, Mauro D'Agati, Anthony d'Offay, Martin d'Orgeval, Alessandra d'Urso, Tenzing Dakpa, Pascal Dangin, Hans Danuser, Kapil Das, Moyra Davey, Anna Mia Davidson, Bruce Davidson, Tacita Dean, Gautier Deblonde, Thomas Demand, Patrick Demarchelier, Ad van Denderen, Raymond Depardon, Richard Depardon, Susan Derges, Lucinda Devlin, Bodo von Dewitz, Philip-Lorca diCorcia, Aline Diépois, Babeth Djian, Jim Dine, Mike Disfarmer, Robert Doisneau, Stan Douglas, Diane Dufour, Jean-Louis Dumas, John Duncan, Stephen Dupont, Marcel Dzama, Amelia Earhart, Harold Edgerton, William Eggleston, Richard Ehrlich, Arthur Elgort, Fouad Elkoury, Ed van der Elsken, Annabel Elston, Joakim Eneroth, J. H. Engström, Okwui Enwezor, Mitch Epstein, Joakim Eskildsen, Ute Eskildsen, Roe Ethridge, Walker Evans, Wendy Ewald, William A. Ewing, Thobias Fäldt, Marc Ferrez, Dan Flavin, Maja Forsslund, Samuel Fosso, Martine Fougeron, Martine Franck, Robert Frank, Peter Fraser, Leonard Freed, David Freund, Peter Friedl, Lee Friedlander, Julien Frydman, Peter Galassi, Michael Galinsky, Tamar Garb, Philippe Garner, Daniel Gaujac, Tierney Gearon, Isa Genzken, Julian Germain, Ralph Gibson, Thomas Gizolme, Robert Gober, Frank Gohlke, Jim Goldberg, David Goldblatt, Nan Goldin, Félix González-Torres, Dryden Goodwin, Antony Gormley, John Gossage, Alan Govenar, Sheela Gowda, Paul Graham, Robert Graham, Alexandra Grant, Günter Grass, Angela Grauerholz, Howard Greenberg, Colin Grey, Joel Grey, Stefan Grissemann, Sid Grossman, L. Fritz Gruber, Harry Gruyaert, Tomasz Gudzowaty, Kadir Guirey, F. C. Gundlach, Andreas Gursky, Carsten Güttler, Ernst Haas, Jefferson Hack, Heinz Hajek-Halke, Jitka Hanzlová, Cristóbal Hara, Chauncey Hare, Amanda Harlech, Takumi Hasegawa, Dave Heath, Lois Hechenblaikner, William Heick, Manfred Heiting, Kiluanji Kia Henda, Mat Hennek, Lewis Hine, Satoshi Hirano, Marianne Hirsch, Damien Hirst, Gil Hochberg, Axel Hoedt, Evelyn Hofer, Maja Hoffmann, Dan Holdsworth, Jacob Holdt, E. O. Hoppe, Rebecca Horn, Roni Horn, Peter Hujar, Gentaro Ishizuka, Graciela Iturbide, Kenro Izu, John P. Jacob, Roland Jaeger, Mikael Jansson, Paul Jasmin, Jan Jedlička, Adam Jeppesen, Marc Joseph, Valérie Jouve, Donald Judd, Nadav Kander, Allan Kaprow, James Karales, Betsy Karel, Steven Kasher, Ed Kashi, Philipp Keel, Peter Keetman, Seydou Keïta, Ellsworth Kelly, Clay Ketter, Annette Kicken, Hiroh Kikai, Chris Killip, Atta Kim, Ernst Ludwig Kirchner, Keizo Kitajima, Konrad Klapheck, Chris Klatell, Eric Klemm, Deborah Klochko, Herlinde Koelbl, Toru Komatsu, Alberto Korda, Harmony Korine, Gleb Kosorukov, Josef Koudelka, Mona Kuhn, Peter W. Kunhardt, Jr., Guillermo Kuitca, Brigitte Lacombe, Karl Lagerfeld, Mark Laita, Suzy Lake, Maria Lassnig, Karine Laval, June Leaf, Robert Lebeck, Jocelyn Lee, Saul Leiter, Zoe Leonard, Sze Tsung Leong, Henry Leutwyler, Sébastien Lifshitz, Zhang Lijie, Broy Lim, Kai Löffelbein, Glen Luchford, Håkan Ludwigson, David Lynch, Peter MacGill, Arnaud Maggs, David Maisel, Kazimir Malevich, Renate von Mangoldt, Yves Marchand, Brice Marden, Mary Ellen Mark, Tyrone Martinsson, Urs Marty, Albert Maysles, Kristine McKenna, Daniel McLaughlin, David McMillan, Larry McPherson, Hans van der Meer, Romain Meffre, Susan Meiselas, Klaus Mettig, Ray Metzker, Sébastien Meunier, Duane Michals, Diana Michener, Maria Miesenberger, Aernout Mik, Boris Mikhailov, Domingo Milella, Yann Mingard, Joan Mitchell, Guido Mocafico, Curtis Moffat, Santu Mofokeng, László Moholy-Nagy, Inge Morath, Toshiaki Mori, Christopher Morris, Zanele Muholi, Frank-Heinrich Müller, Romney Müller-Westernhagen, Eadweard Muybridge, Péter Nádas, Andrei B. Nakov, Mark Neville, Arnold Newman, Jackie Nickerson, Shelley Niro, Nicholas Nixon, Isamu Noguchi, Paulo Nozolino, Hank O'Neal, Arnold Odermatt, Chris Ofili, Ken Ohara, Mikael Olsson, Shigeru Onishi, Orri, Monte Packham, Orhan Pamuk, Tod Papageorge, Jongwoo Park, Trent Parke, Gordon Parks, Susan Paulsen, Andreas Pauly, Gilles Peress, Slavica Perkovic, Carolyn Peter, Anders Petersen, Mark Peterson, Benoît Peverelli, Walter Pfeiffer, Justine Picardie, Jean Pigozzi, Andri Pol, Robert Polidori, Chantal Pontbriand, Sebastian Posingis, Luke Powell, Ken Price, Ivor Prickett, Bernhard Prinz, Barbara Probst, Noah Purifoy, Marc Quinn, Walid Raad, Jo Ractliffe, Neo Rauch, Timm Rautert, Man Ray, Lou Reed, Keanu Reeves, Dirk Reinartz, Gaia Repossi, Christian von Reventlow, John Reynolds, Bettina Rheims, Jason Rhoades, Clare Richardson, Olivier Richon, John Riddy, Michael Roberts, Tiny Robinson, Torbjørn Rødland, RongRong, Judith Ross, Paolo Roversi, Michal Rovner, Margit Rowell, Leo Rubinfien, Nancy Rubins, Hans-Jörg Ruch, Esther Ruelfs, Michael Ruetz, Willi Ruge, Ed Ruscha, Paul Ruscha, Mark Ruwedel, Liza Ryan, Tomoyuki Sagami, Britt Salvesen, Anastasia Samoylova, Fred Sandback, August Sander, Lise Sarfati, Carlos Saura, Andrew Savulich, Matthias Schaller, Christoph Schifferli, Ken Schles, Jason Schmidt, Joachim Schmidt, Toni Schneiders, Martin Schoeller, Collier Schorr, Gotthard Schuh, Lawrence Schwartzwald, Sean Scully, Peter Sekaer, Richard Serra, Maria Sewcz, Fazal Sheikh, Liu Heung Shing, Malick Sidibé, Jeanloup Sieff, Holger Sierks, Ivan Sigal, Roman Signer, Taryn Simon, Dayanita Singh, Hedi Slimane, Bridget Smith, Tony Smith, Gunnar Smoliansky, Lindokuhle Sobekwa, Rosalind Fox Solomon, Mario Sorrenti, Sanlé Sory, Monika Sosnowski, Alec Soth, Jerry Spagnoli, David Spero, Nancy Spero, Klaus Staeck, Urs Stahel, Hannah Starkey, Simon Starling, Gerhard Steidl, Albert Steiner, Otto Steinert, Joel Sternfeld, Jamey Stillings, Paul Strand, Christer Strömholm, Jock Sturges, Mikhael Subotzky, Larry Sultan, Antanas Sutkus, Tatsuo Suzuki, Gerda Taro, Al Taylor, Sam Taylor-Johnson, Juergen Teller, Woong Soak Teng, Andrea Tese, Philipp Thesen, Miroslav Tichý, Guy Tillim, Wolfgang Tillmans, Philip Trager, Charles H. Traub, Cecilia Tubiana, Jakob Tuggener, Lars Tunbjörk, Deborah Turbeville, Tomi Ungerer, JoAnn Verburg, Jake Verzosa, Massimo Vitali, Robert Voit, Jürgen Vollmer, Stephen Waddell, Peter Waelty, Jeff Wall, Brian Wallis, Andy Warhol, John Warwicker, Toshiya Watanabe, Patrick Waterhouse, Karlheinz Weinberger, Lawrence Weiner, Marta Weiss, Ai Weiwei, James Welling, Thomas Weski, Henry Wessel, Kanye West, Colin Westerbeck, Jonas Wettre, Gereon Wetzel, Alexandra Whitney, Kai Wiedenhöfer, Matthew S. Witkovsky, Petra Wittmar, John Wood, Tom Wood, Donovan Wylie, Sharon Ya'ari, Thomas Zander, Renhui Zhao, Liu Zheng, Harf Zimmermann, Andrea Zittel, Bettina von Zwehl

Steidl books, 2006–2020

2006

Bailey, David: Havana

Balet, Catherine: Identity

Bischof, Werner: WernerBischofPictures

Bourdin, Guy: A Message for You

Broomberg, Adam, and Chanarin, Oliver: Chicago

Charles, Ray: a four dimensional being writes poetry on a field with sculptures

Coddington, Grace: The Catwalk Cats

Cohen, Stéphanie: Désir d'une femme pour un homme

Colom, Joan: Raval

d'Offay, Anthony: Warhol's World

d'Orgeval, Martin: Pâques

Dean, Tacita: Analogue: Films, Photographs, Drawings 1991–2006

Dean, Tacita: Die Regimentstochter

Dewitz, Bodo von: Facts / Tatsachen

Dine, Jim: Pinocchio

Disfarmer, Mike: Original Disfarmer Photographs

Engström, J. H.: Haunts

Enwezor, Okwui: Snap Judgments

Epstein, Mitch: Work

Evans, Walker: Lyric Documentary

Ewald, Wendy: Towards a Promised Land

Frank, Robert: Come Again

Gibson, Ralph: Refractions

Gonzales-Torres, Felix: Felix Gonzalez-Torres

Grey, Joel: Looking Hard at Unexamined Things

Gundlach, F. C.: Martin Munkácsi

Hajek-Halke, Heinz: Artist, Anarchist

Hofer, Andreas: This Island Earth

Horn, Roni: Doubt Box

Horn, Roni: Rings of Lispector (Agua Viva)

International Center of Photography: Ecotopia

International Center of Photography: Unknown Weegee

Joseph, Marc: New and Used

Kasher, Steven: Least Wanted: A Century of American Mugshots

Kim, Atta: ON-AIR

Kirchner, Ernst Ludwig: The Photographic Work

Klochko, Deborah: Picturing Eden

Lagerfeld, Karl: Room Service

Leiter, Saul: Early Color

Leong, Sze Tsung: History Images

Ludwigson, Håkan: Taken Out of Context

Marden, Brice: Paintings on Marble

McCarthy, Paul: Head Shop / Shop Head

McPherson, Larry: Beirut City Center

Michals, Duane: Foto Follies: How Photography Lost Its Virginity on the Way to the Bank

Mocafico, Guido: Medusa

Moholy-Nagy, László: Color in Transparency

Morath, Inge: The Road to Reno

Morris, Christopher: My America

Nádas, Péter: Own Death

Odermatt, Arnold: On Duty

Ohara, Ken: Extended Portrait Studies

Peter, Carolyn: A Letter from Japan: The Photographs of John Swope

Polidori, Robert: Havana

Quinn, Marc: Fourth Plinth

Rautert, Timm: Deutsche in Uniform

Richon, Olivier: Real Allegories

Rødland, Torbjørn: White Planet, Black Heart

Rowell, Margit: Ruscha Photographer

Ruscha, Paul: Full Moon

Schifferli, Christoph: Paper Dreams

Schmidt, Jason: Artists

Schorr, Collier: Neighbors / Nachbarn

Scully, Sean: Glorious Dust

Signer, Roman: Travel Photos

Smith, Tony: Not an Object. Not a Monument

Solomon, Rosalind: Polish Shadow

Soth, Alec: Niagara

Spagnoli, Jerry: Daguerreotypes

Spero, David: Churches

Staeck, Klaus: Pornografie

Steiner, Albert: The Photographic Work

Sternfeld, Joel: Sweet Earth

Strömholm, Christer: In Memory of Himself

Taylor-Wood, Sam: Still Lives

Teller, Juergen: Nürnberg

Tillmans, Wolfgang: Freedom from the Known

Trager, Philip: Philip Trager

Tunbjörk, Lars: I love Borås!

van der Meer, Hans: European Fields

Wall, Jeff: Catalogue Raisonneé 1978–2004

Wessel, Henry: Five Books

Wiedenhöfer, Kai: The Wall

Zwehl, Bettina Von: Bettina von Zwehl

2007

Alÿs, Francis: The Politics of Rehearsal

Arp, Hans / Jean: Poupées

Bærtling, Olle: A Modern Classic

Bailey, David: NY JS DB 62

Bailey, David: Pictures that Mark can do

Bajac, Quentin, and Chéroux, Clément: Collection Photographs

Belin, Valérie: Valérie Belin

Bloom, Barbara: The Collections of Barbara Bloom

Brohm, Joachim: Ruhr

Broomberg, Adam, and Chanarin, Oliver: Fig.

Brush, Daniel: Thirty Years' Work

Bruyckere, Berlinde De: Schmerzensmann

Burki, Marie José: These Days

Burtynsky, Edward: Quarries

Callahan, Harry: Eleanor

Capa, Robert: This is War!

Colacello, Bob: Out

Davidson, Bruce: Circus

Depardon, Raymond: Villes / Cities / Städte

diCorcia, Philip-Lorca: Philip-Lorca diCorcia

diCorcia, Philip-Lorca: Thousand

Dine, Jim: Aldo et Moi

Dine, Jim: L'Odyssée de Jim Dine

Dufour, Diane, and Toubiana, Serge: The Image to Come

Earhart, Amelia: Image and Icon

Eskildsen, Joakim: The Roma Journeys

Eskildsen, Ute: Rockers Island. Olbricht Collection

Eskildsen, Ute: The Stamp of Fantasy

Ethridge, Roe: Rockaway, NY

Fondation Cartier pour l'art contemporain: Rock 'n' Roll 39–59

Frank, Robert: London / Wales

Frank, Robert: Me and My Brother

Frank, Robert: One Hour

Freed, Leonard: Worldview

Gober, Robert: Sculptures and Installations, 1979–2007

Gormley, Antony: Antony Gormley

Gowda, Sheela: Sheela Gowda

Graham, Paul: a shimmer of possibility

Grass, Günter: Catalogue Raisonné vol. 1: The Etchings

Grass, Günter: Catalogue Raisonné vol. 2: The Lithographs

Gruyaert, Harry: TV Shots

Hara, Cristóbal: Autobiography

Heiting, Manfred: Imagining Paradise

Holdt, Jacob: American Pictures

Horn, Roni: A Kind of You

Horn, Roni: Herdubreid at Home

Horn, Roni: Weather Reports You

Jansson, Mikael: Speed of Life

Jedlicka, Jan: Il Cerchio / The Circle

Kaprow, Allan: 18 Happenings in 6 Parts

Karel, Betsy: Bombay Jadoo

Kelly, Ellsworth: Drawings on a Bus: Sketchbook 23, 1954

Kicken, Annette and Rudolph: Points of View

Klapheck, Konrad: Paintings

Kuhn, Mona: Evidence

Lagerfeld, Karl: Konkret Abstrakt Gesehen

Lagerfeld, Karl: Palazzo

Lagerfeld, Karl: Visions and a Decision

Maysles, Albert: A Maysles Scrapbook

McPherson, Larry E.: The Cows

Mitchell, Joan: Leaving America: New York to Paris 1958–1964

Mitchell, Joan: Works on Paper 1956–1992

Mocafico, Guido: Serpens

Moderna Museet: Karin Mamma Andersson

Nickerson, Jackie: Faith

Papageorge, Tod: Passing through Eden

Photographische Sammlung / SK Stiftung Kultur: City / Image / Cologne

Polidori, Robert: After the Flood

Price, Ken: Sculptures and Drawings

Probst, Barbara: Exposures

Rautert, Timm: When we don't see you, you don't see us either

Reinartz, Dirk: New York 1974

Rhoades, Jason: Black Pussy

Richardson, Clare: Beyond the Forest

Roberts, Michael: Shot in Sicily

Ross, Judith Joy: Eyes Wide Open

Schaller, Matthias: The Mill

Schmidt, Joachim: Photoworks 1982–2007

Serra, Richard: Rolled and Forged

Sheikh, Fazal: Ladli

Sidibé, Malick: Chemises

Simon, Taryn: An American Index of the Hidden and Unfamiliar

Singh, Dayanita: Sent a Letter

Smith, Bridget: Society

Soth, Alec: Dog Days Bogotá

Starling, Simon: Nachbau / Reconstruction

Strand, Paul: Toward a Deeper Understanding

Taro, Gerda: Gerda Taro

Tierney, Gearon: Daddy, where are you?

Tunbjörk, Lars: Vinter

van der Elsken, Ed: Jazz

Wittmar, Petra: Medebach

Wylie, Donovan: British Watchtowers

Wylie, Donovan: Scrapbook

Zander, Thomas: Henry Wessel

2008

Abbott, Berenice: Berenice Abbott

Avedon, Richard: Portraits of Power

Bailey, David: Is that so Kid

Banier, François-Marie: Vive la Vie

Baron, Fabien: Liquid Light 1983–2003

Belly, Lead: A Life in Pictures

Berndt, Jerry: Insight

Beuys, Joseph: Atlantis

Beuys, Joseph: Die Revolution sind wir

Bolofo, Koto: Venus

Büchel, Christoph, and Carmine, Giovanni: CEAU

Christenberry, William: Working from Memory

Cole, Ernest: Photographer

De Bruyckere, Berlinde: In the Woods there were Chainsaws

Demarchelier, Patrick: Patrick Demarchelier

Depardon, Raymond: Manhattan Out

Djian, Babeth: Babeth

Dine, Jim: Poet Singing (the flowering sheets)

Dine, Jim: This is How I Remember, Now

Dumas, Jean-Louis: Photographer

Duncan, John: Bonfires

Dzama, Marcel: Even the Ghost of the Past

Enwezor, Okwui: Archive Fever: Uses of the Document in Contemporary Art

Flavin, Dan: The 1964 Green Gallery Exhibition

Frank, Robert: Paris

Frank, Robert: Peru

Frank, Robert: Pull My Daisy

Frank, Robert: The Americans

Friedl, Peter: Playgrounds

Genzken, Isa: Ground Zero

Horn, Roni: Bird

International Center of Photography: America and the Tintype

International Center of Photography: Bill Wood's Business

International Center of Photography: Heavy Light: Recent Photography and Video from Japan

Iturbide, Graciela: The Hasselblad Award 2008

Jeppesen, Adam: Wake

John Kobal Foundation: Glamour of the Gods

Kikai, Hiroh: Asakusa Portraits

Korda, Alberto: A Revolutionary Lens

Kuitca, Guillermo: Plates No. 01–24

Lagerfeld, Karl: Abstract Architecture

Lagerfeld, Karl: Metamorphoses of an American

Lagerfeld, Karl: You can leave your hat on

Lebeck, Robert: Tokyo / Moscow / Leopoldville

Leiter, Saul: Saul Leiter

Leonard, Zoe: Photographs

Meiselas, Susan: In History

Metzker, Ray K.: Light Lines

Mocafico, Guido: Movement

Moderna Museet: Eclipse: Art in a Dark Age

Moderna Museet: The History Book. On Moderna Museet 1958–2008

Moderna Museet: Time & Place: Los Angeles, 1957–1968

Moderna Museet: Time & Place: Milano-Torino, 1958–1968

Moderna Museet: Time & Place: Rio de Janeiro, 1956–1964

Newman, Arnold: The Early Work

Nilson, Greger: J. H. Engström: CDG/JHE

Ofili, Chris: Devil's Pie

Rauch, Neo: Neo Rauch

Ray, Man, and Gruber, L. Fritz: Jahre einer Freundschaft 1956–1976

Rødland, Torbjørn: I Want to Live Innocent

Ross, Judith Joy: Living with War

Rubinfien, Leo: Wounded Cities

Ruetz, Michael: Eye on Infinity

Ruscha, Edward: Catalogue Raisonné of the Paintings, vol. 3

Schaller, Matthias: Controfacciata

Sheikh, Fazal: The Circle

Signer, Roman: Projections

Singh, Dayanita, and Singh, Raghubir: The Home and the World

Sosnowska, Monika: Photographs and Sketches

Soth, Alec: Sleeping by the Mississippi

Stahel, Urs: Darkside I

Starkey, Hannah: Photographs 1997–2007

Steinert, Otto: Parisian Shapes

Sternfeld, Joel: Oxbow Archive

Sternfeld, Joel: When it Changed

Sturges, Jock: Life Time

Taylor, Al: Early Works

Teller, Juergen: Vivienne Westwood Spring Summer 2008

van Denderen, Ad: So Blue, So Blue

Weiner, Lawrence: Something to Put Something On

Wood, John: On the Edge of Clear Meaning

Zittel, Andrea: Gouaches and Illustrations

2009

Aldridge, Miles: Pictures for Photographs

Bacon, Francis: A Terrible Beauty

Bacon, Francis: New Studies: Centenary Essays

Bailey, David: 8 Minutes

Bailey, David: Eye

Bakkom, Matthew: New York City Museum of Complaint

Banier, François-Marie: Beckett

Banier, François-Marie: Grandes Chaleurs

Banier, François-Marie: I Missed You

Bourgeois, Louise: Nothing to Remember

Brohm, Joachim: Ohio

Burger-Utzer, Brigitta, and Stefan, Grissemann: Frank Films: The Film and Video Work of Robert Frank

Burtynsky, Edward: Oil

Clarke, Brian: Christophe

Clarke, Brian: Work

Cornell, Lauren: Younger than Jesus

D'Agati, Mauro: Palermo Unsung

d'Orgeval, Martin: Touched by Fire

Demand, Thomas: Nationalgalerie

Dewitz, Bodo von: Politische Bilder

Diepois, Aline, and Gizolme, Thomas: Dust Book

Dine, Jim: Boy in the World (a memoir)

Dine, Jim: Old Me, Now. Self-portrait drawings 2008–2009

Eggleston, William: Paris

Epstein, Mitch: American Power

Eskildsen, Ute: Clare Strand

Frank, Robert: Father Photographer

Goldberg, Jim: Open See

Goodwin, Dryden: Cast

Graham, Paul: a shimmer of possibility

Graham, Paul: Paul Graham

Hack, Jefferson: Another Fashion Book

Hare, Chauncey: Protest Photographs

Horn, Roni: Roni Horn aka Roni Horn

Horn, Roni: Vatnasafn / Library of Water

International Center of Photography: Dress Codes

Iturbide, Graciela: Asor

Ketter, Clay: Clay Ketter

Klemm, Eric: Silent Warriors

Kuhn, Mona: Native

Lacombe, Brigitte: anima I persona

Laita, Mark: Created Equal

Lassnig, Maria: The Pen is the Sister of the Brush

Luchford, Glen: Glen Luchford

Marty, Urs: Urs Marty

McKenna, Kristine: The Ferus Gallery

Morath, Inge: Iran

Müller, Frank-Heinrich: EAST. Zu Protokoll / For the Record

Nixon, Nicholas: Live, Love, Look, Last

Pfeiffer, Walter: In Love with Beauty

Ray, Man: Trees + Flowers – Insects Animals

Reed, Lou: Romanticism

Rosenheim, Jeff: Walker Evans and the Picture Postcard

Roversi, Paolo: Studio

Ruch, Hans-Jörg: Historic Houses in the Engadin

Ruetz, Michael: Spring of Discontent

Ruscha, Edward: Catalogue Raisonné of the Paintings, vol. 4

Salvesen, Britt: New Topographics

Sandback, Fred: Fred Sandback

Schorr, Collier: There I Was

Schuh, Gotthard: A Kind of Infatuation

Smoliansky, Gunnar: One Picture at a Time

Stahel, Urs: Darkside II

Steidl, Gerhard: I am Drinking Stars! History of a Champagne

Teller, Juergen: Election Day

Teller, Juergen: Marc Jacobs Advertising 1998–2009

Turbeville, Deborah: Past Imperfect

Vollmer, Jürgen: On Filmsets and Other Locations

Warwicker, John: The Floating World. Ukiyo-e

Wylie, Donovan: Maze

2010

Adams, Robert: Gone?

Adams, Robert: Tree Line. Hasselblad Award 2009

Alÿs, Francis: Sign Painting Project

Balog, Robert: Zhang Huang, Studio

Discover the complete list at steidl.de

2006 2007 2007 2007 2007 2009

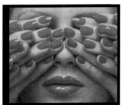

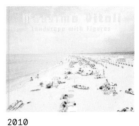

2010 2010 2010 2010 2010

2011 2011 2011 2012 2012 2012 2013

2013 2013 2013 2013 2014 2014 2014

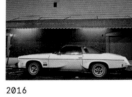
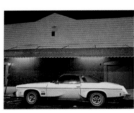

2014 2014 2015 2015 2016 2016

2016 2017 2018 2018 2019 2019

2019 2019 2019 2019 2020 2020

Born in 1950 in Göttingen, Germany, Gerhard Steidl founded his publishing house and screen-printing workshop for graphic art and posters in 1968. Today Steidl publishes the largest worldwide program of contemporary photobooks and an ambitious German literature list. He furthermore conceives and curates international exhibitions including those of Robert Frank, Orhan Pamuk and Karl Lagerfeld.

Steidl Book Culture, 2006–2020 comprises all the visual books printed and published by Steidl over the last 15 years—around 1,000 titles in total. This unprecedented collection, including many books otherwise out of print, is a rare opportunity to possess a piece of recent book-making history, and features works by some of the most renowned practitioners of the medium, including Robert Adams, Lewis Baltz, Bruce Davidson, Robert Frank, Nan Goldin, Karl Lagerfeld, Dayanita Singh, Joel Sternfeld and Juergen Teller, and seminal visual artists such as Jim Dine, Roni Horn and Ed Ruscha.

Steidl Book Culture, 2006–2020 is a visual and tactile workshop in the craft of Steidl books: how design, typography, paper, and printing and binding methods are always individualized to realize the photographer's particular vision as a "multiple"—an enduring democratic art object at a reasonable price. Delivered with an illustrated inventory of all books and a certificate of authenticity signed by Gerhard Steidl, this compendium of only 50 sets is conceived as a site-specific installation within libraries, schools and universities, as well as for individuals to foster their personal book-collecting traditions. In Steidl's no-nonsense words: "This is how we make books. This is Steidl book culture."

I see myself as a student and the photographers are my professors.
Gerhard Steidl

● Gerhard Steidl (ed.)
Steidl Book Culture, 2006–2020

50 sets available

Contains all Steidl publications
between 1 January 2006 and 31 December 2020
936 titles (plus remaining 2020 publications)
in total
Each book is brand-new, unread and
in original packaging
Over 70 titles are multi-volume sets
e.g. Lewis Baltz, Works (10 books in a slipcase)
Placed in chronological order in cardboard boxes,
each labeled with publication year
Boxes packed in seaworthy cardboard containers
on Euro pallets
Ready for transport by air, sea, road or rail
Ex-works Göttingen, freight costs not included

€ 30,000.00 / £ 25,000.00 / US$ 35,000.00
Introductory price until 31 August 2020:
€ 25,000.00 / £ 20,000.00 / US$ 30,000.00
ISBN 978-3-95829-769-2

Koto Bolofo was born in South Africa in
1959 and raised in Great Britain. Bolofo
has photographed for magazines such as
Vogue, Vanity Fair and GQ, and made short
films for the Berlinale and the Venice
Film Festival. He has created advertising
campaigns for companies including Hermès,
Christian Dior, Louis Vuitton and Dom
Pérignon. Bolofo's books with Steidl
include Venus (2008), Horsepower (2010),
I Spy with My Little Eye, Something
Beginning with S (2010), Vroom! Vroom!
(2010), La Maison (2011) and The Prison
(2014).

How does an artist's dream book become a reality? How is paper
made? What do the serpentine spaces of Steidl Publishers look like?
How does a bookbinder miraculously transform printed sheets into
the proud volumes on your bookshelf? Koto Bolofo reveals all this and
more in *One Love, One Book*, his photo-documentation of the worlds
of papermaking, printing and bookbinding.

Bolofo began his visual journey at Hahnemühle Paper Mill, founded
in 1584 and today one of the world's oldest, capturing the combi-
nation of artisanal know-how and advanced technology on which
Hahnemühle's quality is based. His next stop was Göttingen, where
he shows an insider's view of how Steidl books are made and their
dedication to creating multiples: books as democratic art objects at
affordable prices. Bolofo finally traveled to Leipzig to photograph the
secrets of bookbinding. Complementing the patient, hushed quality
of his pictures are playful texts by Bolofo himself in which his childlike
delight at the wonders of bookmaking cannot be repressed.

*It was early in the summer of 2012 that the Wonderful Wizard of
Steidlville invited me and my whimsical eye to visit the kingdom of his
publishing house at Düstere Strasse 4, to see if I could explore and
document the complexity of the labyrinth and really discover How to
Make a Book with Steidl.* Koto Bolofo

● Koto Bolofo
One Love, One Book
Steidl Book Culture. The Book as Multiple

Text by Koto Bolofo
Book design by Holger Feroudj / Steidl Design
192 pages
8 × 10.1 in. / 20.2 × 25.6 cm
110 black-and-white and 170 color photographs
Four-color process
Open-spine softcover
€ 20.00 / £ 15.00 / US$ 25.00
ISBN 978-3-95829-734-0

Steidl

A Harvest of Books

Fall is the traditional season for collecting and storing nature's bounty, to sustain ourselves in the dark winter months. It's a time for gathering goodness and reaping rewards.

While writing this in April 2020—when self-isolation and solitude are still the norm—we're well aware that the months ahead will be an unprecedented challenge for us all. And so it's more important than ever that we nurture ourselves, not just our bodies, but our imaginations and intellects; that we use our resources to craft new worlds.

We hope you enjoy picking the fruits of our labors in our new book program, and that they provide sustenance for many seasons to come.

● available
● coming soon
● previously announced

To ease the gloom
of troubled times,
It might just help
to read some
rhymes...

My name is
Mohte

No longer must you use your eyes
To search for rainbows in the skies;
Instead just paint them with your mind
On every object you can find!

Umbrellas! Gloomy black or brown
To stop the rain from falling down?
For me they're purple, green, gold, red—
A carnival above my head!

"Mirror, mirror on the wall,
Who's the fairest of them all?"

"Well well, cruel queen," the mirror said,
"Despite the crown upon your head
And all the riches you may own—

Your fur-lined slippers, golden throne,

Your snappy clothes and shoes, your jewels,

Your palaces with swimming pools—

I find you ugly, far from nice:
In fact you've got a heart of ice!"

Monte Packham is the author of books
including ABC Photography (2016), Living
with Matisse, Picasso and Christo: Theodor
Ahrenberg and His Collections (2018),
Book of the Year at the 2019 Collector's
Awards, and Photo Adventures (2019). Born
in Sydney in 1981, he holds degrees in
art history and law from the University
of Sydney. Steidl has published Packham's
Concentric Circles (2011).

Rhyme Time is an unconventional illustrated book for children and all those with a healthy relationship to their inner child. Imaginatively combining retro images with new rhymes, the book brings visual nostalgia and the traditions of children's verse up to date. The illustrations are 1960s line drawings Packham carefully colored-in as a child in 1988; now, more than 30 years later, he has rearranged these vibrant images into playful stories and captured them in rhyme. The unexpected results are both original tales, like that of Humphrey who chased a pesky elf from his garden with a cricket bat, and tongue-in-cheek reinterpretations of beloved fairy tales and nursery rhymes—if Snow White isn't actually the fairest in the land, then who is? And why did Jack and Jill really climb that steep and nasty hill?

On rainy days I like to bake
Some bread or scones, a pie or cake;
I weigh the flour, pour the milk
And make my batters smooth as silk.
Indeed my favorite foods are sweet:
At every mealtime I could eat
Just ice cream, jellies, chocolate eggs,
Or sugar-coated dragons' legs!
Monte Packham

Monte Packham
Rhyme Time

Text and illustrations by Monte Packham
Book design by Monte Packham, Holger Feroudj
and Gerhard Steidl
72 pages
7.4 × 9.7 in. / 18.7 × 24.7 cm
247 color images
Four-color process
Hardcover

€ 25.00 / £ 20.00 / US$ 35.00
ISBN 978-3-95829-774-6

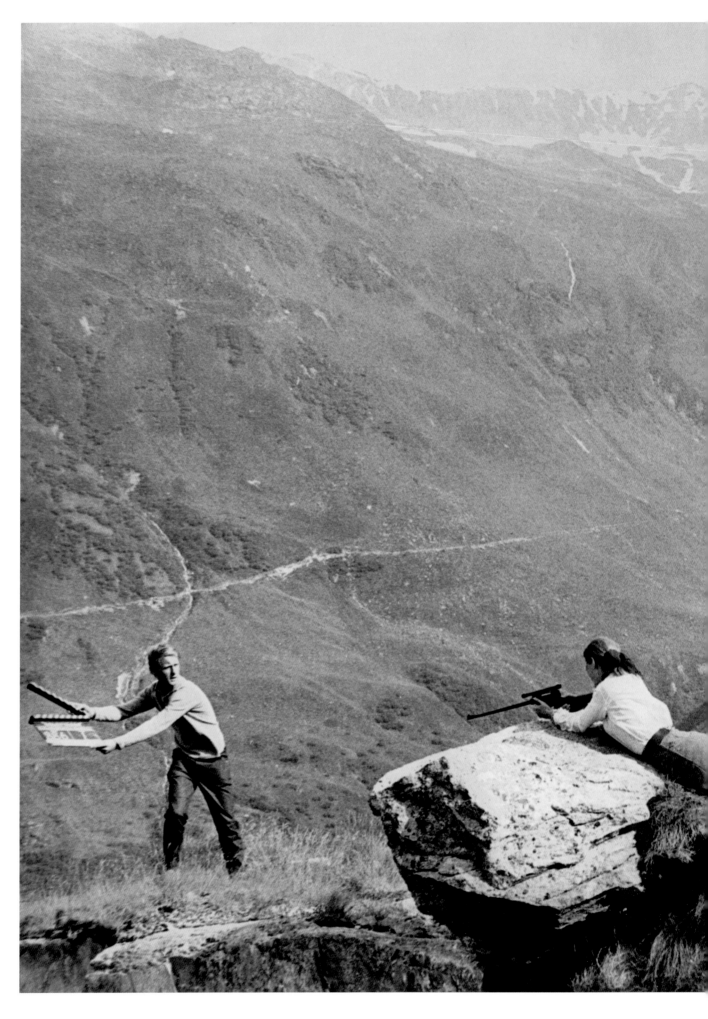

Steffen Appel and Peter Waelty, The Goldfinger Files

Lunch break in the car park.
Horst and Guggi serve the
Swiss malt drink Helomalt
(slogan: "Gives strength for 2").

From left to right: press officer Tom Carlile, Helmuth P.
Gottinger of United Artists Germany and co-producer
Harry Saltzman. Set doctor Heini Stäbler: "Saltzmann
was rarely seen on set. He preferred to stay at the
hotel with his family." The crew was quite happy with
Saltzman's absence, as the Canadian was considered
a rather difficult, quick-tempered character. Film jour-
nalist Erich Kocian believes that he used his stay in
Switzerland to look for locations for "On Her Majesty's
Secret Service", because according to plans at the
time, that was to be the next Bond adventure.

134. INSERT: MIRROR FROM BOND'S POV.

A WHITE TRIUMPH Open Convertible swiftly overtaking
Aston Martin.

After lunch the tracking
car is used to record short
driving footage before the
tyre-shredder scene as
well as for rear projections.
The camera in use is a
Mitchell GC with variable
tempo, high and low speed.
This is because fast car
rides are recorded slowly
and only accelerated in the
finished film. On the tracking
car director Guy Hamilton
sits left and on the right the
script girl Constance Willis
with screenplay.

152. INSERT: KNIFE FLICKING FROM ASTON'S HUB CAP

Knife slashes Triumph's tyres (during scream of brakes)
returns invisibly into hub cap.

Guggi from the Hammond's on the
tracking car – a converted vintage
1929 Rolls-Royce Phantom II.

Tania Mallet has only had her driving licence for a
few weeks and is consequently insecure: she is
encouraged to drive faster again and again.

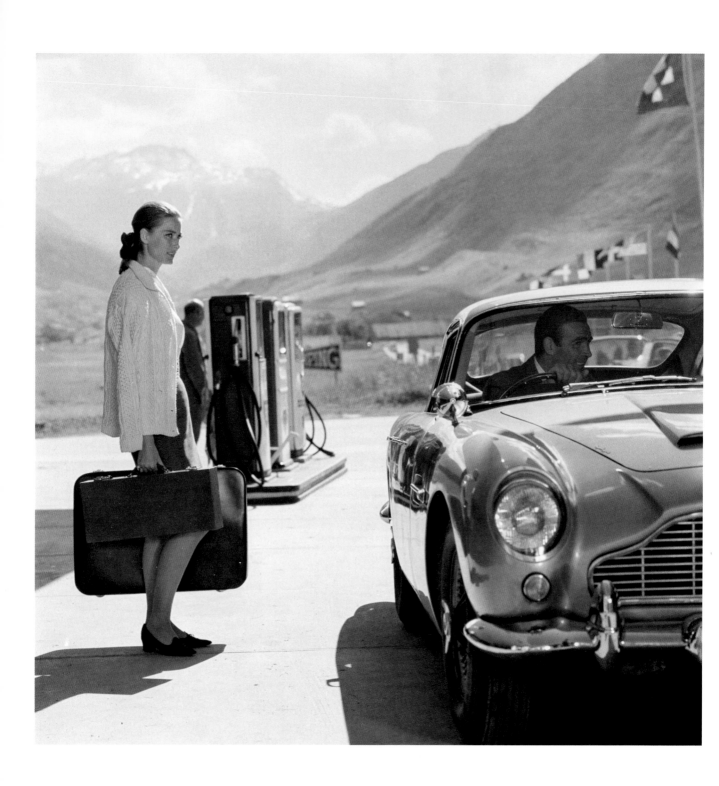

Born in Frankfurt in 1969, Steffen Appel has collaborated with numerous directors and producers of the James Bond films of the last 57 years, among other filmmakers. He is the owner of an important archive of film-related photography, props and other materials, including an Aston Martin DB5 in silver birch (not unlike James Bond's own). Appel has contributed to various books and in 2015 was part of the production crew for the twenty-fourth James Bond film Spectre.

Born in Aarau in 1965, Peter Waelty studied history and English at the University of Zurich. From 2000 he was editor-in-chief and digital director for various Swiss online news sites. He is the author of James Bond und die Schweiz (2008), and the editor of Blick war dabei – Boulevardfotografie von 1959 bis 2019, published by Steidl in 2019.

As one of popular culture's most charming and enduring characters, James Bond needs no introduction. Neither does *Goldfinger* (1964), perhaps *the* classic Bond film and undoubtedly the beginning of 1960s Bondmania. Incorporating much unpublished material including photographs and the original typed screenplay, *The Goldfinger Files* is an illustrated history of the film's iconic scenes shot in Switzerland's Urseren Valley, crowned by the car chase with Bond's gadget-laden Aston Martin.

To maximize publicity for the film, its makers took the unorthodox step of inviting journalists and photographers onto the set, resulting in a wealth of photos including those by Hans Gerber, Josef Ritler and Erich Kocian. These give us an insider's view of the famous sequence—Goldfinger's Rolls-Royce on the dusty mountain road, Tilly Masterson's failed assassination attempt on him, the chase between her Mustang and Bond's Aston Martin, and finally Goldfinger's smelting factory. Dozens of private pictures revealing candid, behind-the-scenes moments complete this documentary flipbook of golden-age James Bond culture.

Do you expect me to talk? James Bond
No, Mr. Bond, I expect you to die. Auric Goldfinger

Steffen Appel and Peter Waelty
The Goldfinger Files
The Making of the Iconic Alpine
Sequence in the James Bond Movie
"Goldfinger"

Foreword by Franck Hamilton
Texts by Steffen Appel and Peter Waelty
Photos by Hans Gerber, Josef Ritler and Erich Kocian and others
Book design by Holger Feroudj / Steidl Design
192 pages
10.6 × 13 in. / 27 × 33 cm
179 black-and-white and 126 color photographs and 41 illustrations
Four-color process
Hardcover

€ 38.00 / £ 35.00 / US$ 45.00
ISBN 978-3-95829-746-3

"Things, people and events harbor within them more than we can know or understand, until looked at with slight inflection. If you get it right, you don't have to explain."—John Gossage. With this characteristic off-kilter curiosity John Gossage continues his loving yet critical, generous yet ironic vision of America; *I Love You So Much!!!!!!!!!* is the fourth book in his ongoing series on this theme, following *Should Nature Change* (2019), *Jack Wilson's Waltz* (2019) and *The Nicknames of Citizens* (2020), all published by Steidl. Gossage is as always open to the wonders of the everyday, be he making a portrait of a young artist or a tree; and he relishes the poetry of pattern in his subjects—the ripples of a tablecloth, a grid of tiles, the serpentine curls of an electrical cord. The title of the book (with not one exclamation mark too few) is taken from a handwritten inscription Gossage found on an old but beloved car in Rochester, Minnesota, for him a moment of gritty glory: "It read like an afterlife, a murmur of its inhabitants long after they had parked the car and left."

It has always seemed reasonable to me that there is a story and that there are clues. To make an inanimate object have a life and a story is a common aspiration that I indulge in this book and many of my others. John Gossage

● John Gossage
I Love You So Much!!!!!!!!!

Text by John Gossage
Book design by John Gossage
160 pages
9.4 × 11.4 in. / 24 × 29 cm
97 black-and-white photographs
Quadratone
Clothbound hardcover with dust jacket

€ 45.00 / £ 40.00 / US$ 55.00
ISBN 978-3-95829-674-9

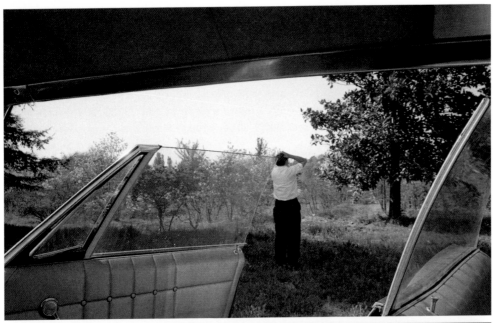

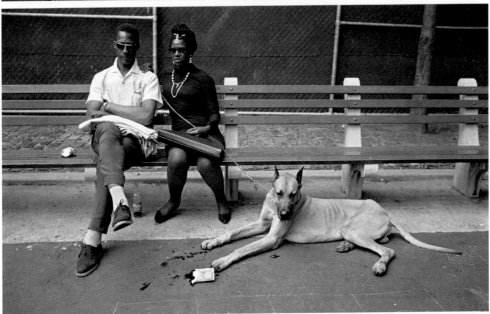

Born in Chicago in 1933, Bruce Davidson began photographing at the age of ten in Oak Park, Illinois. Davidson studied at the Rochester Institute of Technology and Yale University before being drafted into the army. After leaving military service in 1957, he freelanced for Life and in 1958 became a member of Magnum Photos. Davidson's solo exhibitions include those at the Museum of Modern Art, the Smithsonian American Art Museum and the Walker Art Center, and his awards include a Guggenheim Fellowship and the first National Endowment for the Arts Grant in Photography. In 2011 he was awarded an honorary doctorate in fine arts from the Corcoran College of Art and Design. Davidson's books at Steidl include Outside Inside (2010), Subway (2011), Black & White (2012), England / Scotland 1960 (2014) and Nature of Los Angeles 2008-2013 (2015).

Lesser Known presents Bruce Davidson's photos made between 1955 and 1993 that have been overshadowed until now. Consisting of 130 images that have been consistently overlooked throughout Davidson's long career, the book is the result of a year-long undertaking by the photographer and his studio to examine 60 years of contact sheets and edit individual images into a singular work that plots his professional and personal growth. *Lesser Known* showcases Davidson's perpetual versatility and adaptability as a photographer through a focus on early assignments, the intimate documentation of his family life and smaller series such as unpublished color photographs from major bodies of work including "East 100th Street" and "Campers."

This new body of work reflects both a passion and purpose over time.
Bruce Davidson

Bruce Davidson
Lesser Known

Edited by Teresa Kroemer, Meagan Connolly and Bruce Davidson
Foreword by Bruce Davidson
Book design by Duncan Whyte / Steidl Design
192 pages
11.4 × 11.4 in. / 29 × 29 cm
114 black-and-white and 16 color photographs
Tritone and four-colour process
Clothbound hardcover with dust jacket

€ 65.00 / £ 60.00 / US$ 75.00
ISBN 978-3-95829-321-2

BRUCE DAVIDSON LESSER KNOWN

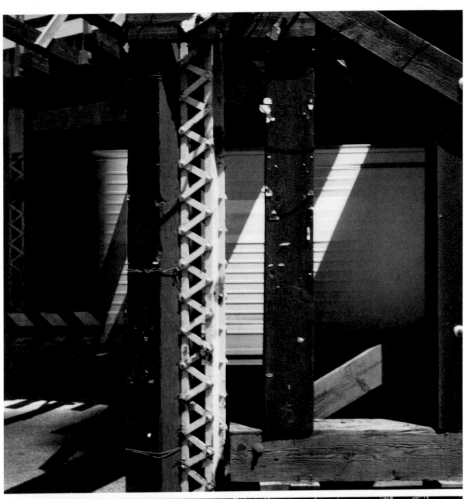

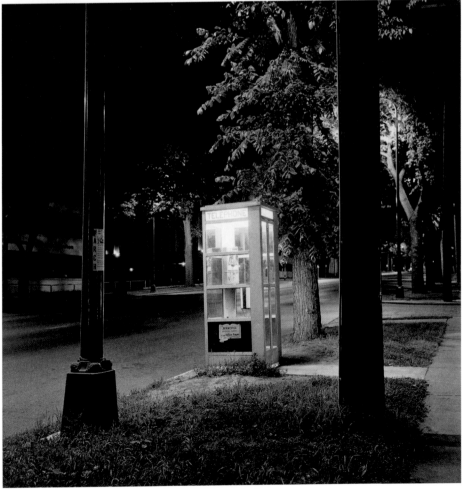

Frank Gohlke was born in 1942 in Wichita Falls, Texas. In 1967 he abandoned the study of literature to become a photographer, encouraged by Walker Evans, who saw his first photographs, and Paul Caponigro, with whom he studied informally at his home in Connecticut. Gohlke has received two fellowships from the Guggenheim Foundation, two from the National Endowment for the Arts, and a Fulbright Research Fellowship to Kazakhstan in 2013-14. His work has been exhibited and collected internationally, including three solo shows at the Museum of Modern Art. His books include Measure of Emptiness (1992), Mount St. Helens (2005), Accommodating Nature (2007), Thoughts on Landscape (2009), and Landscapes as Longing with Joel Sternfeld and Suketu Mehta, published by Steidl in 2016.

In the summer of 1971 Frank Gohlke moved with his wife and young daughter from Middlebury, Vermont, to Minneapolis, Minnesota. His vocation as a photographer had begun four years prior, but he had yet to define the subject that would occupy him for the next 45 years: the landscapes of ordinary life.

The three bodies of work brought together in *Speeding Trucks and Other Follies* were all made between Gohlke's arrival in Minneapolis and the end of 1972 when he began photographing grain elevators, a project that first established his renown. In different ways these early series obliquely describe Gohlke's process of adjustment to his new surroundings.

The "Speeding Trucks" photos of the first section began when Gohlke noticed how the shadows of the elm trees that once lined most Minneapolis streets were momentarily materialized on the bodies of passing trucks. The travel trailers in the second section were all found in a Minnesota State Park on one of the family's infrequent camping trips, while late-night rambles through Gohlke's Minneapolis neighborhood led organically to his series of dramatic night pictures in the last section. Notwithstanding their various subject matter, Gohlke's photos in this book collectively perform a kind of timeless alchemy on the everyday stuff of visual experience.

Looking at these photos, it's hard not to believe that things really look like that; but we know they don't. In the interstice between the picture's testimony and the evidence of our senses is where my photos reside. Frank Gohlke

Frank Gohlke
Speeding Trucks and Other Follies

Book design by Frank Gohlke and Holger Feroudj / Steidl Design
96 pages
9.6 × 10.2 in. / 24.5 × 26 cm
48 black-and-white photographs
Tritone
Clothbound hardcover with a tipped-in photograph

€ 45.00 / £ 38.00 / US$ 55.00
ISBN 978-3-95829-254-3

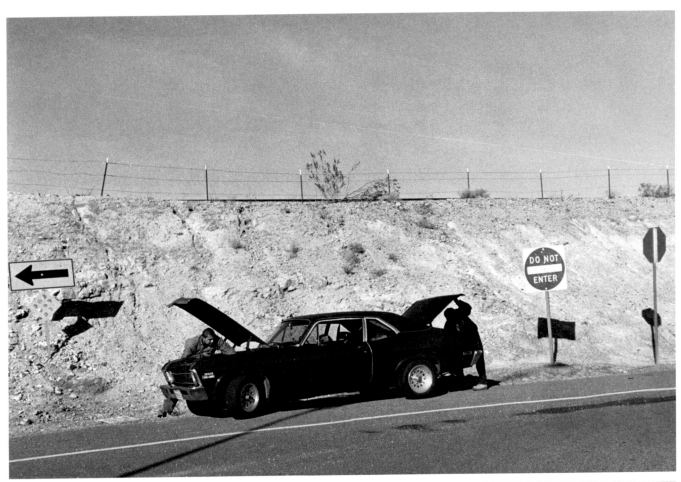

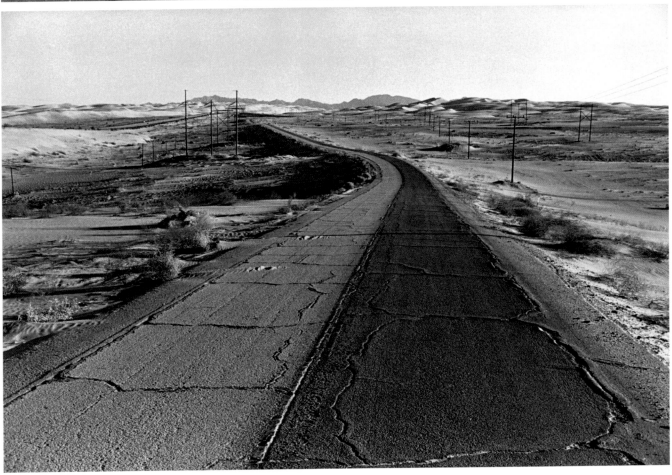

Born in New Jersey, Henry Wessel
(1942-2018) was awarded two Guggenheim
fellowships and three fellowships from
the National Endowment for the Arts. His
work is held in the permanent collections
of major American, European and Asian
museums, and his solo exhibitions include
those at the Museum of Modern Art in New
York and the Museum of Contemporary Art
in Los Angeles. Steidl has published many
of Wessel's books, including Waikiki
(2011) Incidents (2013) and Traffic /
Sunset Park / Continental Divide (2016).

In the fall of 1960 Henry Wessel left his family home in New Jersey
to attend college in Central Pennsylvania. At the time, he had never
been further west than Philadelphia. On Friday afternoons, to offset
the daily classroom cadence, Wessel would pack a knapsack and
hitchhike west. Once Saturday afternoon had ended, he would cross
the highway and hitchhike back east, hoping to arrive in time for class
on Monday morning. Though Wessel would not begin to photograph
until years later, these early forays west planted seeds of discovery
that proved fruitful for decades to come.

Hitchhike is a westward journey from the grassy farmlands in
the Midwest to the wide, open, dusty landscape further west. The
sequence of photos draws from Wessel's 50-year archive and includes
images of barns, gas stations, traveling salesmen, dogs asleep in truck
beds, families eating in diners and open highways—all lit by bright
western light, almost physical in its presence.

*The process of photographing is a pleasure: eyes open, receptive,
sensing, and at some point, connecting. It's thrilling to be outside
your mind, your eyes far ahead of your thoughts. Henry Wessel*

Henry Wessel
Hitchhike

Book design by Steidl Design
80 pages
11.7 × 11.4 in. / 29.7 × 29 cm
36 black-and-white photographs
Tritone
Clothbound hardcover with a tipped-in photograph

€ 45.00 / £ 40.00 / US$ 50.00
ISBN 978-3-95829-569-8

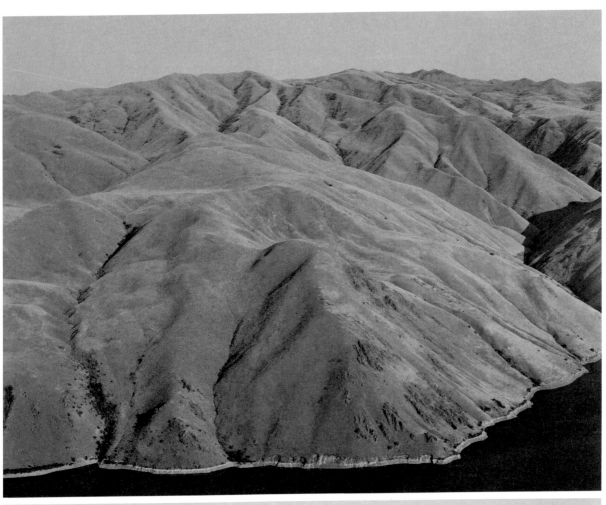

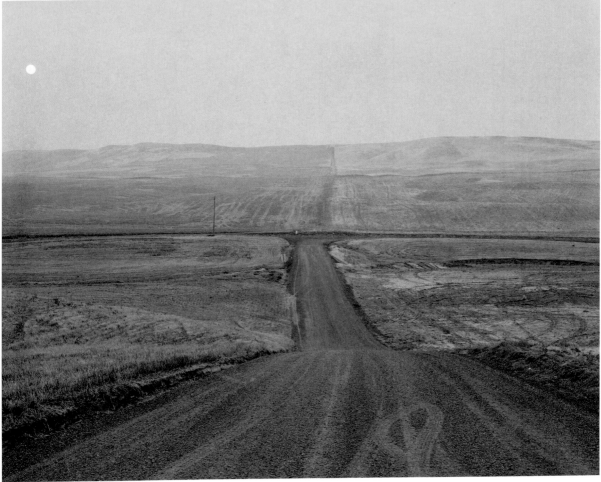

Born in Boston in 1940, Diana Michener holds a Bachelor of Arts from Barnard College in New York and later studied with Lisette Model at New York's New School for Social Research. Michener has exhibited internationally, including her retrospective "Silence Me" at the Maison Européene de la Photographie in Paris in 2001. Her books with Steidl include the award-winning Dogs, Fires, Me (2005), 3 Poems (2006), Sweethearts (2009), Figure Studies (2011) and A Song of Life (2018).

For many years Diana Michener desired to photograph the horizon, yet hesitated—how to capture this defining feature of the landscape that is strangely elusive, a line which marks where earth and sky only seem to meet? Then, two years ago, Michener took up an 8 × 10 analogue camera and felt drawn to the landscape outside Walla Walla, Washington, where she spends her summers. So began her engagement with the horizon, which she followed throughout mostly desert and semi-arid environments in Big Bend National Park, Texas, the Golan Heights, Israel, the Bardenas Reales, Spain, and beyond. Michener intuits the horizon in a trance-like state, grasping its many changing guises: as an elegant line drawn by the setting sun, dissolving into haze, all but obscured by majestic boulders, or merely implied in a close-up image of wave-like rock sediments.

Landscape—horizon line—the moment sky meets land or water. Symbolically we stand confined or expanded by our relationship to this line. Diana Michener

● Diana Michener
Trance

Book design by Diana Michener and Gerhard Steidl
112 pages
15.6 × 13.6 in. / 39.5 × 34.5 cm
51 black-and-white photographs
Tritone
Clothbound hardcover with a tipped-in photograph in a slipcase

€ 75.00 / £ 65.00 / US$ 85.00
ISBN 978-3-95829-757-9

Slipcase

Book

Photograph hand-tinted by Edwin Hale Lincoln

Edwin Hale Lincoln (1848-1938) served
as a drummer boy in the Civil War and
later became a national leader of Civil
War veterans. He began photographing in
Boston around 1874, documenting yacht
races and the extravagant summer homes of
the Gilded Age in the 1880s. Lincoln's
photographs were awarded numerous medals
at photographic exhibitions (including
one that put him on a par with a young
Alfred Stieglitz in 1891), but two
years later he stopped exhibiting and
moved to western Massachusetts. There
Lincoln photographed ancient trees and
endangered wildflowers and orchids, which
he self-published in elegant volumes of
mounted platinum prints. His photographs
have been printed in many books and
magazines, among them Gustav Stickley's
The Craftsman.

In this first book-length appraisal of his work, Edwin Hale Lincoln
(1848–1938) is shown to be an independent artist who sought to pre-
serve glimpses of fleeting beauty with his camera. Affiliated with the
American Arts and Crafts movement, Lincoln began his photographic
career in Boston, specializing in interiors. In the 1880s he started
documenting yacht races, using then new technology to freeze the
glorious motion of sailing ships, including the famed yacht *America*.
Lincoln later moved to western Massachusetts where he captured
the motifs for which he is best known: centuries-old trees, delicate
wildflowers and orchids. These subjects had something in common
with the great wooden sailing ships—they were vanishing. As engine
power replaced the elegance of sails, millions of elms and chestnut
trees would soon die off, fragile flora risked extinction. Lincoln
sought to eternalize their essences in his work. Based on 30 years
of research, *Ephemeral Beauty. The Platinum Photographs* reveals
the strikingly modernist character of Lincoln's work, and explores his
influences, from Ralph Waldo Emerson to Gustav Stickley, as well as
rediscovering the publication of his photographs in illustrated popular
magazines and books.

*Edwin Hale Lincoln's vast series remind us of photography's original
ambition to reproduce the world in order to save it—as durably and
beautifully as possible on platinum paper—and of an individual
photographer's unshakable faith that such a task was not above his
personal abilities.* François Brunet

Edwin Hale Lincoln
Ephemeral Beauty
The Platinum Photographs

Edited and text by Wm. B. Becker
Foreword by François Brunet
Book design Wm. B. Becker and Gerhard Steidl
144 pages
10 × 12 in. / 25.4 × 30.5 cm
80 black-and-white photographs
Quadratone and four-color process
Clothbound hardcover

€ 85.00 / £ 75.00 / US$ 95.00
ISBN 978-3-95829-750-0

IN THE LATE FALL OF 1976 I drove to Memphis to start a project of photographing unremarked Civil War battlefields, sites where blood had been spilled but now were mundane scrub forest or a Piggly Wiggly parking lot. As usual when traveling that part of the South, I stayed for a night or two with Bill in the house on Central.

On the dining room table were a couple of stacks of large prints, the results from a trip he'd taken with Viva, Memphis to Plains, Georgia, sometime in October, possibly at the behest of the *NY Times Sunday Magazine*. The nominal editorial prompt was that the election was coming; a relatively unknown Jimmy Carter was the Democratic candidate; Plains was his home; and who better to take a look at it than the Southern photographer so recently celebrated and reviled for the MoMA show that summer. (As it turned out, whoever suggested the idea never saw any prints and Bill never saw any money.)

Bill told me he'd sent all the rolls of film, each yielding eight or so color negatives two inches by three inches (or four times the image size of 35mm film), to his regular lab in Chicago and asked his printer, Don Gottlinger, to print a third of the rolls every image onto 20" roll paper and two-thirds onto 16" roll paper. So these were big prints: 30" x 20" and 24" x 16".

I love looking at Bill's work in bulk. The first I ever saw of his pictures was at least several hundred 8" x 10" prints in 1974, a fragment of the Los Alamos Project, and they changed the way I saw the world. (That these unique original prints, just as they were when he picked them up from the commercial printer in Memphis, had been left for safe-keeping in an aluminum Halliburton case in a closet of the Upper East Side apartment of Noel E. Parmentel's girlfriend was just the way things happened.)

To see this quantity of images, taken only a few weeks previous, some on the way to but mostly in and around Plains, was a bit deranging. Some were beautiful. Some calmly presented visual facts. Some were haunting. Some were hard to look at.

To see how Bill saw that little town of Plains, to see what he saw on the way there, that big tree, the ferns, the cafe, was revelatory. What I saw, the first composed work made after the MoMA show, was just as much a portrait of Bill at that specific and personal moment as it was of the town at that historic moment. There was no-one looking at the world as he did just then, as has been true before and since. No wonder everybody fell in love with him. Not his fault.

"What are you going to do with them?"

"I guess I have to pick a few and send them up to Marvin."

This was a grim prospect. Not that Marvin Heiferman was then or now a bad person. It's just that he ran the uptown Castelli, Toiny's gallery, and Bill loved only Leo in Soho. That was one reason.

The other was that the work wasn't a few pictures. It was a hundred, a little more. No matter how nice or good or whatever the individual pictures are, what matters is the work, that moment of attention in the life of the artist, what exactly and solely happened at that time and its ability to alter the way we see the world, the only world we share with the artist.

So, having recently been sold by Harry Lunn a gorgeous pristine copy of Alexander Gardner's *Sketchbook of the Civil War* (Harry held up an X-Acto knife

and said he'd cut the binding the next day if I didn't buy the book at that moment, but that night's another story), I suggested to Bill that I publish the entire work as a limited-edition book, two volumes, bound and cased, big prints on big pages.

He liked that idea. By the time it got past midnight, we may even have talked about how rich we would get from it. (Gardner, it must be said, went bankrupt after he published his masterwork.)

That also was the night Bill asked if I knew Walter Hopps. I didn't and Bill thought I should call him, that he'd be up even though it was 2 a.m. in Washington. "Walter," he said, "has more balls in the air than anyone I know. Some of them are so high, you don't know *when* they're going to come down."

And so the night *Election Eve* was born was also the first night I ever spoke to Walter Hopps.

Back in New York with the negatives, I mounted the individual images from contact prints on index cards. Gardner had a hundred images in two volumes so I would too. Of the maybe hundred and eight images in the work, a few were duplicative (not many, two or three) and a few seemed extraneous. (I can't believe I was so purist as not to include that great picture of Viva. Young and foolish, what can I say.)

I had 11 x 14s made of all hundred so Lloyd Fonvielle and I could lay them out on the floor of the loft on 29th Street and shuffle them around.

At some point the pattern became clear: start on the road and end up in Plains, and group those by space or subject or both. Finish with that single haunted image of Andersonville as the sun is going down.

Lloyd wrote a perfect essay about the way Bill sees, creating images of spaces in time "like the empty stage in some ballets after the curtain has risen, before the dancers enter."

Katy Homans imagined the design and typography; Stephen Harvard made the map; Michael Bixler pulled pages off the big press up in Boston and I had a couple of sets bound and cased in a very old shop somewhere in Manhattan far south of 29th Street.

Bill's cousin Maudie worked at the Light Gallery uptown and made the first sale, to the Australian National Gallery—surprising good news!—so I had bound the rest of the edition of seven (five numbered, two *hors commerce* and lettered for Bill and me, and an unsigned exhibition set), but by a different bindery, I don't recall why; perhaps the original went out of business. My assistant Leslie worked in the loft all summer perfectly trimming and adhering the images to pages with a 3M product that I thought wouldn't mess up the images over time (and it hasn't).

My mother, when we knelt on the living room rug at home and I showed her the two enormous volumes and the pictures in them, thought I'd done something wonderful.

I was 27 when I published *Election Eve* and had no real idea how lucky I was. I know now.

Caldecot Chubb
Los Angeles, August 2017

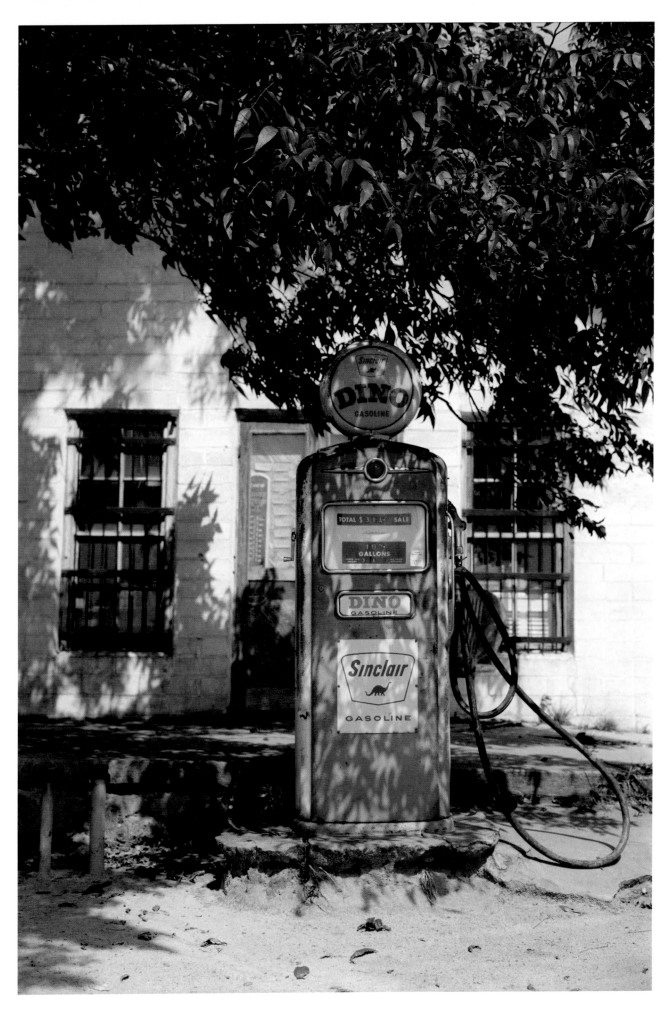

Born in Memphis in 1939, William Eggleston is regarded as one of the greatest photographers of his generation and a major American artist who has fundamentally changed how the urban landscape is viewed. He obtained his first camera in 1957 and was later profoundly influenced by Henri Cartier-Bresson's The Decisive Moment. Eggleston introduced dye-transfer printing, a previously commercial photographic process, into the making of artists' prints. His exhibition "Photographs by William Eggleston" at the Museum of Modern Art in New York in 1976 was a milestone. He was also involved in the development of video technology in the seventies. Eggleston is represented in museums worldwide, and in 2008 a retrospective of his work was held at the Whitney Museum of American Art in New York and at Haus der Kunst in Munich in 2009. Eggleston's books published by Steidl include Chromes (2011), Los Alamos Revisited (2012), The Democratic Forest (2015), Morals of Vision (2019), Flowers (2019) and Polaroid SX-70 (2019).

In 1977 William Eggleston released *Election Eve*, his first and most elaborate artist's book, containing 100 original prints in two leather-bound volumes housed in a linen box. It was published by Caldecot Chubb in New York in an edition of only five, and has since become Eggleston's rarest collectible book. This new Steidl edition recreates the full original sequence of photos in a single volume, making it available to the wider public for the first time.

Election Eve contains images made in October 1976 during Eggleston's pilgrimage from Memphis to the small town of Plains, Georgia, the home of Jimmy Carter who in November 1976 was elected 39th President of the United States. Eggleston began photographing even before he left Memphis and depicted the surrounding countryside and villages of Sumter County, before he reached Plains. His photos of lonesome roads, train tracks, cars, gas stations and houses are mostly empty of people and form an intuitive, unsettling portrait of Plains, starkly different to the idealized image of it subsequently promoted by the media.

The photographs have a quietude and unsentimental romanticism, as well as an edge of poignance, which belie the expectations of hopefulness or portentousness suggested by a knowledge of the time and place in which they were made. On the eve of the election, when nothing had yet been decided, when everything—whatever that everything was—hung in the balance, Eggleston made an elegy … a statement of perfect calm. Lloyd Fonvielle

● William Eggleston
Election Eve

Texts by Caldecot Chubb and Lloyd Fonvielle
Book design by Gerhard Steidl and Duncan Whyte
192 pages
13 × 9.8 in. / 33 × 25 cm
100 color photographs
Four-color process
Half-linen hardcover

€ 75.00 / £ 65.00 / US$ 80.00
ISBN 978-3-95829-266-6

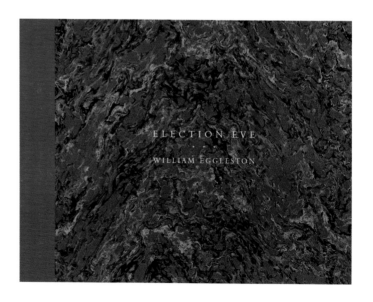

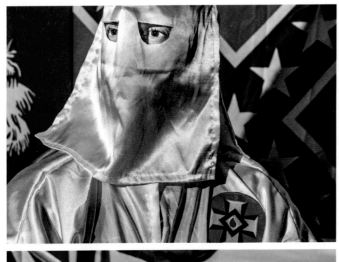

94

Mark Peterson's photographs have been
published in the New York Times Magazine,
New York, The New Yorker, Fortune,
Time and Geo, among many others. His
awards include the 2018 W. Eugene
Smith Fund Grant for his work on white
supremacy in the United States, and
his photographs have been featured in
numerous exhibitions including "Museums
are Worlds" at the Louvre in 2012. Steidl
published Peterson's Political Theatre
in 2016, one of Time's Best Photobooks
of 2016 and winner for traditional book
at the 2017 Lucie Photo Book Prize. In
2017 Photo District News named Peterson
Photographer of the Year for Political
Theatre and his campaign work.

In *White Noise* Mark Peterson examines the rhetoric of the White
House on immigration and Muslim bans, and how this echoes and
intersects with nationalism, Western chauvinism, white supremacy,
neo-Nazis, and all those calling for an ethnostate in America. Peterson
began his project as a means to understand the divisive mood of the
country following the 2016 presidential election. His often confront-
ing subjects include anti-Muslim rallies in New York; families on
Confederate Memorial Day in the South; white nationalists protesting
in Charlottesville, preceding the murder of Heather Heyer; leaders
of the Ku Klux Klan in their homes; burning swastikas. The result is a
vital and unsettling portrait of the normalization of this reality in the
United States; in Claudia Rankine's words: "What our government
won't acknowledge Mark Peterson has. His images focus on the terror
that has taken advantage of our refusal to look it squarely in its face
and acknowledge it as homegrown and thriving."

Always take sides. Neutrality helps the oppressor, never the victim.
Silence encourages the tormentor, never the tormented. Elie Wiesel

Mark Peterson
White Noise

Text by Claudia Rankine
Book design by David Shields,
Holger Feroudj and Gerhard Steidl
132 pages
11.5 × 8 in. / 29.2 × 20.3 cm
58 black-and-white and 37 color photographs
Four-color process
Hardcover

€ 35.00 / £ 28.00 / US$ 40.00
ISBN 978-3-95829-736-4

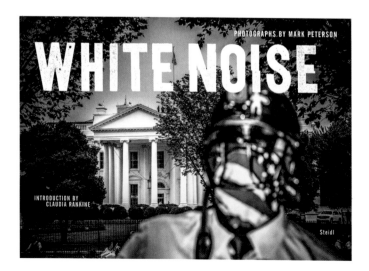

A major figure in the photography world, Joel Sternfeld was born in New York City in 1944. He has received numerous awards including two Guggenheim fellowships, a Prix de Rome and the Citibank Photography Award. Sternfeld holds the Nobel Foundation Chair in Art and Cultural History at Sarah Lawrence College. His books published by Steidl include American Prospects (2003), Sweet Earth (2006), Oxbow Archive (2008), First Pictures (2012), Landscape as Longing (2016) with Frank Gohlke, Rome after Rome (2019) and Our Loss (2019).

History in Pictures offers a new dialogic space in which human history and what it means to be human in the world now may be considered. Using unaltered photographs and texts that look behind and around the images, Joel Sternfeld speculates on representative moments and sites to create a portal to what will be on the other side if our course goes unaltered. Sternfeld's pictures often puzzle with notions of Westernization, globalization and identity, such as a young man in rural Peru selling a hot dog on a croissant with evident discomfiture, a girl role-playing as a French maid in a club in Japan, a wax figure of Kim Kardashian at Madame Tussauds, and Rocko Gieselman, the first University of Vermont student to register an undefined gender. Modernism, contradiction, inequality, hate, technology, high science and emergent sexual identities have re-shaped human existence forever. *History in Pictures* allows a mode back onto ourselves at a time when things are changing so quickly.

Our world is transforming at a staggering pace, but what do feelings of hope, danger, confusion or love yet compel us to do? Joel Sternfeld

Joel Sternfeld
History in Pictures

Text by Joel Sternfeld
Book design by Joel Sternfeld and
Holger Feroudj / Steidl Design
152 pages
15.4 × 12 in. / 39 × 30.5 cm
65 color photographs
Four-color process
Clothbound hardcover with a tipped-in photograph

€ 65.00 / £ 58.00 / US$ 75.00
ISBN 978-3-95829-760-9

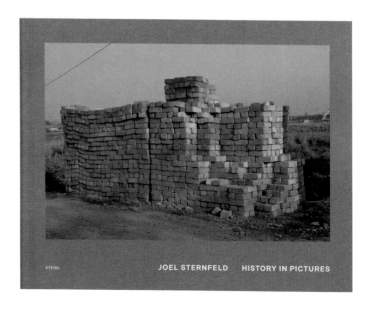

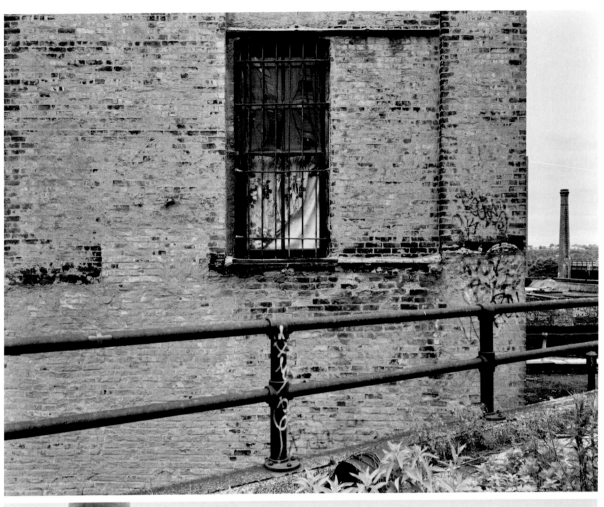

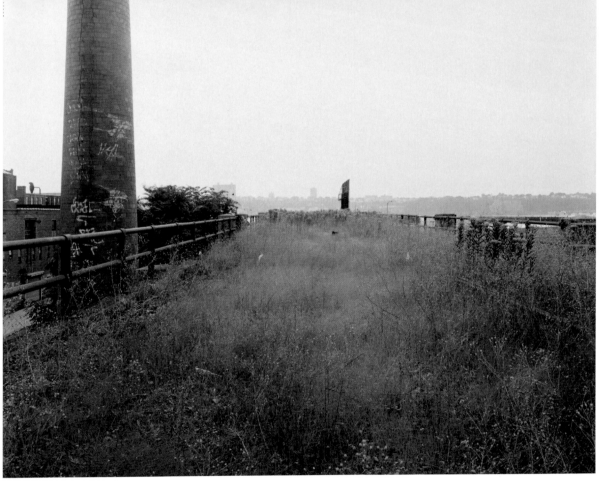

A major figure in the photography world, Joel Sternfeld was born in New York City in 1944. He has received numerous awards including two Guggenheim fellowships, a Prix de Rome and the Citibank Photography Award. Sternfeld holds the Nobel Foundation Chair in Art and Cultural History at Sarah Lawrence College. His books published by Steidl include American Prospects (2003), Sweet Earth (2006), Oxbow Archive (2008), First Pictures (2012), Landscape as Longing (2016) with Frank Gohlke, Rome after Rome (2019) and Our Loss (2019).

With nine additional photos, a larger format, and an expanded, up-to-date timeline, this is the new and revised edition of Joel Sternfeld's *Walking the High Line*, which documents the overgrown elevated freight rail line above New York's West Side before it was transformed into the cherished High Line public park in 2009.

In the dark days following the September 11 attacks in New York in 2001, Joel Sternfeld came to Gerhard Steidl with the hope of quickly making a book. For the previous two years Sternfeld had been photographing the abandoned railroad and working with a group, the Friends of the High Line, that wanted to save it and turn it into a park. Powerful real estate and political interests seeking to tear it down and commercially develop the land beneath it were using the chaos of the period to rush forward their plans.

Steidl agreed—and six weeks later there were finished books in New York. It was a small volume but it played a crucial role in allowing New Yorkers to see for the first time the beauty of a secret railroad in all the seasons. Like the photographs made by William Henry Jackson in the 1870s of Yellowstone that led Congress to establish a national park, the pictures proved pivotal in the making of the High Line park.

The poet-keeper of the High Line is the photographer Joel Sternfeld.
Adam Gopnik

Joel Sternfeld
Walking the High Line
Revised Edition

Texts by Adam Gopnik and John Stilgoe
Book design by Joel Sternfeld and Gerhard Steidl
80 pages
11.7 × 9.7 in. / 29.7 × 24.6 cm
6 black-and-white and 49 color photographs and 4 illustrations
Four-color process
Clothbound hardcover with dust jacket

€ 48.00 / £ 40.00 / US$ 55.00
ISBN 978-3-95829-764-7

The Human Condition

Born in 1932 outside Pittsburgh, Duane Michals is regarded as one of the great photographic innovators of the past century, widely known for his work with series and multiple exposures, and for incorporating handwritten texts as key components in his works. Since his first solo exhibition at the Museum of Modern Art, New York, in 1970, Michals has had numerous one-person shows in Japan, Europe and the US. In 2014 the Carnegie Museums in Pittsburgh mounted a major retrospective. Michals' books include Homage to Cavafy (1978); Salute, Walt Whitman (1996); The Essential Duane Michals (1997); A Visit with Magritte, published by Steidl in 2011; ABC Duane (2014), a TIME magazine Best Photobook of the Year; and Duane Michals: Portraits (2017).

Appearing in 1970, Duane Michals' *Sequences* became one of the key photography books of the decade. Michals' concise narratives, typically composed of six or seven uncaptioned images, were surreal, provocative, mysterious—and sometimes flat-out funny. They fueled a radically new direction for a generation of artists exploring the fictional potential of photography. Critic Jed Perl, reviewing a traveling retrospective organized by Pittsburgh's Carnegie Museums in 2014, called the sequences of small, black-and-white images "freshly minted fairy tales for adults. These surreal visual fables were shown at the Museum of Modern Art in 1970, when the museum was the arbiter of all things photographic. [...] With [his] cosmic-comic sequences, Michals became photography's genial troublemaker, seen by some as thumbing his nose at the lyric realism of Henri Cartier-Bresson's 'decisive moment' and Alfred Stieglitz's perfect prints. What can all too easily be underestimated is the quick, agile intelligence that Michals brought to his troublemaking. That's what has given his dissident spirit its staying power." Spanning half a century, *Things are Queer. 50 Years of Sequences* brings together a generous selection of Michals' sequences, including many that have never before been published.

Everything was theatre; even the most ordinary event was an act in the drama of my little life. Duane Michals

Duane Michals
Things are Queer
50 Years of Sequences

Text by Duane Michals
Book design by Steidl Design
384 pages
13 × 10 in. / 33 × 25.4 cm
360 black-and-white and 40 color photographs
Tritone and four-color process
Hardcover

€ 45.00 / £ 40.00 / US$ 55.00
ISBN 978-3-95829-756-2

DUANE MICHALS
50 YEARS OF SEQUENCES THINGS ARE QUEER

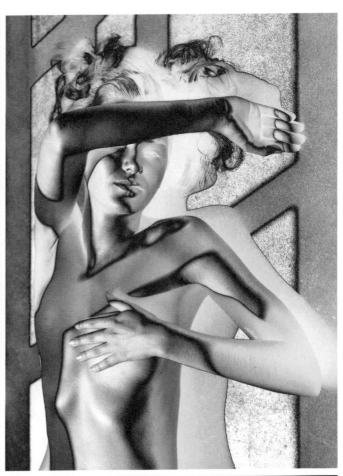

Born in São Paulo in 1969 and today based in Los Angeles, Mona Kuhn is best known for her large-scale dreamlike photographs of the human form. Her work often references classical themes and is distinguished by the close relationships she develops with her subjects, resulting in images of remarkable naturalness and intimacy, of people naked yet comfortable in their own skin. Kuhn's photographs are held in collections such as the J. Paul Getty Museum, Los Angeles, the Los Angeles County Museum of Art and the Museum of Fine Arts, Houston. Her books with Steidl include Photographs (2004), Evidence (2007), Native (2009), Bordeaux Series (2011), Private (2014) and She Disappeared into Complete Silence (2018).

In *835 Kings Road* Mona Kuhn lyrically reconsiders the realms of time and space within the architectural elements of the Schindler House in Los Angeles. Built by Austrian architect Rudolph M. Schindler in 1922, the house was both a social and design experiment and an avant-garde hub for intellectuals and artists in the 1920s and '30s.
For this project Kuhn collaborated with the Department of History of Art and Architecture at UC Santa Barbara, and gained access to Schindler's private archives including blueprints, letters and notes. Alongside reproducing some of these for the first time in this book, Kuhn reinterprets the dichotomy between memory and record in a series of color photos, and solarized gelatin silver prints, a technique favored by the Surrealists. The enigmatic subject of her solarized pictures is a fictional, ethereal figure inspired by a letter from Schindler to a mysterious woman. Kuhn's impressionistic photos render this female presence physical, even as it seems to be demater-ializing: fleeting images that question the very nature of photography as record.

I'm most comfortable representing the nude as minimal, timeless, almost monastic. But this time, I wanted to transcend the physical limitations of our presence, of our body, and cross the elements of time and space. Mona Kuhn

Exhibition: Art, Design and Architecture Museum, UC Santa Barbara, 8 September to 6 December 2020

Mona Kuhn
835 Kings Road

Texts by Silvia Perea and David Dorenbaum
Book design by Mona Kuhn and Gerhard Steidl
200 pages
9.3 × 12.2 in. / 23.7 × 31 cm
25 black-and-white and 47 color photographs and 33 illustrations
Four-color process
Hardcover

€ 45.00 / £ 40.00 / US$ 55.00
ISBN 978-3-95829-755-5

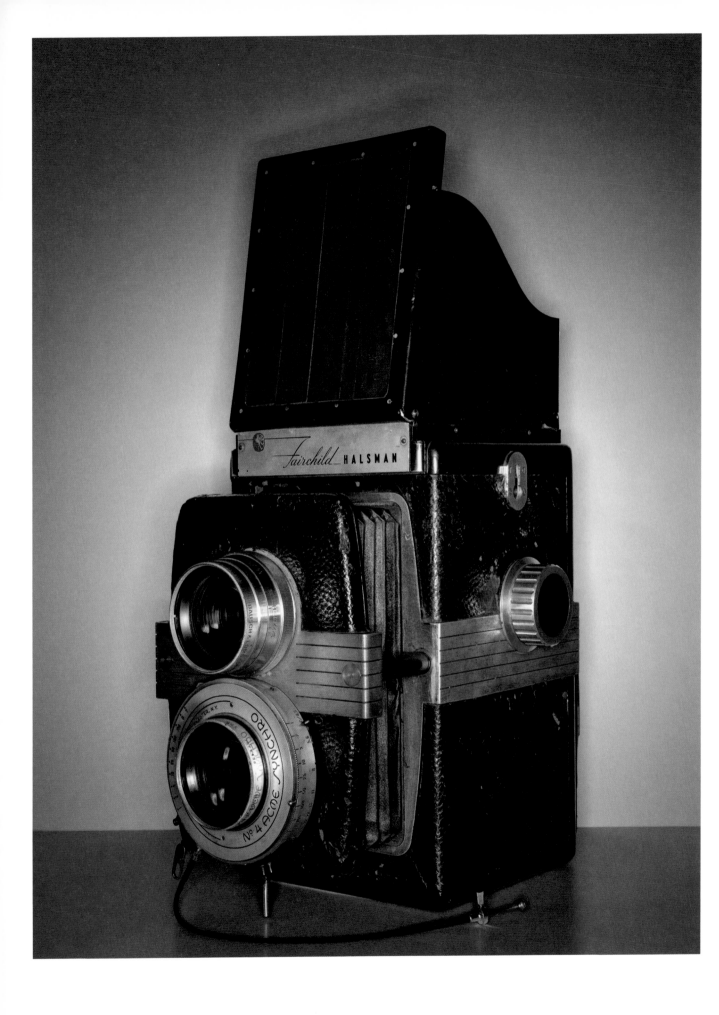

Born in 1961 in Switzerland, Henry Leutwyler moved to Paris in 1985 and established himself there as an editorial photographer. In 1995 he moved to New York City where he lives and works today. Leutwyler's photos have been published in the New York Times Magazine, National Geographic, Vanity Fair and The Wall Street Journal, among others. His books with Steidl are Neverland Lost: A Portrait of Michael Jackson (2010), Ballet. Photographs of the New York City Ballet (2012), Document (2016) and Hi there! (2020)

In this book Henry Leutwyler documents the professional and private life of renowned *Life* magazine photographer Philippe Halsman (1906–79), who had a total of 101 *Life* covers to his name—more than any other photographer. Leutwyler first saw Halsman's work as a teenager in an exhibition at the International Center of Photography in 1979; now, more than 40 years later, his fascination has finally found fruition. With his trademark approach, both forensic and imaginative, he teases out the meanings held within inanimate objects and how they reveal their owner's personality. In close collaboration with the Halsman Archive, Leutwyler has photographed hundreds of objects belonging to Halsman—from his cameras to his glasses, from his passport to a range of letters (from Janet Leigh, Richard Avedon and Richard Nixon, to name but a few), from table-tennis bats and balls to a collection of jewel-like, paper-wrapped soaps from around the world—in the words of Halsman's grandson Oliver Halsman Rosenberg, "magical evidence of a time that will never exist again."

In this book I have attempted yet again to tell a story and draw a portrait, through one's belongings. Objects talk. Henry Leutwyler

● Henry Leutwyler
Philippe Halsman
A Photographer's Life

Texts by Irene Halsman, Oliver Halsman Rosenberg and Mark Lubell
Book design by Chris Gautschi
400 pages
8 × 11.8 in. / 20.3 × 30 cm
322 color photos
Four-color process
Clothbound hardcover with a belly-band

€ 58.00 / £ 54.00 / US$ 65.00
ISBN 978-3-95829-792-0

David Bailey, born in London in 1938, is one of the most successful photographers of his generation; his career, in and beyond photography, spans 60 years. Bailey's books with Steidl include Bailey's Democracy (2005), Havana (2006), NY JS DB 62 (2007), Is That So Kid (2008), Eye (2009), Delhi Dilemma (2012), Bailey's East End (2014), Tears and Tears (2015) and Bailey's Naga Hills (2017).

Bailey's Matilda is David Bailey's love letter to Australia, but in typical Bailey fashion it's not what you'd expect. This is no rosy portrait of "the lucky country," but a gritty yet affectionate vision of rural and small-town Australia in the early 1980s: black-and-white images of a dead cockatoo, kangaroo and sheep, of painted advertising for Queensland's beloved XXXX beer, of a gravestone and dead tree trunks against a lead sky. His human subjects are the Indigenous people of Australia, not the descendants of its white colonists.

Bailey embraces all the flaws and accidents of his prints—their blurrings, smudges and stains—and enhances them with his own scribbles and crops, creating painterly results. In his own words it's all about chance: "This book should have been washed up in a bottle on the sea shore. All damp with the pages almost stuck together. Just coming apart in the hands of our beachcomber. After a brief look, he takes it to a man he sort of knows at the library. The library man realizes the pages are mostly taken on a Polaroid camera. He dries the pages on a radiator and passes them on to another man that has a small printing press. Now the pages have a sort of accidental history. So after their long journey, the pages end up being printed for anyone to see. That's the story I would like this book to be."

David Bailey
Bailey's Matilda

Text by David Bailey
Book design by David Bailey
84 pages
10.2 × 13 in. / 26 × 33 cm
46 black-and-white photographs
Tritone
Clothbound hardcover

€ 58.00 / £ 54.00 / US$ 65.00
ISBN 978-3-95829-749-4

David Bailey, born in London in 1938, is
one of the most successful photographers
of his generation; his career, in and
beyond photography, spans 60 years.
Bailey's books with Steidl include
Bailey's Democracy (2005), Havana (2006),
NY JS DB 62 (2007), Is That So Kid
(2008), Eye (2009), Delhi Dilemma (2012),
Bailey's East End (2014), Tears and Tears
(2015) and Bailey's Naga Hills (2017).

For the past 39 years, David Bailey has photographed his wife
Catherine using Polaroid film. Developing organically over the decades,
the book grew with no specific purpose in mind. The result is this
visual poem, a witness to their working collaborations and personal
adventures. In Bailey's words: "The years went by with great ease and
charm. I have been lucky to have such a willing and beautiful subject
in my wife and partner in this adventure we have shared together.
It came about not by making a plan. All my good ideas seem to
happen by accident. My books start with a vague idea, then grow into
something I never knew. It's never what I had in mind, in fact I never
have any structure. The pictures just merge together and seem to me
in my dyslexic mind that they were meant to be just where they are.
The average Polaroid takes a few minutes to develop. This book has
taken nearly 40 years."

David Bailey
117 Polaroids

Text by David Bailey
Book design by David Bailey
160 pages
10.2 × 13 in. / 26 × 33 cm
66 black-and-white and 51 color photographs
Four-color process
Clothbound hardcover

€ 58.00 / £ 54.00 / US$ 65.00
ISBN 978-3-95829-702-9

CATHERINE BAILEY

117
POLAROIDS

DAVID BAILEY

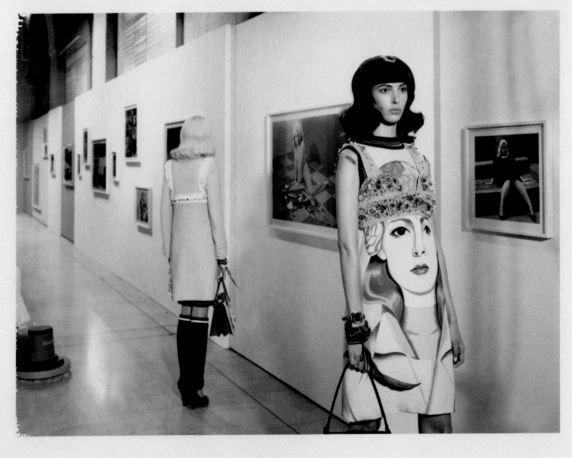

Born in London in 1964, Miles Aldridge
has published his photographs in such
influential magazines as American and
Italian Vogue, Numéro and The New Yorker.
His solo exhibitions include those at
Lyndsey Ingram in London, Reflex in
Amsterdam and Fahey/Klein in Los Angeles,
and his work is held in permanent
collections such as the National
Portrait Gallery and the British Museum
in London, the Fondation Carmignac in
Porquerolles and the International Center
of Photography in New York. Aldridge's
books printed by Steidl include Pictures
for Photographs (2009) and Other Pictures
(2012).

Please Please Return Polaroid is Miles Aldridge's ongoing love letter to Polaroid, a process once integral to the craft of many photographers but now more or less extinct, apart from the rare and out-of-date material traded on eBay for exorbitant prices. The sequel to Aldridge's *Please Return Polaroid* of 2016, this book presents new and vintage Polaroids from his more than 20-year archive in a seemingly random sequence shaped by a dreamlike logic and surprising juxtapositions. *Please Please Return Polaroid* explores Aldridge's dedication to analogue processes where cut-and-paste is still a manual process, made with scissors, gaffer tape, intuition and not a little patience. Aldridge continues to use Polaroids as part of his work-in-progress "sketches," often scratching, tearing and taping them together, even drawing over them; each mark part of the creative act. Known for creating immaculate photos of a less than perfect world, Aldridge revels in these unpolished images, transforming some into extreme enlargements filling double pages with their re-worked and damaged surfaces. Long live Polaroid!

Miles sees a color-coordinated, graphically pure, hard-edged reality.
David Lynch

Exhibition: Fotografiska, Stockholm, September 2020

● Miles Aldridge
Please Please Return Polaroid

Text by Michael Bracewell
Book design by Miles Aldridge
208 pages
11.6 × 11.6 in. / 29.5 × 29.5 cm
117 color photographs
Four-color process
Clothbound hardcover with a tipped-in photograph

€ 45.00 / £ 40.00 / US$ 55.00
ISBN 978-3-95829-748-7

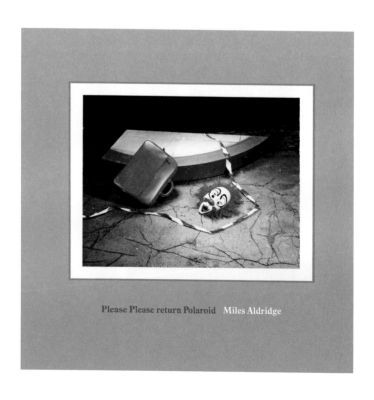

Please Please return Polaroid Miles Aldridge

Born in 1940 in Tokyo, where he today lives and works, Nobuyoshi Araki worked in advertising after completing his studies in photography and film at Chiba University; he devoted himself exclusively to photography from the mid-1960s. Araki's oeuvre spans erotic portraits of women, artificial still lifes, images of plants, documentary-style depictions of everyday life, architectural photography, as well as diaristic photos of himself and his deceased wife Yoko. He has published around 400 books, shown in many international exhibitions, and his work is part of important collections worldwide. Steidl has published Araki's Impossible Love (2018).

Juergen Teller, born in Erlangen, Germany, in 1964, studied at the Bayerische Staatslehranstalt für Photographie in Munich. His work has been published in influential magazines such as Vogue, System, i-D, POP and Arena Homme+, and has been the subject of solo exhibitions including those at the Institute of Contemporary Arts in London, the Fondation Cartier pour l'art contemporain in Paris and Martin-Gropius-Bau in Berlin. Teller won the prestigious Citibank Photography Prize in 2003, and from 2014 to 2019 held a professorship at the Akademie der Bildenden Künste Nürnberg. His books with Steidl include Louis XV (2005), Marc Jacobs Advertising, 1998-2009 (2009), Siegerflieger (2015), The Master IV (2019) and Handbags (2019).

Leben und Tod is the latest collaboration between these two seminal photographers and is the culmination of their joint exhibition at artspace AM, Tokyo, in 2019. This intensely personal project concentrates on Teller's series "Leben und Tod" (Life and Death), which reflects upon the death of his uncle and step-father Artur, juxtaposing photographs of his mother and homeland in Bubenreuth, Bavaria, with symbolic images of fertility and life on holiday in Bhutan with his partner Dovile Drizyte.

Inspired by this series, Araki asked to photograph Teller's "childhood memory objects," items of particular emotional significance to him and his parents. Teller eagerly collected such personal gems, among them toys, a porcelain figurine and bridges made in the family's violin workshop; the resulting images by Araki are haunting yet playful, creating an intriguing narrative alongside the original story.

This book embodies the deep affection and admiration between Araki and myself. At the gallery opening, he announced to the audience of journalists that I am like his son! I was overwhelmed with joy.
Juergen Teller

Nobuyoshi Araki and Juergen Teller
Leben und Tod

Text by Juergen Teller
Book design by Juergen Teller
72 pages
10.2 × 7.5 in. / 26 × 19 cm
67 color photographs
Four-color process
Clothbound hardcover with dust jacket

€ 38.00 / £ 35.00 / US$ 45.00
ISBN 978-3-95829-745-6

Leben und Tod

Born in 1973 in Bolinas, California, Harmony Korine is a filmmaker, screenwriter and artist. He has written and directed cult films including Gummo (1997), Breakers (2012) and The Beach Bum (2019); and his paintings and photographs have been exhibited at institutions including the Museum of Contemporary Art, San Diego, Kunsthalle Düsseldorf and Centre Pompidou, Paris. Korine's first novel A Crackup at the Race Riots was published in 1998.

Juergen Teller, born in Erlangen, Germany, in 1964, studied at the Bayerische Staats-lehranstalt für Photographie in Munich. His work has been published in influential magazines such as Vogue, System, i-D, POP and Arena Homme+, and has been the subject of solo exhibitions including those at the Institute of Contemporary Arts in London, the Fondation Cartier pour l'art contemporain in Paris and Martin-Gropius-Bau in Berlin. Teller won the prestigious Citibank Photography Prize in 2003, and from 2014 to 2019 held a professorship at the Akademie der Bildenden Künste Nürnberg. His books with Steidl include Louis XV (2005), Marc Jacobs Advertising, 1998-2009 (2009), Siegerflieger (2015), The Master IV (2019) and Handbags (2019).

"We drove around for days. Miles and miles of dead barren cotton wool land, depressing countryside and abandoned towns. I asked Bill, 'Where are we going? Where the fuck are you taking us?' He replied laughing, 'I wanted to show you nothing.'"—Juergen Teller. *William Eggleston 414* is Harmony Korine and Juergen Teller's visual memoir of a road trip they took ten years ago with William Eggleston and his son, Winston, from Memphis to Mississippi. Featuring photos and short introductions by Korine and Teller, this record of their spontaneous, intimate journey captures their love for each other through the shared experience of the American road, and combines images of gas stations, abandoned trucks, evangelical households, banal landscapes and hotel rooms with candid portraits. Certain photos cleverly re-visit Eggleston's own famous motifs—strings of colored electric lights, road signs, people in cars—and yet the star of the show is without doubt Eggleston himself, always impeccably groomed, whether seated at the kitchen table, holding the hand of cousin Maude Schuyler Clay, or playing the grand piano.

We had no real plans. No goals. Just followed the light. We drove like this for a few days. On the last night, Eggleston played us the piano. He was wearing black leather gloves. I think there was a pistol somewhere in the room. It was beautiful. Harmony Korine

● Harmony Korine and Juergen Teller
William Eggleston 414

Texts by Harmony Korine and Juergen Teller
Book design by Juergen Teller
144 pages
11.3 × 8.2 in. / 28.6 × 20.9 cm
121 color photographs
Four-color process
Clothbound hardcover with dust jacket

€ 38.00 / £ 35.00 / US$ 45.00
ISBN 978-3-95829-763-0

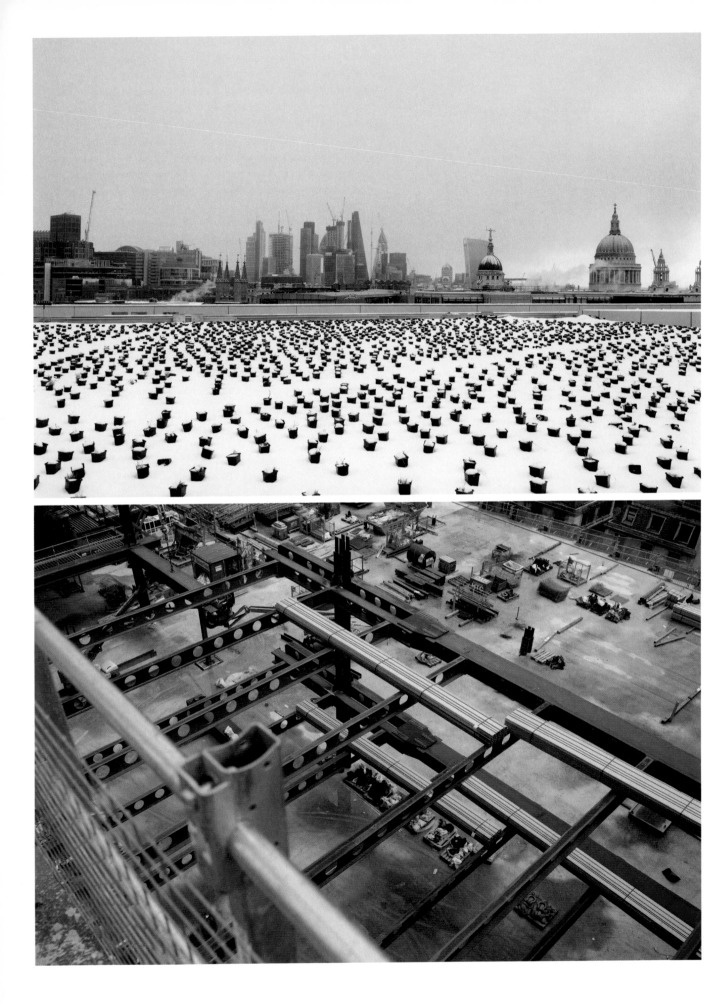

Juergen Teller, born in Erlangen, Germany, in 1964, studied at the Bayerische Staats- lehranstalt für Photographie in Munich. His work has been published in influential magazines such as Vogue, System, i-D, POP and Arena Homme+, and has been the subject of solo exhibitions including those at the Institute of Contemporary Arts in London, the Fondation Cartier pour l'art contemporain in Paris and Martin-Gropius- Bau in Berlin. Teller won the prestigious Citibank Photography Prize in 2003, and from 2014 to 2019 held a professorship at the Akademie der Bildenden Künste Nürnberg. His books with Steidl include Louis XV (2005), Marc Jacobs Advertising, 1998-2009 (2009), Siegerflieger (2015), The Master IV (2019) and Handbags (2019).

● Juergen Teller
Plumtree Court

Text by Juergen Teller
Book design by Catalin Plesa and Juergen Teller
256 pages
9.8 × 13 in. / 24.8 × 33 cm
412 color photographs
Four-color process
Clothbound hardcover with dust jacket

€ 38.00 / £ 35.00 / US$ 45.00
ISBN 978-3-95829-744-9

This book traces the five-year construction of Plumtree Court, Goldman Sachs' new headquarters in Central London, through Juergen Teller's inimitable vision. Teller relished immersing himself in such a long-term project, one thrillingly different to the fashion world he knows so well. From the rising walls of reinforced concrete and lattices of scaffolding, to the sparkling glass facades and gleaming interiors of the finished building, Teller became obsessed with recording intricate details within the larger shifting context: "I liked the diggers, cranes, cables, concrete and dirt. Not in a macho or childish way, but appreciating how all this construction work produces such a beautiful mess."

The project allowed Teller to draw on his own past experiences of collaborating with architects—with David Adjaye, who built his home (as well as the auditorium at Plumtree Court), and with 6a architects, who built his studio. His juxtaposition of final photos and collages throughout the book—seen here for the first time in his work— embodies the contrasts between past and present, order and chaos, architectural forms and the surrounding cityscape.

All my life I thought I would never work for a bank. And here I am.
Juergen Teller

JUERGEN TELLER

PLUMTREE COURT

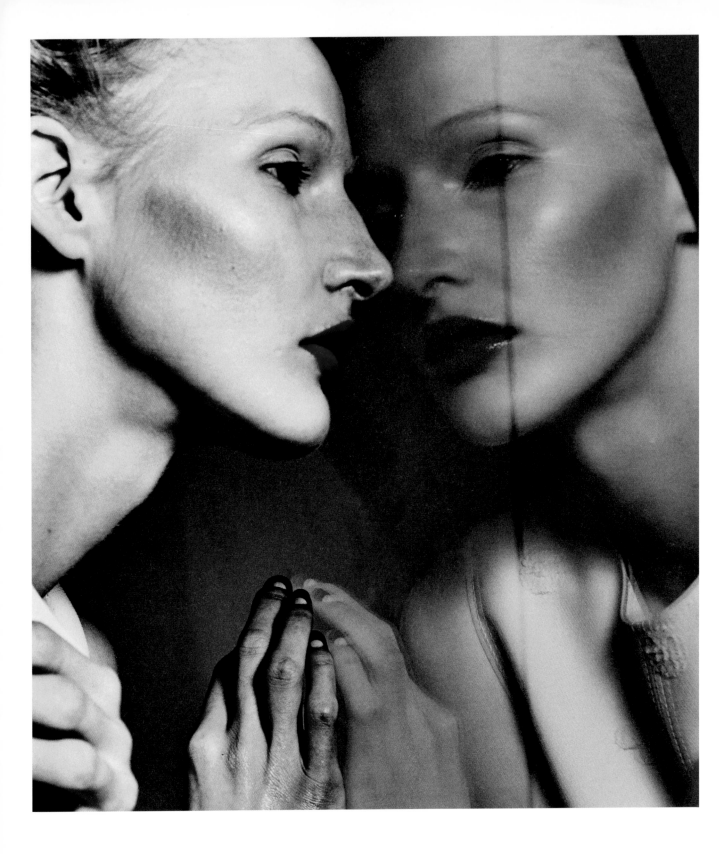

Steidl Comte

Our newest imprint presents books of Michel Comte's artworks and photography, books he has edited, and those he has selected to become part of the Steidl Comte family. Their art direction and design are by Jens Remes, Michel Comte and Gerhard Steidl, collaborating as an artistic collective.

Aviator
Neoclassic
Light V
EL & Us
The New World Order
Garden of Beauty
The Water in Between

Born in Zurich in 1954, the multimedia
artist Michel Comte studied in France
and England, and began his career in art
restoration, specializing in contemporary
art; his restoration works include those by
Andy Warhol, Yves Klein and Miró. In 1979
Comte met Karl Lagerfeld who gave him his
first commercial assignment for Chloé and
later Chanel. He has since collaborated with
Vogue Italia, Vanity Fair and Interview,
and with brands such as Dolce & Gabbana,
Gianfranco Ferré, Calvin Klein, BMW, Ferrari
and LVMH, among many others. Comte later
traveled to conflict zones to raise funds
for humanitarian projects such as "People
and Places with No Name." In 2008 he met
Ayako Yoshida and has since dedicated more
time to art and personal projects; together
they produced their first 3D feature film
The Girl From Nagasaki in 2013. Comte opened
"Neoclassic," his exhibition on the rise
and fall of neoclassicism, at the National
Gallery of Parma in fall 2016. He has
completed four exhibitions from his "Light"
series: at Museo Maxxi, Rome; La Triennale,
Milan; Galerie Urs Meile, Beijing; and most
recently at Dirimart, Istanbul. "Light"
is a study of natural landscapes through
large-scale sculptures, photography, video
installations and projections, exploring
the impact of environmental decline on the
world's glaciers and glacial landscapes.
Comte's books with Steidl include Aiko T
(2000), Michael Schumacher: Driving Force
(2003) and Light (2016).

This book is a visual biography of the legendary Swiss aviation
pioneer Alfred Comte (1895–1965). Combining historical photos and
documents with texts by Comte's son (also Alfred) and grandson the
photographer Michel Comte, the book is the first to comprehensively
explore the aviator's extraordinary life and achievements.

Alfred Comte grew up in the village of Delsberg in the Berner
Jura, where his brother had a carpentry shop and Alfred became
obsessed with building model airplanes. At the time, newspapers
lauded the courageous first aviators—and Comte's dream was born.
At the age of 17, he took a taxi from Gare du Nord to Villacoublay,
where a plane crashed just yards from the still moving vehicle.
Unmoved, Comte spent his savings on flying lessons on an early
Morane machine; he was a fearless and calculated student and soon
made his first solo flights as well as forays into aerobatics. Comte
joined the Swiss Air Force at the outbreak of the First World War,
during which Oskar Bider selected him to train 63 young pilots.
Among them was the avid photographer Walter Mittelholzer, who
later became Comte's first partner in the Comte Mittelholzer & Cie,
which in time became Swissair.

● Michel Comte (ed.)
Aviator

Edited by Michel Comte
Texts by Michel Comte, Alfred Comte and Tyler Brûlé
Book design by Jens Remes
224 pages
9.4 × 11.8 in. / 24 × 30 cm
200 black-and-white and 50 color photographs
Four-color process
Clothbound hardcover

€ 58.00 / £ 54.00 / US$ 65.00
ISBN 978-3-95829-576-6

Steidl Comte

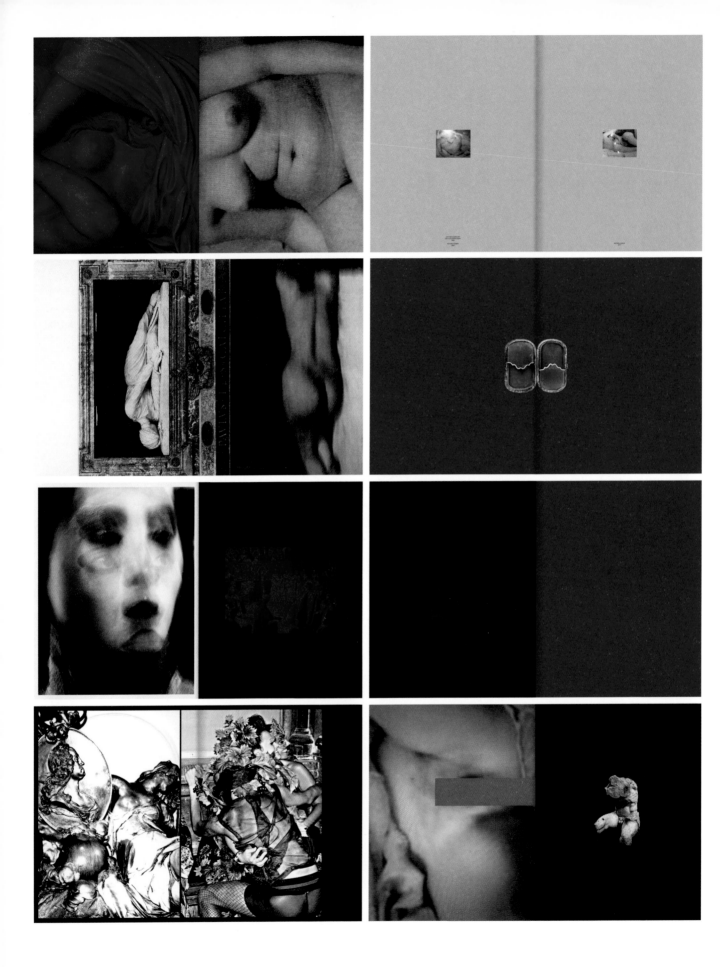

Born in Zurich in 1954, the multimedia
artist Michel Comte studied in France
and England, and began his career in art
restoration, specializing in contemporary
art; his restoration works include those by
Andy Warhol, Yves Klein and Miró. In 1979
Comte met Karl Lagerfeld who gave him his
first commercial assignment for Chloé and
later Chanel. He has since collaborated with
Vogue Italia, Vanity Fair and Interview,
and with brands such as Dolce & Gabbana,
Gianfranco Ferré, Calvin Klein, BMW, Ferrari
and LVMH, among many others. Comte later
traveled to conflict zones to raise funds
for humanitarian projects such as "People
and Places with No Name." In 2008 he met
Ayako Yoshida and has since dedicated more
time to art and personal projects; together
they produced their first 3D feature film
The Girl From Nagasaki in 2013. Comte opened
"Neoclassic," his exhibition on the rise
and fall of neoclassicism, at the National
Gallery of Parma in fall 2016. He has
completed four exhibitions from his "Light"
series: at Museo Maxxi, Rome; La Triennale,
Milan; Galerie Urs Meile, Beijing; and most
recently at Dirimart, Istanbul. "Light"
is a study of natural landscapes through
large-scale sculptures, photography, video
installations and projections, exploring
the impact of environmental decline on the
world's glaciers and glacial landscapes.
Comte's books with Steidl include Aiko T
(2000), Michael Schumacher: Driving Force
(2003) and Light (2016).

This book is Michel Comte's personal analysis of the neoclassical
style. Employing an eclectic approach including original photos,
reproductions of neoclassical treasures, and reworked images of
masterpieces such as Michelangelo's *Pietà* and Jacques-Louis David's
The Coronation of Napoleon, Comte traces the classical aesthetic
and its rebirth as the neoclassic throughout the ages. From the
Parthenon to Gianni Versace's designs, from Bernini to Albert Speer's
Reich Chancellery, the style has persisted and transformed itself
again and again, as empires rose and fell around it. In Comte's
words, the neoclassic demonstrates a "dream of perfection," one
we are seduced by even as we know its danger: "History tells us that
'grandeur' is destined to fail."

Beauty remains. Michel Comte

● Michel Comte
Neoclassic

Text by Michel Comte
Book design by Jens Remes
80 pages
9.4 × 11.8 in. / 24 × 30 cm

Vol. 1
120 pages
35 black-and-white and 110 color photographs

Vol. 2
120 pages
30 black-and-white and 100 color photographs

Four-color process
Two softcovers in a slipcase

€ 95.00 / £ 85.00 / US$ 125.00
ISBN 978-3-95829-751-7

Steidl Comte

Vol. 1 Vol. 2

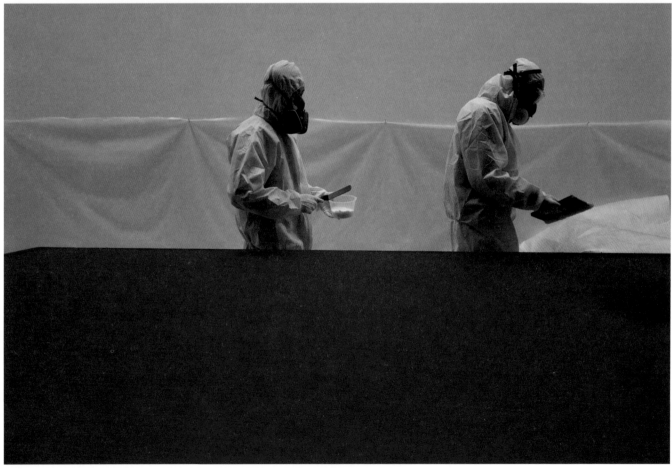

Born in Zurich in 1954, the multimedia
artist Michel Comte studied in France
and England, and began his career in art
restoration, specializing in contemporary
art; his restoration works include those by
Andy Warhol, Yves Klein and Miró. In 1979
Comte met Karl Lagerfeld who gave him his
first commercial assignment for Chloé and
later Chanel. He has since collaborated with
Vogue Italia, Vanity Fair and Interview,
and with brands such as Dolce & Gabbana,
Gianfranco Ferré, Calvin Klein, BMW, Ferrari
and LVMH, among many others. Comte later
traveled to conflict zones to raise funds
for humanitarian projects such as "People
and Places with No Name." In 2008 he met
Ayako Yoshida and has since dedicated more
time to art and personal projects; together
they produced their first 3D feature film
The Girl From Nagasaki in 2013. Comte opened
"Neoclassic," his exhibition on the rise
and fall of neoclassicism, at the National
Gallery of Parma in fall 2016. He has
completed four exhibitions from his "Light"
series: at Museo Maxxi, Rome; La Triennale,
Milan; Galerie Urs Meile, Beijing; and most
recently at Dirimart, Istanbul. "Light"
is a study of natural landscapes through
large-scale sculptures, photography, video
installations and projections, exploring
the impact of environmental decline on the
world's glaciers and glacial landscapes.
Comte's books with Steidl include Aiko T
(2000), Michael Schumacher: Driving Force
(2003) and Light (2016).

● Michel Comte
Light V

Text by Clemens Jahn
Book design by Jens Remes
184 pages
11.7 × 11.7 in. / 29.7 × 29.7 cm
105 black-and-white and 95 color photographs
Four-color process
Softcover

€ 38.00 / £ 35.00 / US$ 45.00
ISBN 978-3-95829-856-9

Light V is the latest book in Michel Comte's ongoing exploration of
global warming and the responsibility we bear in addressing this
grave problem. Here Comte shares his most recent climate-centered
installations and exhibitions, in which he embraces abstract forms as
well as the concept of repetition. From large-scale pigment paintings,
to series of glass works, and sculptures, he comprehensively reminds
us of the fragility of earth. Comte's ultimate message: nature is the
museum of the future; let us protect our biosphere.

Steidl Comte

Born in Zurich in 1954, the multimedia
artist Michel Comte studied in France
and England, and began his career in art
restoration, specializing in contemporary
art; his restoration works include those by
Andy Warhol, Yves Klein and Miró. In 1979
Comte met Karl Lagerfeld who gave him his
first commercial assignment for Chloé and
later Chanel. He has since collaborated with
Vogue Italia, Vanity Fair and Interview,
and with brands such as Dolce & Gabbana,
Gianfranco Ferré, Calvin Klein, BMW, Ferrari
and LVMH, among many others. Comte later
traveled to conflict zones to raise funds
for humanitarian projects such as "People
and Places with No Name." In 2008 he met
Ayako Yoshida and has since dedicated more
time to art and personal projects; together
they produced their first 3D feature film
The Girl From Nagasaki in 2013. Comte opened
"Neoclassic," his exhibition on the rise
and fall of neoclassicism, at the National
Gallery of Parma in fall 2016. He has
completed four exhibitions from his "Light"
series: at Museo Maxxi, Rome; La Triennale,
Milan; Galerie Urs Meile, Beijing; and most
recently at Dirimart, Istanbul. "Light"
is a study of natural landscapes through
large-scale sculptures, photography, video
installations and projections, exploring
the impact of environmental decline on the
world's glaciers and glacial landscapes.
Comte's books with Steidl include Aiko T
(2000), Michael Schumacher: Driving Force
(2003) and Light (2016).

EL & Us—engineering life and us—explores the thin line between contemporary art and molecular research. It is the compelling collaboration between Michel Comte and the NCCR MSE (National Center of Competence in Research Molecular Systems Engineering) at the University of Basel and ETH Zurich, to translate science into art and reveal this life-changing research to a broad audience.

The cutting-edge combination of biology and engineering allows deep interventions into living organisms that are now on the verge of substantially impacting human health and disease treatment. Such comprehensive, paradigm-shifting change accordingly requires the consent of a society well informed through interactive and ethically conducted debate. To facilitate this and bridge the communication gap between complex science and the general public, the NCCR MSE has created Art of Molecule, an interdisciplinary framework through which contemporary artists discuss, challenge and (re-)form the project's research goals. *EL & Us* is Michel Comte's proactive contribution to this project and its central issue: can engineering life lead to a better future?

Michel Comte
EL & Us

Book design by Steidl Comte
256 pages
9.6 × 12.6 in. / 24.5 × 32 cm
30 black-and-white and 70 color photographs
Four-color process
Clothbound hardcover with transparent dust jacket

€ 58.00 / £ 54.00 / US$ 65.00
ISBN 978-3-95829-857-6

Steidl Comte

Clothbound hardcover

Transparent dust jacket

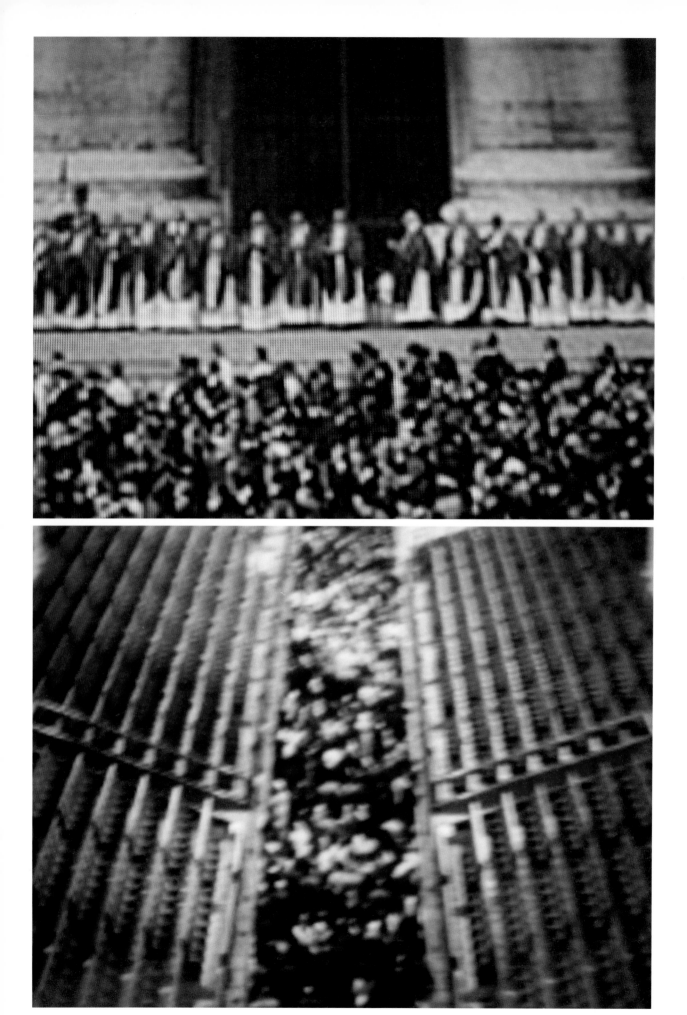

Born in Zurich in 1954, the multimedia
artist Michel Comte studied in France
and England, and began his career in art
restoration, specializing in contemporary
art; his restoration works include those by
Andy Warhol, Yves Klein and Miró. In 1979
Comte met Karl Lagerfeld who gave him his
first commercial assignment for Chloé and
later Chanel. He has since collaborated with
Vogue Italia, Vanity Fair and Interview,
and with brands such as Dolce & Gabbana,
Gianfranco Ferré, Calvin Klein, BMW, Ferrari
and LVMH, among many others. Comte later
traveled to conflict zones to raise funds
for humanitarian projects such as "People
and Places with No Name." In 2008 he met
Ayako Yoshida and has since dedicated more
time to art and personal projects; together
they produced their first 3D feature film
The Girl From Nagasaki in 2013. Comte opened
"Neoclassic," his exhibition on the rise
and fall of neoclassicism, at the National
Gallery of Parma in fall 2016. He has
completed four exhibitions from his "Light"
series: at Museo Maxxi, Rome; La Triennale,
Milan; Galerie Urs Meile, Beijing; and most
recently at Dirimart, Istanbul. "Light"
is a study of natural landscapes through
large-scale sculptures, photography, video
installations and projections, exploring
the impact of environmental decline on the
world's glaciers and glacial landscapes.
Comte's books with Steidl include Aiko T
(2000), Michael Schumacher: Driving Force
(2003) and Light (2016).

● Michel Comte
The New World Order

Texts by Michel Comte and Beatrice Trussardi
Book design by Steidl Comte
256 pages
10.6 × 13 in. / 27 × 33 cm
20 black-and-white and 80 color photographs
Four-color process
Clothbound hardcover with dust jacket

€ 50.00 / £ 45.00 / US$ 60.00
ISBN 978-3-95829-858-3

Imagery of crowds and mass gatherings has been the focal point of
Michel Comte's work for many years now. Particularly powerful are
the yearly Easter blessings in the Vatican City; the papal conclaves
with aerial views of all the gathered cardinals have not changed since
the Middle Ages. From Shibuya's crossings to New York's Times Square;
from the Hajj in Mecca, to Woodstock, the World Cup final, and the
Italian Grand Prix; from the March on Washington with Martin Luther
King, to Hong Kong in 2019–2020—each of these places attracts
enormous crowds approaching a point of imminent danger that have
led to catastrophic events in the past.

In November 2019 the first cases of COVID-19 were reported
in the city of Wuhan in Hubei province; in the months since, our
world has changed. Social distancing has become the new norm and
our entire perspective towards gathering, meeting and closeness
have taken on different meanings. Suddenly, images of crowds look
unfamiliar. The dots are drifting apart.

Steidl Comte

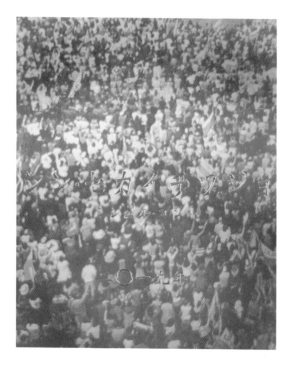

Born in Zurich in 1954, the multimedia artist Michel Comte studied in France and England, and began his career in art restoration, specializing in contemporary art; his restoration works include those by Andy Warhol, Yves Klein and Miró. In 1979 Comte met Karl Lagerfeld who gave him his first commercial assignment for Chloé and later Chanel. He has since collaborated with Vogue Italia, Vanity Fair and Interview, and with brands such as Dolce & Gabbana, Gianfranco Ferré, Calvin Klein, BMW, Ferrari and LVMH, among many others. Comte later traveled to conflict zones to raise funds for humanitarian projects such as "People and Places with No Name." In 2008 he met Ayako Yoshida and has since dedicated more time to art and personal projects; together they produced their first 3D feature film The Girl From Nagasaki in 2013. Comte opened "Neoclassic," his exhibition on the rise and fall of neoclassicism, at the National Gallery of Parma in fall 2016. He has completed four exhibitions from his "Light" series: at Museo Maxxi, Rome; La Triennale, Milan; Galerie Urs Meile, Beijing; and most recently at Dirimart, Istanbul. "Light" is a study of natural landscapes through large-scale sculptures, photography, video installations and projections, exploring the impact of environmental decline on the world's glaciers and glacial landscapes. Comte's books with Steidl include Aiko T (2000), Michael Schumacher: Driving Force (2003) and Light (2016).

Already in the 1970s Michel Comte worked for Bergdorf Goodman in New York on their impressive window displays. This was an early collaboration with Andy Warhol, and marked a time when Comte discovered the bold impact simple yet exquisitely executed decorative schemes could have on passersby. Since these opportune beginnings, he has created numerous such projects, mostly incorporating natural elements—the full bounty of flora. *Garden of Beauty. Combining Worlds with Flowers* explores Comte's recent use of flowers to wrap buildings in Stuttgart and Düsseldorf for the luxury retailer Breuninger. Together with art director Jens Remes, Comte creates an entirely new retail environment and branding aesthetic.

● Michel Comte
Garden of Beauty
Combining Worlds with Flowers

Text by Michel Comte
Book design by Jens Remes
224 pages
9.1 × 11.8 in. / 23 × 30 cm
30 black-and-white and 250 color photographs
Four-color process
Clothbound hardcover with a tipped-in photograph

€ 48.00 / £ 45.00 / US$ 55.00
ISBN 978-3-95829-859-0

Steidl Comte

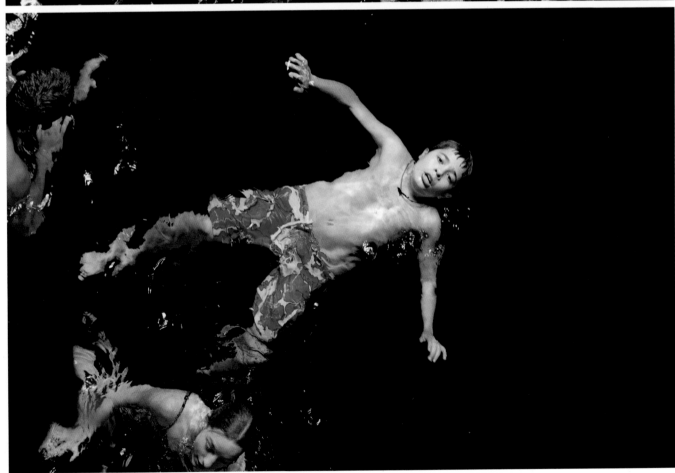

Born in 1960 in New York, Francine Fleischer initially studied figurative painting and ballet, experiences which continue to inform her photographic exploration of the human figure, often within natural landscapes. Fleischer completed her Bachelor of Fine Arts at Purchase College, State University of New York; she later received a grant in media arts from New York University before working in the studios of Annie Leibovitz and Michel Comte. She has exhibited internationally, and her work is held in private and public collections including the Portland Museum of Art, and has been published in Condé Nast Traveller, M Le Magazine Du Monde and the Sunday Telegraph, among others.

Francine Fleischer took the photographs in *The Water in Between* in an exquisite and mysterious *cenote*, a deep natural well caused by the collapse of surface rock exposing the ground water beneath, and one once used by the Mayan civilization for human sacrifice. This exotic pool rimmed with draping vines is now a popular site for recreational swimming in today's Mexico. This curious contradiction of purpose is palpable in Fleischer's meditative and vibrant images of bathers taken 30 meters below the earth's surface; captured unstaged and in natural light, her subjects play out unexpected choreographies and narratives. Photographed over a period of ten years, *The Water in Between* is a study of human nature and interactions, as well as an unapologetic appreciation of the beauty of a great shaft of light rendering bodies in dark moving water, with chiaroscuro qualities reminiscent of Caravaggio and the painterly textures of Rubens.

When I gaze down on these bathers frolicking in the inky water, it is like looking down the rabbit hole into another world of subterranean dreams, Dantean scenarios, vulnerability and joy. Francine Fleischer

● Francine Fleischer
The Water in Between

Edited by Michel Comte
Texts by Michel Comte and Francine Fleischer
Book design by Jens Remes
104 pages
14.2 × 11.4 in. / 36 × 29 cm
32 color photographs
Four-color process
Clothbound hardcover with a tipped-in photograph

€ 85.00 / £ 80.00 / US$ 95.00
ISBN 978-3-95829-860-6

Steidl Comte

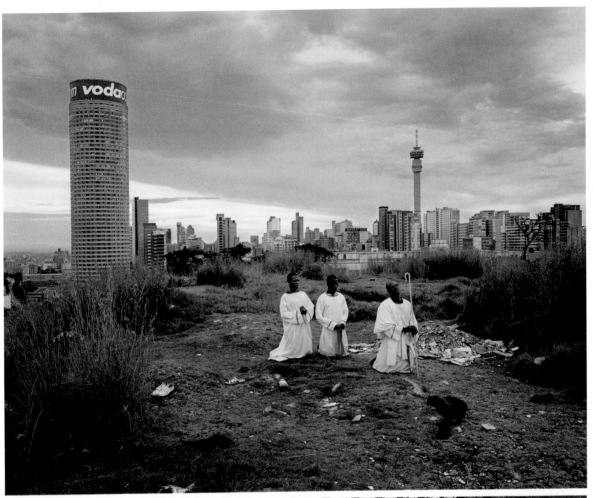

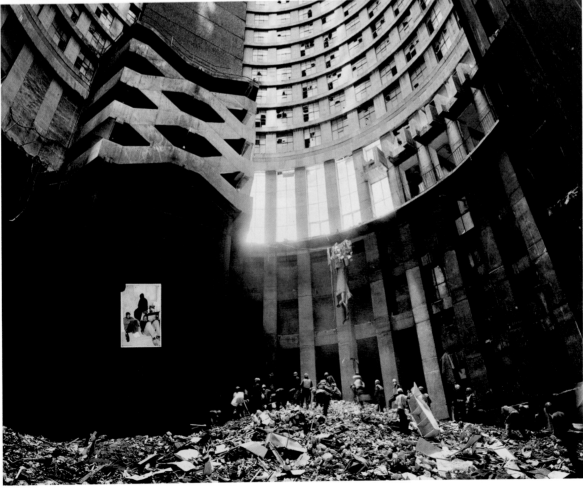

Born in Cape Town in 1981, Mikhael
Subotzky is an artist working across
mediums including film, photography,
painting and collage. His work is a
fractured attempt to place himself in
relation to the social, historical
and political narratives surrounding
him, and combines the directness of
social documentary photography with a
reconsideration of the photographic
medium itself. Subotzky's work is held
in public collections including the
Museum of Modern Art, New York, Tate
Modern, London, and the San Francisco
Museum of Modern Art, and has been
exhibited at the Liverpool (2012),
Lubumbashi (2013) and Venice (2015)
Biennials. He lives and works in
Johannesburg.

Born in Bath in 1981, Patrick Waterhouse
is an artist whose work plays with
narrative representation and explores the
construction of history and its origins.
His projects are often collaborative,
shaped by close engagement with his
subjects. Waterhouse's work has been
exhibited at the Guggenheim Museum,
Bilbao, the National Gallery of Art,
Washington D.C., as well as the Lubumbashi
(2013) and Liverpool Biennials (2012);
it is held in collections including the
Guggenheim Museum, New York, the San
Francisco Museum of Modern Art and Centre
Pompidou, Paris. His latest book is
Restricted Images. Made with the Warlpiri
of Central Australia (2018).

Mikhael Subotzky and Patrick Waterhouse worked at Ponte City, the iconic Johannesburg apartment building and Africa's tallest residential skyscraper, for more than six years. There they photographed its residents and exhaustively documented the building—every door, the view from every window, the image on every television screen. This remarkable body of photographs appears here in counterpoint to an extensive archive of found material and historical documents; a sustained sequence of essays and documentary texts is also integrated into the visual story. In the essays, some of South Africa's leading scholars and writers explore Ponte City's unique place in Johannesburg and in the imagination of its citizens. What emerges is a complex portrait of a place shaped by contending projections, a single, unavoidable building seen as refuge and monstrosity, dreamland and dystopia, a lightning rod for a society's hopes and fears, and always a beacon to navigate by. This long-term project received the Discovery Award at Les Rencontres d'Arles in 2011. The first edition of *Ponte City*, published by Steidl in 2014 and now out-of-print, was awarded the Deutsche Börse Photography Prize in 2015.

In order to reconstitute its story, one must pay close attention to this multitude of voices, disentangling what is true from what is felt or imagined and constitutes a different kind of reality. It is an inevitably polyphonic narrative that Mikhael Subotzky and Patrick Waterhouse offer us here. Clément Chéroux

Exhibition: San Francisco Museum of Modern Art, 2020/2021

● Mikhael Subotzky and Patrick Waterhouse
Ponte City Revisited: 54 Storeys

Edited by Ivan Vladislavić
Introduction by Clément Chéroux
Texts by Lindsay Bremner, Denis Hirson,
Harry Kalmer, Kgebetli Moele, Sean O'Toole,
Melinda Silverman, Ivan Vladislavić and
Percy Zvomuya
Book design by Tim Wan
416 pages
8.3 × 10.9 in. / 21 × 27.8 cm
152 color photographs and 114 illustrations
Four-color process
Softcover

€ 48.00 / £ 40.00 / US$ 55.00
ISBN 978-3-95829-761-6

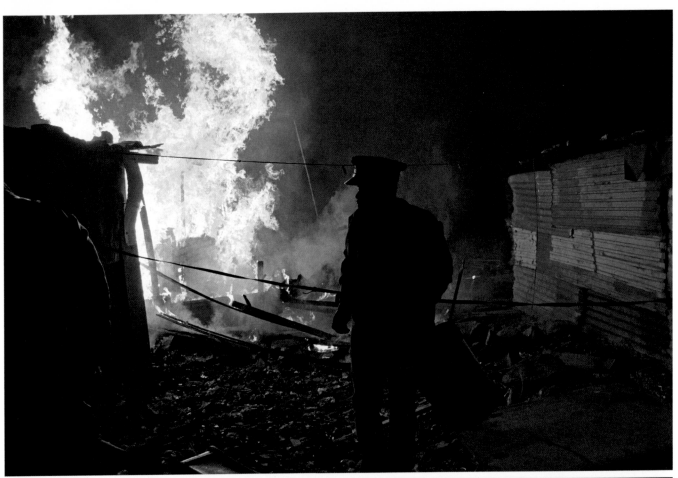

Born in 1995 in Katlehong, Johannesburg, Lindokuhle Sobekwa came to photography through his participation in the "Of Soul and Joy" project in the Thokoza township in south-east Johannesburg. In 2017 he was selected by the Magnum Foundation for Photography and Social Justice to develop I Carry Her Photo With Me. Sobekwa's work has been exhibited in South Africa, Norway, the US and Iran; in 2018 he became a Magnum nominee.

Lindokuhle Sobekwa began this project after finding a family portrait with his sister Ziyanda's face cut out. He describes her as a secretive, rebellious and rough presence, and recalls the dark day when she chased him and he was hit by a car: she disappeared hours later and returned only a decade later, ill. By this time Sobekwa had become a photographer and realized the family had no picture of her: "One day I saw this beautiful light coming in through the window shining on her face. I lifted up the camera to catch the moment and she shot me an evil look and said: 'Stop! If you take that picture I'm going to kill you!' So I lowered my camera. I still wish I had taken the shot." Ziyanda died soon after.

Employing a scrapbook aesthetic with handwritten notes, I Carry Her Photo With Me is a means for Sobekwa to engage both with the memory of his sister and the wider implications of such disappearances—a troubling part of South Africa's history. The book complements his wider work on fragmentation, poverty and the long-reaching ramifications of apartheid and colonialism across all levels of South African society.

Disappearances like my sister's are not unique to my family [...] it is something that is not often talked about and has a serious impact on families and communities. Lindokuhle Sobekwa

Lindokuhle Sobekwa
I Carry Her Photo With Me

Text by Lindokuhle Sobekwa
Book design by Lindokuhle Sobekwa
and Gerhard Steidl
104 pages
7.5 × 10 in. / 19 × 25.3 cm
20 black-and-white and 25 color photographs
and 1 illustration
Four-color process
Hardcover

€ 40.00 / £ 35.00 / US$ 45.00
ISBN 978-3-95829-754-8

Born in 1985 in Sikkim, Tenzing Dakpa is
a second-generation Tibetan who today
lives and works between Sikkim, Goa and
New Delhi. He completed his Bachelor
of Fine Arts at the College of Art,
University of New Delhi in 2009, and his
Master of Fine Arts in Photography at the
Rhode Island School of Design in 2016.
Dakpa's photographs have been exhibited
at institutions including Sol Koffler
Gallery, Rhode Island (2015), Asia House,
London (2018) and indigo+madder, London
(2019).

● Tenzing Dakpa
The Hotel

Text by Tenzing Dakpa
Book design by Tenzing Dakpa
96 pages plus a text insert
7.5 × 12 in. / 19 × 30.5 cm
45 black-and-white photographs
Tritone
Otabind softcover with dust jacket

€ 30.00 / £ 25.00 / US$ 35.00
ISBN 978-3-95829-742-5

The hotel in this book is both real and metaphorical, an actual establishment run by Tenzing Dakpa's parents in Sikkim, Northeast India, and a prism through which he revisits his family history and place within it. Dakpa's photos reveal the physical spaces of the hotel, its guest rooms, dining room, the family's cat on a flight of stairs; as well as signs of daily working life there: sheets hanging out to dry, clipping plants in the garden, his parents engaged in various tasks.

For the hotel is both public and private, a business and a home: a transient place for guests who come and go and a residence that holds the memories of its owners and projects their hopes.

As the only member of his family not involved in running the hotel, Dakpa's photos allow him to negotiate his migration and detachment from it, while intensely exploring his family relationships. In Dakpa's words, one's sense of self is inseparable from the places we create, both physically and in our minds: "The nature of our official identity and place on paper is adopted and the one which is in our memory is fragmented, revealed only in places we once remember."

At a certain level, photography's development continues to be propelled by a desire to confer immortality by reproducing the subject, and yet it paradoxically ends up capturing unfulfilled desires—to fully know the subject and ourselves. Krittika Sharma

Winner of the Singapore International Photography Festival Photobook Award 2018

SINGAPORE
INTERNATIONAL
PHOTOGRAPHY
FESTIVAL

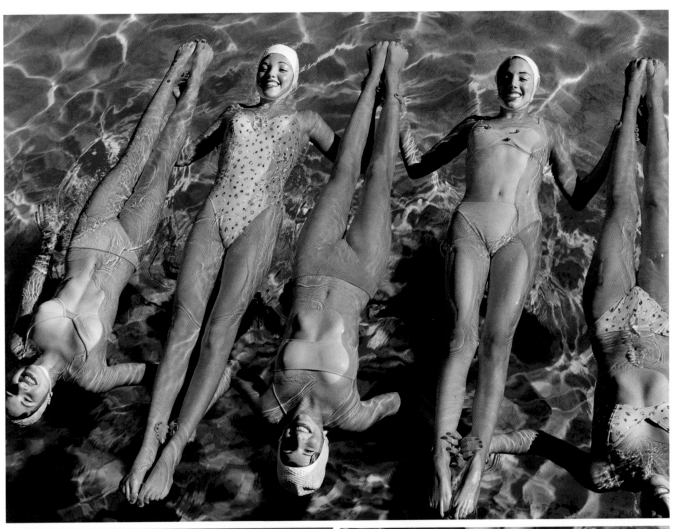

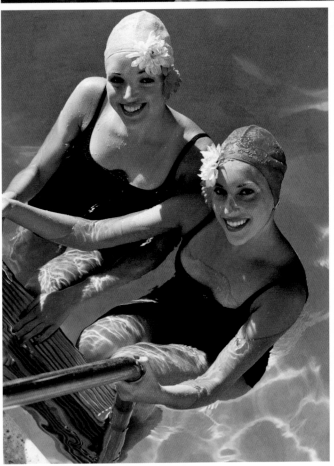

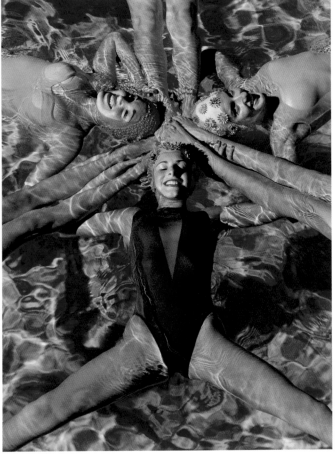

Koto Bolofo was born in South Africa in 1959 and raised in Great Britain. Bolofo has photographed for magazines such as Vogue, Vanity Fair and GQ, and made short films for the Berlinale and the Venice Film Festival. He has created advertising campaigns for companies including Hermès, Christian Dior, Louis Vuitton and Dom Pérignon. Bolofo's books with Steidl include Venus (2008), Horsepower (2010), I Spy with My Little Eye, Something Beginning with S (2010), Vroom! Vroom! (2010), La Maison (2011) and The Prison (2014).

If one had to choose a single series that summed up Koto Bolofo's unconventional approach to fashion photography, it could well be *Say Cheese*—pictures brimming with light and delight which defy the often stilted, glum or over-dramatized images of the industry. These photos were originally published in 2000 in *Vogue Italia*, then under the legendary Franca Sozzani, whom Bolofo first met in 1984 and worked with for more than 25 years. He fondly remembers the exceptional creative freedom she gave him and other photographers at the magazine—Sozzani provided the clothes, they did the rest.

And so it was with *Say Cheese*: Bolofo was given a wardrobe of female swimwear, and with the help of his frequent stylist Nicoletta Santoro, he shunned professional models, instead enlisting a vibrant squad of real synchronized swimmers, California's Riverside Aquettes. The resulting images show a variety of female bodies at ease and play—floating and twirling in sparkling, sun-filled water, clad in retro looks, from Great Gatsby flair to flowered 1950s bathing caps, and each wearing Bolofo's favorite accessory: a genuine smile.

My work has always been "off fashion," while still being in fashion.
Koto Bolofo

● Koto Bolofo
Say Cheese

Foreword by Monte Packham
Book design by Rahel Bünter / Steidl Design
48 pages
11.4 × 14.6 in. / 29 × 37 cm
30 color photographs
Four-color process
Clothbound hardcover

€ 38.00 / £ 35.00 / US$ 45.00
ISBN 978-3-95829-733-3

Born in Turin in 1986, Gaia Repossi
studied painting at the École Nationale
Supérieure des Beaux-Arts in Paris and
received a master's degree in archaeology
from the Sorbonne. Since 2007 she has
been creative and artistic director
at the House of Repossi. Her jewelry
is characterized by modern, minimalist
motifs and the innovative use of complex
patterns; her references include
contemporary art and architecture, such
as the work of Alexander Calder, Cy
Twombly, Franz West and Le Corbusier,
as well Brutalism, Minimalism and the
Bauhaus. Repossi's most successful and
renowned creations for the house include
her Berbere (2010), Antifer (2014) and
Brevis (2019) collections.

This book is the first to explore the visual identity and legacy of
Repossi, the influential Italian jeweler across four generations. From
its founding in 1920 in Turin to the work of Costantino Repossi and
the expansion of the house under his son Alberto in Monte Carlo and
Paris, and today as a leader in contemporary jewelry under Alberto's
daughter Gaia, *Repossi* offers a behind-the-scenes look at the
fundamentals of the brand.

The book features an eclectic wealth of visual material, much
drawn from the Repossi archives and published here for the first
time—from vintage portraits and sketches to advertising campaigns,
from jewelry still lifes to the artists that inspire Gaia Repossi such as
Robert Mapplethorpe and Donald Judd, as well as her 2016 collabo-
ration with Rem Koolhaas on the revolutionary flagship store on Place
Vendôme, the center of the high-jewelry universe. *Repossi* is a tribute
from Gaia Repossi to her father for the legacy she inherited, and a
contemporary transcript of the brand under her leadership—shaped
by the values of simplicity, curiosity, discipline, a healthy disregard for
ostentation, and not a little surprise.

*Jewelry should be a tribute to humanity. It's ancestral. We can't erase
its collective roots.* Gaia Repossi

● Gaia Repossi (ed.)
Repossi

Foreword by Gaia Repossi
Texts by Audrey Bartis, Rem Koolhaas, Lucy Moore,
Monte Packham, Isabella Seniuta, Michael Stout and
Francesco Vezzoli
Interview by Isabella Seniuta with Gaia Repossi
Photos by Juergen Teller, David Sims and others
Book design by Holger Feroudj / Steidl Design
232 pages
7.7 × 9.3 in. / 19.5 × 23.5 cm
60 black-and-white and 370 color photographs
Four-color process
Hardcover

€ 65.00 / £ 55.00 / US$ 75.00
ISBN 978-3-95829-758-6

Born in New York in 1956, Jerry Spagnoli
is one of the principal practitioners
of the daguerreotype and lectures
regularly on the subject. His work is
held in the collections of the Whitney
Museum of American Art in New York, the
Museum of Fine Arts in Boston and the
National Portrait Gallery in Washington
D.C. Spagnoli's work has appeared in
many books, and Steidl has published his
Daguerreotypes (2006), American Dreaming
(2011) and Regard (2019).

In *Local Stories*, Jerry Spagnoli contests the notion of history as a narrative told to support particular agendas, and installs personal experience in its place—the myriad stories we as individuals create on a daily basis. History is no longer a chronicle of "facts" written by those in power, but a collaborative social fabric shaped by our memories and ever growing. "It is beyond the power of any medium to communicate that vast ocean of experience, but perhaps it is possible to point in that direction," explains Spagnoli, "These images are my attempt." His photos encompass the city, suburbia, the countryside and all between throughout the world—from the neon noise of Times Square to a peaceful cafe on the Île Saint-Louis, from a street parade to friends picnicking under cherry blossoms, from the Forbidden City to surfers bobbing patiently on their boards, waiting for the next wave. "This fundamental sensation of moving through time is what unites us all as humans and presiding over it all, there before the beginning, and certain to be there after the end, the sun in the center of the sky."

Everyone is equal at the most basic level, of living in a state of con-sciousness of the past and anticipation of the future. Jerry Spagnoli

Jerry Spagnoli
Local Stories

Text by Jerry Spagnoli
Book design by Jerry Spagnoli and Gerhard Steidl
152 pages
15 × 11.8 in. / 38 × 30 cm
72 color photographs
Four-color process
Clothbound hardcover

€ 40.00 / £ 35.00 / US$ 45.00
ISBN 978-3-95829-759-3

Local Stories

Dayanita Singh was born in New Delhi in 1961 and studied at the National Institute of Design in Ahmedabad and the International Center of Photography in New York. Singh's exhibitions include those at the Serpentine Gallery in London, Hamburger Bahnhof in Berlin, the Hayward Gallery in London, the Art Institute of Chicago, and the Museum für Moderne Kunst in Frankfurt. In 2013 she represented Germany at the Venice Biennale. Bookmaking is central to her practice. Singh's books with Steidl include Privacy (2004), Go Away Closer (2007), Sent a Letter (2007), Dream Villa (2010), File Room (2013), Museum of Chance (2014) and Museum Bhavan, Book of the Year at the 2017 Paris Photo-Aperture Foundation Photobook Awards and recipient of the 2018 ICP Infinity Award for Artist's Book.

"I wanted to suggest a conversation among these chairs, which have always seemed to me more like people than objects, with distinct personalities and genders even." With this sentiment in mind, Dayanita Singh went about photographing the many chairs living throughout the houses and public buildings designed by Geoffrey Bawa (1919–2003), whom Singh deems a "tropical modernist" and the most influential architect of the South Asian region. Less still lifes than portraits, Singh's images show how Bawa's spaces engage with the chairs, be they designed or collected by Bawa, or installed after his passing. Made to celebrate the hundredth anniversary of Bawa's birth, *Bawa Chairs* is constructed as an accordion-fold booklet in the manner of Singh's *Chairs* (2005), *Sent a Letter* (2007) and *Museum Bhavan* (2017), and intended to be unfolded and installed at will—transforming the book into an exhibition, and the reader into a curator.

I want something ordinary on the outside and like a jewel inside.
Dayanita Singh

Dayanita Singh
Bawa Chairs

Book design by Dayanita Singh
27 pages
3.5 × 5.4 in. / 9 × 13.7 cm
27 black-and-white photographs
Tritone
Accordion-fold booklet

€ 30.00 / £ 25.00 / US$ 35.00
ISBN 978-3-95829-673-2

Born in Copenhagen in 1971 and based today near Berlin, Joakim Eskildsen studied bookmaking with Pentti Sammallahti at the University of Art and Design in Helsinki. His books include the self-published Nordic Signs (1995), Bluetide (1997) and iChickenMoon (1999); and The Roma Journeys (2007) and American Realities (2016) with Steidl. His work has been published in The New Yorker, the New York Times Magazine and Time magazine, among others. Eskildsen is represented by Persons Projects and Robert Morat Galerie in Berlin, Purdy Hicks Gallery in London, and Polka Galerie in Paris.

Cuban Studies is Joakim Eskildsen's third book in his trilogy on dysfunctional political systems, following *American Realities* (2016), which dealt with people living under the official poverty line in the United States after the financial collapse of 2011, and *Cornwall* (2018), a poetic photographic study of the county that voted for Britain to leave the European Union but would now decide otherwise. *Cuban Studies* is the result of Eskildsen's journeys between 2013 and 2016, when, accompanied by Cuban journalist Abel Gonzalez, he traveled throughout the country during a period of major transition following economic reforms. "The more I learned about Cuba," says Eskildsen, "the more difficult it became to understand. It was like learning to see the world from a different angle, so distinct from what I knew that I decided to keep an open mind and take the position of the listener, following my instincts rather than anything else. From my very first journey, Cuba put a spell on me that made me return again and again. It was a time of optimism and uncertainty, and great hopes for the future."

I visualize my projects as books even before they're half-finished. For me the book is the backbone of the project. Joakim Eskildsen

⬤ Joakim Eskildsen
Cuban Studies

Text by Abel Gonzalez
Book design by Joakim Eskildsen and Gerhard Steidl
144 pages
7.1 x 12.3 in. / 18 x 31.2 cm
118 color photographs
Four-color process
Clothbound hardcover

€ 35.00 / £ 30.00 / US$ 40.00
ISBN 978-3-95829-704-3

Holger Sierks, Carsten Güttler and Cecilia
Tubiana of the Max Planck Institute
for Solar System Research in Göttingen
represent the team of scientists and
engineers that built and operated OSIRIS.
It took more than 30 years of planning,
construction and travel for OSIRIS to
finally reach comet 67P.

Comets as beautiful phenomena in the night sky have fascinated humans and inspired our imagination for millennia. Having witnessed the formation of our solar system 4.6 billion years ago, comets are also a scientist's dream to study. Composed of fluffy dust, several ices and rich organics, it has long been believed that they preserve pristine material from this early time and therefore hold the key to understanding the origin of the solar system with all its planets—and ultimately life. To make this dream a reality, the Rosetta mission visited a comet named 67P/Churyumov-Gerasimenko between 2014 and 2016. On board the orbiting Rosetta spacecraft were eleven scientific instruments as well as Philae, an in situ laboratory to land on the comet's surface. The camera system OSIRIS (Optical, Spectroscopic and Infrared Remote Imaging System) can certainly be considered the "Eyes of Rosetta."

This book collects the most stunning images acquired by OSIRIS and compiled by the scientists who were responsible for the development and operation of the camera system. From the launch of the Rosetta spacecraft on board an Ariane 5 rocket, to a journey through space of more than ten years to reach 67P/Churyumov-Gerasimenko, *OSIRIS – The Eyes of Rosetta* allows us to explore a comet with our own eyes and discover how exotic yet oddly familiar it is.

Holger Sierks, Carsten Güttler
and Cecilia Tubiana (eds.)
OSIRIS – The Eyes of Rosetta
Journey to Comet 67P, a Witness
to the Birth of Our Solar System

Texts by Holger Sierks, Carsten Güttler
and Cecilia Tubiana
Book design by Steidl Design
328 pages
11.8 × 11.8 in. / 30 × 30 cm
245 black-and-white and 11 color photographs
Tritone process
Hardcover

€ 75.00 / £ 70.00 / US$ 85.00
ISBN 978-3-95829-622-0

Born in 1955 in Oregon, Jamey Stillings
incorporates documentary, artistic and
commissioned projects in his photography.
He has exhibited internationally and
his work is held in the collections of
the United States Library of Congress,
the Museum of Fine Arts, Houston, the
Los Angeles County Museum of Art, and
the Nevada Museum of Art. With his
book The Evolution of Ivanpah Solar
(Steidl, 2015), Stillings won the
International Photography Awards
Professional Book Photographer of the
Year in 2016.

With *ATACAMA*, Jamey Stillings again shares his distinctive aerial perspective to examine dramatic large-scale renewable energy projects, the visual dynamic of enormous mining operations and the stark beauty of the Atacama Desert, so often scarred by human activity. Chile produces a third of the world's copper and has the largest known lithium reserves, and we utilize these resources daily in our cars, computers and smartphones. The country's mining industry has traditionally been dependent on imported coal, diesel and natural gas for its energy. Yet the Atacama Desert has excellent solar and wind potential: new renewable energy projects there now supply significant electricity to the northern grid, transmit power to population centers in the south, and are reducing mining's dependence on fossil fuel.

Stillings' aesthetic interest in the human-altered landscape and concerns for environmental sustainability are principal pillars of his work. His photography elicits a critical dialogue about meeting our needs and desires while seeking equilibrium between nature and human activity. *ATACAMA*, the latest chapter in his ongoing project "Changing Perspectives," shows how photography can concurrently be a source of inspiration, motivation and information, and reminds us that a carbon-constrained future is crucial to a responsible approach to life on earth.

Stillings is that rare mix of artist and activist. He has immersed himself in the scientific literature, informing the creation of his images that are both stunningly beautiful and profoundly instructional. Mark Sloan, Director and Chief Curator, Halsey Institute of Contemporary Art

● Jamey Stillings
ATACAMA
Renewable Energy and Mining
in the High Desert of Chile

Texts by Mark Sloan and Jamey Stillings
Book design by David Chickey
160 pages
15 black-and-white and 45 color photographs
9.1 × 13.4 in. / 23.2 × 34 cm
Tritone and four-color process
Clothbound hardcover

€ 65.00 / £ 60.00 / US$ 75.00
ISBN 978-3-95829-708-1

In Jim Dine's bluntly honest words, *Electrolyte in Blue* is a "long hate poem" about "the evil in our now small world and those who unleashed it," exploring themes of anti-Semitism, racism, climate change, as well as the world leaders he condemns, strong among them Donald Trump. Dine's fury and disappointment are clear, yet his vision is not merely bleak. He lays his words over luminous etchings, aquatints and lithographs of botanical themes in buoyant color. Luscious foliage, flowers, fruit and vegetables celebrate the natural world and offer solace against the social, political and environmental concerns which Dine voices. The book is based upon the original *Electrolyte in Blue*, a unique book object in an edition of one, typeset and printed by hand by Ruth Lingen, with whom Dine has collaborated for decades. All in all *Electrolyte in Blue* is a macabre and glorious document, dark and light, full of compelling contradictions, and with Dine's "dilemma of trying to stay human and alive under the present circumstances" at its center.

This book is about me being 85 years old and doing exactly what I want to do. Jim Dine

Born in 1935 in Cincinnati, Ohio, Jim Dine completed a Bachelor of Fine Arts at Ohio University in 1957 and has since become one of the most profound and prolific contemporary artists. Dine's unparalleled career spans 60 years, and his work is held in numerous private and public collections. His books with Steidl include Pinocchio (2006), Hot Dream (52 Books) (2008), A Printmaker's Document (2013), Paris Reconnaissance (2018), 3 Cats and a Dog (Self-portrait) (2019) and The Secret Drawings (2020).

Jim Dine
Electrolyte in Blue

Text by Jim Dine
Book design by Jim Dine, Ruth Lingen and
Paloma Tarrio Alves / Steidl Design
120 pages
9.4 × 12.6 in. / 24 × 32 cm
100 color images
Four-color process
Clothbound hardcover

€ 38.00 / £ 35.00 / US$ 45.00
ISBN 978-3-95829-752-4

ELETROLYTE IN BLUE
THIS IS WHAT, WHO/
WE NOW WERE
THE "BIG BOY" TOMATO,
THE BING CHERRY
A BLACKWIDOW SPIDER
AND THE CARROT
(ORANGE)
MY WHITE STALLION
BIBB LETTUCE AND

Born in 1957 in Bhadravati, India, Sheela Gowda is an artist who removes everyday materials with symbolic meaning from their surroundings and transforms them into installations that explore questions of society, politics, gender and labor conditions. Gowda has participated in the biennials of Lyon (2007), Venice (2009), Kochi (2012), Gwangju (2014) and São Paulo (2014), as well as documenta 12 (2007). In 2019 she received the Maria Lassnig Prize.

This book explores the eclectic practice of artist Sheela Gowda and her ongoing engagement with the paradoxes and predicaments of urban and rural life in modern India. With an emphasis on her sprawling installations, we see her use of distinctive materials from her native India, whose textures, colors and scents lend her work narrative form as well as metaphorical force. Through the imaginative employment of cow dung, kumkum powder, coconut fibers, hair, threads, stones, tar barrels and tarpaulins—which carry magical, cult and ritual, personal and functional connotations—Gowda blends traditions of craftsmanship and practical application with poetic intensity.

Gowda began her career as an oil painter, testing out themes and approaches that would shape her later practice: the everyday life of middle-class India, the conflicts women confront at work and at home, appropriating media images that touch on political and social tensions. In the early 1990s she first adopted cow dung as a medium (initially in paintings, later in three-dimensional pieces and installations), exploring its relevance to the Hindu cult of the cow and omnipresence in today's India, from practical uses (in construction, flooring, insulation), to its purifying, healing properties and sacred significance.

Art is about how you look at things. Sheela Gowda

Co-published with Lenbachhaus, Munich

Exhibition: Lenbachhaus, Munich, 31 March to 26 July 2020

● Sheela Gowda
It.. Matters

Bilingual edition (English / German)
Edited by Eva Huttenlauch and Matthias Mühling for the Städtische Galerie im Lenbachhaus und Kunstbau München
Texts by Eva Huttenlauch and Janaki Nair
Book design by Avinash Veeraraghavan and Holger Feroudj / Steidl Design
184 pages
8.5 × 10.4 in. / 21.5 × 26.5 cm
107 color photos and 40 illustrations
Four-color process
Hardcover

€ 35.00 / £ 30.00 / US$ 40.00
ISBN 978-3-95829-705-0

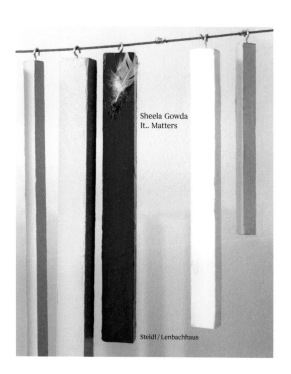

Sheela Gowda
It.. Matters

Steidl / Lenbachhaus

Born in Strasbourg, Tomi Ungerer (1931-2019), failed his final school exams yet subsequently hitchhiked throughout Europe and published his first drawings in the legendary Simplicissimus magazine. He began his extensive career as an illustrator, children's book author and artist in New York. In 2003 Ungerer was appointed the first Ambassador for Childhood and Education by the Council of Europe, and in 2007 the Tomi Ungerer Museum opened in Strasbourg, making him the first living artist with a museum dedicated to his life and work in France. In 2014 he received France's National Order of Merit, and in 2018 he was appointed Commandeur de la Legion d'Honneur by French president Emmanuel Macron.

This extravagant book presents 330 of Tomi Ungerer's illustrations, paintings and collages, many of them previously unpublished. When Ungerer moved from the Alsace to New York in the mid-1950s and began working as a graphic designer and illustrator, a crazy new world opened itself up to him, which the gifted artist transformed into what are perhaps the most remarkable and powerful works of his career—expressive and universal pictures that present the land of opportunity in an inimitable manner.

Tomi Ungerer's work is record-breaking.
Frankfurter Allgemeine Sonntagszeitung

Co-published with Diogenes, Zurich

● Tomi Ungerer
America

Edited by Philipp Keel
Foreword by Tomi Ungerer
Afterword by Philipp Keel
Book design by Kobi Benezri and Philipp Keel
416 pages
11 × 14.4 in. / 28 × 36.5 cm
330 color images
Four-color process
Clothbound hardcover

€ 85.00 / £ 80.00 / US$ 95.00
ISBN 978-3-95829-574-2

Liu Zheng
Dream Shock

Edited and introduction by Mark Holborn
Book design by Jesse Holborn
108 pages
11.5 × 12.1 in. / 29.2 × 30.8 cm
60 black-and-white photographs
Tritone
Clothbound hardcover with a tipped-in photograph

€ 48.00 / £ 44.00 / US$ 55.00
ISBN 978-3-95829-267-3

Hannah Collins
Noah Purifoy

Edited with Mark Holborn
Text by Hannah Collins
Book design by Hannah Collins (following
Walker Evans' book Message from the Interior)
44 pages
13.8 × 14.5 in. / 35 × 36.7 cm
18 black-and-white photographs
Quadratone
Clothbound hardcover

€ 75.00 / £ 68.00 / US$ 85.00
ISBN 978-3-95829-268-0

Ed Kashi
Abandoned Moments

Edited by Jennifer Larsen, Marjorie Steffe
and Mallika Vora
Foreword by Alison Nordstrom
Book design by Mallika Vora
128 pages
11 × 8.5 in. / 27.9 × 21.6 cm
26 black-and-white and 42 color photographs
Four-color process
Clothbound hardcover

€ 38.00 / £ 34.00 / US$ 45.00
ISBN 978-3-95829-274-1

Charles H. Traub
Skid Row

Texts by Tom Huhn and Charles H. Traub
Book design by Yoav Friedländer
112 pages
9.2 × 10.5 in. / 23.4 × 26.7 cm
51 black-and-white photographs
Tritone
Clothbound hardcover

€ 45.00 / £ 40.00 / US$ 50.00
ISBN 978-3-95829-625-1

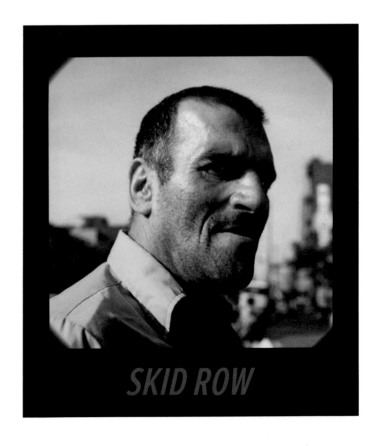

● Donovan Wylie and Chris Klatell
Lighthouse

Photographs by Donovan Wylie
Text by Chris Klatell
Book design by Donovan Wylie, Bernard Fischer
and Gerhard Steidl
80 pages
11.6 × 9.1 in. / 29.5 × 23 cm
21 black-and-white photographs
Four-color process
Clothbound hardcover with dust jacket

€ 38.00 / £ 35.00 / US$ 45.00
ISBN 978-3-95829-639-8

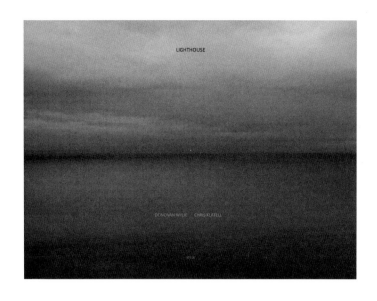

● Mark Neville
Ukraine – Stop Tanks with Books

Edited by David Campany
Book design by Steidl Design
192 pages
11.8 × 10.6 in. / 30 × 27 cm
20 black-and-white and 60 color photographs
Tritone and four-color process
Half-linen hardcover with a tipped-in photograph

€ 45.00 / £ 40.00 / US$ 50.00
ISBN 978-3-95829-618-3

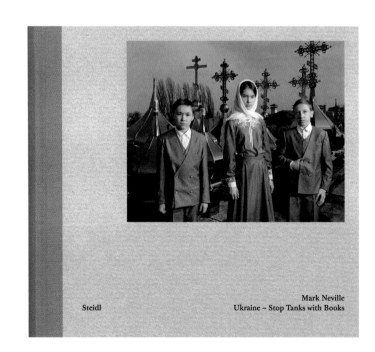

Evelyn Hofer
Dublin

Edited by Andreas Pauly and Sabine Schmid
Book design by Steidl Design
160 pages
8.7 × 11.2 in. / 22 × 28.5 cm
63 black-and-white and 14 color photographs
Tritone and four-color process
Clothbound hardcover with a tipped-in photograph

€ 45.00 / £ 40.00 / US$ 50.00
ISBN 978-3-95829-632-9

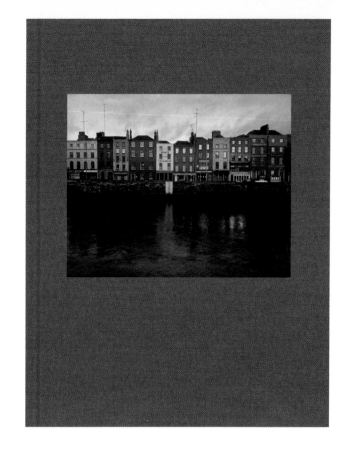

Hank O'Neal
You've Got to Do a Damn Sight Better than That, Buster
Working with Berenice Abbott 1972–1991

Text by Hank O'Neal
Photographs by Berenice Abbott, Hank O'Neal and others
Book design by Steidl Design
304 pages
11.6 × 12.2 in. / 29.5 × 31 cm
309 black-and-white and 86 color photographs and 65 illustrations
Four-color process
Clothbound hardcover with a tipped-in photograph

€ 45.00 / £ 40.00 / US$ 50.00
ISBN 978-3-95829-701-2

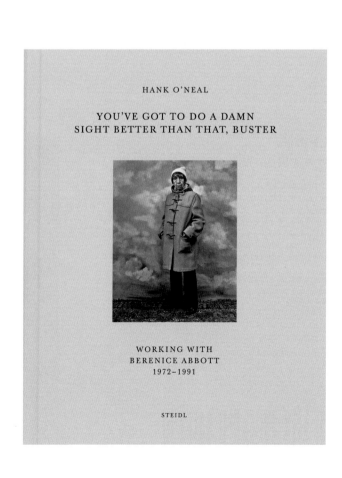

● Manfred Heiting (ed.)
Dr. Paul Wolff & Alfred Tritschler
Publications 1906–2019

Bilingual edition (English / German)
Edited and book design by Manfred Heiting
Introduction by Manfred Heiting
Text by Kristina Lemke
Essays by Rainer Stamm and Ed Schwartzreich
520 pages
10.7 × 11.5 in. / 27.1 × 29.3 cm
2,300 color illustrations
Four-color process
Hardcover

€ 95.00 / £ 85.00 / US$ 125.00
ISBN 978-3-95829-614-5

● Roni Horn
Remembered Words

Book design by Roni Horn
296 pages
10.2 × 14 in. / 26 × 35.5 cm
296 color images
Four-color process
Clothbound hardcover

€ 85.00 / £ 75.00 / US$ 95.00
ISBN 978-3-86930-996-5

● **Anders Petersen**
Zoo

Edited and book design by Greger Ulf Nilson
320 pages
8.3 × 11 in. / 21 × 28 cm
240 black-and-white photographs
Tritone
Half-linen hardcover

€ 45.00 / £ 40.00 / US$ 50.00
ISBN 978-3-95829-333-5

● **Anders Petersen**
City Diary #4

Edited and book design by Greger Ulf Nilson
64 pages
9.2 × 12.2 in. / 23.4 × 31 cm
56 black-and-white photographs
Tritone
Half-linen softcover in an envelope

€ 45.00 / £ 40.00 / US$ 50.00
ISBN 978-3-95829-334-2

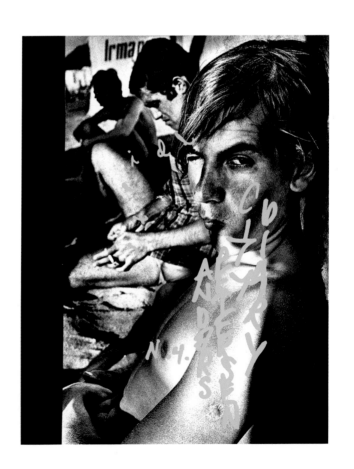

Hello, Spring!

To help you through the cold winter months, here's a little preview of our Spring-Summer 2021 program

Shelby Lee Adams
The Book of Life

Anna Atkins
Photographs of British Algæ

Jeff Brouws
Silent Monoliths.
The Coaling Tower Project

Langdon Clay
42nd Street, 1979

Ernest Cole
House of Bondage

Mauro D'Agati
Palermo Panorama

Adolphe de Meyer
Le Prélude à l'après-midi d'un faune

Paul Drake and Helen File
The Last Watchtowers of
the Inner German Border

David Freund
Playground Once

Sheva Fruitman
Half-Frame Diary. End of the Century

Frank Gohlke
Measure of Emptiness

Angela Grauerholz
The Hundred Headless Woman

Ernst Haas
Abstrakt

Volker Heinze
+ - 0

Gleb Kosorukov
Samasthiti

Sze Tsung Nicolás Leong
Paris, Novembre

Ken Light
What's Going On?

Guido Mocafico
Leopold & Rudolf Blaschka.
The Marine Invertebrates

Christoph Niemann
Souvenir

Sebastian Posingis
Salt River

Luke Powell
Asia Highway

Gunnar Smoliansky
Hands

Gunnar Smoliansky
Promenade Pictures

Christer Strömholm
Lido

Andy Summers
The Bones of Chuang Tzu

Marq Sutherland
Pilgrim

Henry Wessel
Walkabout / Man Alone /
Botanical Census

Kai Wiedenhöfer
WALL and PEACE

Backlist

Abbott, Berenice
The Unknown Berenice Abbott

€ 285.00 / £ 240.00 / US$ 350.00
ISBN 978-3-86930-650-6

Adams, Bryan
Untitled

€ 125.00 / £ 95.00 / US$ 125.00
ISBN 978-3-86930-988-0

Abbott, Berenice
Paris Portraits 1925-1930

€ 75.00 / £ 70.00 / US$ 85.00
ISBN 978-3-86930-314-7

Adams, Bryan
Exposed

€ 68.00 / £ 60.00 / US$ 75.00
ISBN 978-3-86930-500-4

A-chan
Off Beat

€ 20.00 / £ 16.00 / US$ 25.00
ISBN 978-3-86930-416-8

Adams, Bryan
Homeless

€ 38.00 / £ 35.00 / US$ 45.00
ISBN 978-3-95829-387-8

A-chan
Vibrant Home

€ 20.00 / £ 16.00 / US$ 25.00
ISBN 978-3-86930-415-1

Adams, Robert
Gone?

€ 48.00 / £ 45.00 / US$ 55.00
ISBN 978-3-86521-917-6

A-chan
Salt'n Vinegar

€ 40.00 / £ 35.00 / US$ 50.00
ISBN 978-3-86930-784-8

Adams, Robert
Tree Line

€ 35.00 / £ 30.00 / US$ 40.00
ISBN 978-3-86521-956-5

Adams, Bryan
Wounded. The Legacy of War

€ 58.00 / £ 48.00 / US$ 65.00
ISBN 978-3-86930-677-3

Adams, Robert
Cottonwoods

€ 45.00 / £ 38.00 / US$ 50.00
ISBN 978-3-95829-096-9

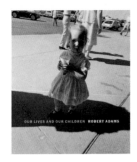

Adams, Robert
Our Lives and Our Children

€ 48.00 / £ 40.00 / US$ 55.00
ISBN 978-3-95829-097-6

Adams, Robert
Perfect Places, Perfect Company

€ 80.00 / £ 68.00 / US$ 85.00
ISBN 978-3-95829-169-0

Adams, Robert
From the Missouri West

€ 95.00 / £ 85.00 / US$ 125.00
ISBN 978-3-95829-168-3

Alam, Shahidul
The Tide Will Turn

€ 28.00 / £ 25.00 / US$ 30.00
ISBN 978-3-95829-693-0

Araki, Nobuyoshi
Impossible Love

€ 58.00 / £ 58.00 / US$ 65.00
ISBN 978-3-95829-553-7

Bailey, David
Bailey's East End

€ 98.00 / £ 90.00 / US$ 125.00
ISBN 978-3-86930-534-9

Bailey, David
Bailey's Democracy

€ 45.00 / £ 40.00 / US$ 50.00
ISBN 978-3-86521-192-7

Bailey, David
Havana

€ 45.00 / £ 40.00 / US$ 50.00
ISBN 978-3-86521-270-2

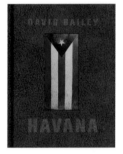

Bailey, David
Is That So Kid

€ 45.00 / £ 40.00 / US$ 50.00
ISBN 978-3-86521-632-8

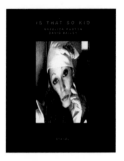

Bailey, David
NY JS DB 62

€ 45.00 / £ 40.00 / US$ 50.00
ISBN 978-3-86521-414-0

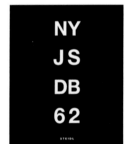

Bailey, David
Pictures that Mark can do

€ 45.00 / £ 40.00 / US$ 50.00
ISBN 978-3-86521-367-9

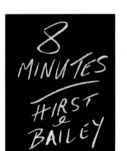

Bailey, David
8 Minutes

€ 45.00 / £ 40.00 / US$ 50.00
ISBN 978-3-86521-864-3

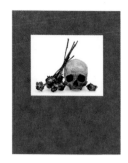

Bailey, David
Flowers, Skulls, Contacts

€ 45.00 / £ 40.00 / US$ 50.00
ISBN 978-3-86930-128-0

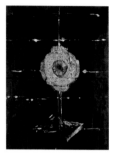

Bailey, David
Eye

€ 45.00 / £ 40.00 / US$ 50.00
ISBN 978-3-86521-708-0

Bailey, David
Delhi Dilemma

€ 98.00 / £ 90.00 / US$ 125.00
ISBN 978-3-86521-991-6

Bailey, David
Tears and Tears

€ 45.00 / £ 40.00 / US$ 50.00
ISBN 978-3-86930-989-7

Bailey, David
Bailey´s Naga Hills

€ 45.00 / £ 40.00 / US$ 50.00
ISBN 978-3-95829-170-6

Balthus
The Last Studies

€ 480.00 / £ 440.00 / US$ 550.00
ISBN 978-3-86930-685-8

Baltz, Lewis
Works – Last Edition

€ 950.00
ISBN 978-3-95829-132-4

Baltz, Lewis
Rule Without Exception /
Only Exceptions

€ 65.00 / £ 50.00 / US$ 80.00
ISBN 978-3-86930-110-5

Baltz, Lewis
Common Objects

€ 40.00 / £ 30.00 / US$ 50.00
ISBN 978-3-86930-785-5

Baltz, Lewis
Texts

€ 24.00 / £ 20.00 / US$ 30.00
ISBN 978-3-86930-436-6

Baltz, Lewis
Candlestick Point

€ 75.00 / £ 70.00 / US$ 85.00
ISBN 978-3-86930-109-9

Baltz, Lewis
Venezia Marghera

€ 8,900.00 / £ 7,900.00 /
US$ 10,000.00
ISBN 978-3-86930-313-0

Lewis Baltz

€ 70.00 / £ 60.00 / US$ 80.00
ISBN 978-3-95829-279-6

Banier, François-Marie
Imprudences

€ 38.00 / £ 32.00 / US$ 45.00
ISBN 978-3-86930-919-4

Banier, François-Marie
Never Stop Dancing

€ 10.00 / £ 8.00 / US$ 12.00
ISBN 978-3-86930-577-6

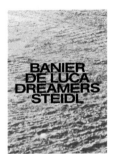

Banier, François-Marie
Battlefields

€ 28.00 / £ 25.00 / US$ 35.00
ISBN 978-3-95829-678-7

Banier, François-Marie
Dreamers

€ 30.00 / £ 25.00 / US$ 35.00
ISBN 978-3-95829-507-0

Baumann / Chuang / Onabanjo (eds.)
Recent Histories

€ 65.00 / £ 60.00 / US$ 75.00
ISBN 978-3-95829-350-2

Berndt, Jerry
Beautiful America

€ 38.00 / £ 30.00 / US$ 45.00
ISBN 978-3-86930-898-2

Beuys, Joseph / Staeck, Klaus
Honey is flowing in all directions

€ 35.00 / £ 30.00 / US$ 40.00
ISBN 978-3-88243-538-2

Blumenfeld, Erwin
Blumenfeld Studio

€ 34.00 / £ 28.00 / US$ 40.00
ISBN 978-3-86930-531-8

Bolofo, Koto
Große Komplikation /
Grand Complication

€ 98.00 / £ 89.00 / US$ 100.00
ISBN 978-3-86930-055-9

Bolofo, Koto
Lord Snowdon

€ 75.00 / £ 68.00 / US$ 85.00
ISBN 978-3-86930-329-1

Bolofo, Koto
Venus Williams

€ 45.00 / £ 35.00 / US$ 55.00
ISBN 978-3-86521-602-1

Bolofo, Koto
Vroom! Vroom!

€ 45.00 / £ 35.00 / US$ 55.00
ISBN 978-3-86521-961-9

Bolofo, Koto
I Spy with My Little Eye,
Something Beginning with S

€ 48.00 / £ 40.00 / US$ 55.00
ISBN 978-3-86930-035-1

Bonami, Francesco / Teller, Juergen
50 Times Bonami and Obrist by Teller

€ 25.00 / £ 24.00 / US$ 30.00
ISBN 978-3-86930-643-5

Bourdin, Guy
A Message for You

€ 55.00 / £ 50.00 / US$ 65.00
ISBN 978-3-86930-551-6

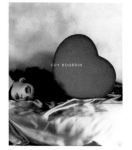

Bourdin, Guy
Untouched

€ 55.00 / £ 50.00 / US$ 65.00
ISBN 978-3-86930-934-7

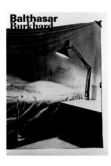

Burkhard, Balthasar
Balthasar Burkhard

€ 48.00 / £ 40.00 / US$ 50.00
978-3-95829-342-7

Burri, René
Mouvement

€ 85.00 / £ 75.00 / US$ 95.00
ISBN 978-3-86930-820-3

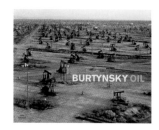

Burtynsky, Edward
Oil

€ 98.00 / £ 85.00 / US$ 125.00
ISBN 978-3-86521-943-5

Burtynsky, Edward
Salt Pans
Little Rann of Kutch, Gujarat,
India

€ 65.00 / £ 60.00 / US$ 75.00
ISBN 978-3-95829-240-6

Burtynsky, Edward
Anthropocene

€ 95.00 / £ 90.00 / US$ 125.00
ISBN 978-3-95829-489-9

Callahan, Harry
Seven Collages

€ 28.00 / £ 22.00 / US$ 40.00
ISBN 978-3-86930-140-2

Campany, David (ed.)
Walker Evans: the magazine work

€ 58.00 / £ 50.00 / US$ 65.00
ISBN 978-3-86930-259-1

Cartier-Bresson, Henri
The Decisive Moment

€ 98.00 / £ 78.00 / US$ 125.00
ISBN 978-3-86930-788-6

Cohen, John
The High & Lonesome Sound

€ 45.00 / £ 35.00 / US$ 50.00
ISBN 978-3-86930-254-6

Chan, Theseus (ed.)
Steidl-Werk No. 23:
Masaho Anotani, Deformed

€ 48.00 / £ 40.00 / US$ 55.00
ISBN 978-3-95829-120-1

Cohen, John
Cheap rents ... and de Kooning

€ 24.00 / £ 20.00 / US$ 25.00
ISBN 978-3-86930-903-3

Clay, Maude Schuyler
Mississippi History

€ 65.00 / £ 58.00 / US$ 75.00
ISBN 978-3-86930-974-3

Cohen, John
Walking in the Light

€ 38.00 / £ 30.00 / US$ 45.00
ISBN 978-3-86930-772-5

Clay, Langdon
Cars – New York City, 1974–1976

€ 95.00 / £ 90.00 / US$ 125.00
ISBN 978-3-95829-171-3

Cole, Teju / Sheikh, Fazal
Human Archipelago

€ 40.00 / £ 35.00 / US$ 45.00
ISBN 978-3-95829-568-1

Close, Chuck
Scribble Book: Self-Portrait

€ 125.00 / £ 100.00 / US$ 145.00
ISBN 978-3-86521-492-8

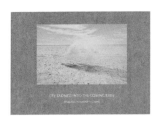

Courtney-Clarke, Margaret
Cry Sadness into the Coming Rain

€ 75.00 / £ 70.00 / US$ 80.00
ISBN 978-3-95829-253-6

Cohen, John
Here and Gone

€ 38.00 / £ 32.00 / US$ 48.00
ISBN 978-3-86930-604-9

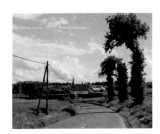

Cuisset, Thibaut
French Landscapes

€ 48.00 / £ 40.00 / US$ 55.00
ISBN 978-3-95829-278-9

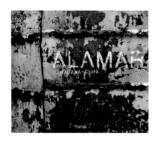

D'Agati, Mauro
Alamar

€ 45.00 / £ 35.00 / US$ 50.00
ISBN 978-3-86521-954-1

d'Urso, Alessandra /
Borghese, Alessandra
For Friends

€ 95.00 / £ 80.00 / US$ 95.00
ISBN 978-3-95829-133-1

D'Agati, Mauro
Sit Lux et Lux Fuit

€ 48.00 / £ 38.00 / US$ 50.00
ISBN ISBN 978-3-86930-488-5

d'Urso, Alessandra /
Borghese, Alessandra
Jubileum

€ 28.00 / £ 25.00 / US$ 30.00
ISBN 978-3-95829-258-1

D'Agati, Mauro
Palermo Unsung

€ 45.00 / £ 39.50 / US$ 50.00
ISBN 978-3-86521-918-3

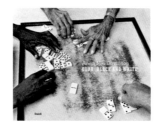

Davidson, Anna Mia
Cuba Black and White

€ 48.00 / £ 40.00 / US$ 60.00
ISBN 978-3-95829-028-0

D'Agati, Mauro
Marzia's Family

€ 40.00 / £ 34.00 / US$ 45.00
ISBN 978-3-86930-605-6

Davidson, Bruce
In Color

€ 78.00 / £ 68.00 / US$ 85.00
ISBN 978-3-86930-564-6

Danuser, Hans
Darkrooms of Photography

€ 48.00 / £ 45.00 / US$ 55.00
ISBN 978-3-95829-337-3

Davidson, Bruce
Black & White

€ 300.00 / £ 280.00 / US$ 350.00
ISBN 978-3-86930-432-8

Das, Kapil
Something So Clear

€ 35.00 / £ 30.00 / US$ 40.00
ISBN 978-3-95829-318-2

Davidson, Bruce
England / Scotland 1960

€ 45.00 / £ 40.00 / US$ 50.00
ISBN 978-3-86930-486-1

Davidson, Bruce
Outside Inside

€ 240.00 / £ 200.00 / US$ 250.00
ISBN 978-3-86521-908-4

Dine, Jim
Entrada Drive

€ 50.00 / £ 45.00 / US$ 55.00
ISBN 978-3-86521-080-7

Davidson, Bruce
Nature of Los Angeles
2008-2013

€ 38.00 / £ 30.00 / US$ 45.00
ISBN 978-3-86930-814-2

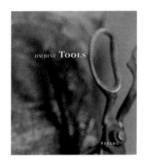

Dine, Jim
Tools

€ 50.00 / £ 45.00 / US$ 55.00
ISBN 978-3-86930-647-6

De Pietri, Paola
Istanbul New Stories

€ 75.00 / £ 70.00 / US$ 85.00
ISBN 978-3-95829-110-2

Dine, Jim
The Photographs, So Far

€ 150.00 / £ 125.00 / US$ 180.00
ISBN 978-3-88243-905-2

Diépois, Aline / Gizolme, Thomas
Abstrakt Zermatt

€ 40.00 / £ 35.00 / US$ 45.00
ISBN 978-3-86930-580-6

Dine, Jim
This Goofy Life of Constant
Mourning

€ 48.00 / £ 40.00 / US$ 55.00
ISBN 978-3-88243-967-0

Dine, Jim
My Tools

€ 28.00 / £ 20.00 / US$ 35.00
ISBN 978-3-86930-828-9

Dine, Jim
This Is How I Remember Now

€ 48.00 / £ 33.00 / US$ 50.00
ISBN 978-3-86521-603-8

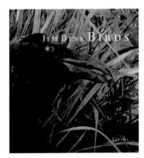

Dine, Jim
Birds

€ 50.00 / £ 45.00 / US$ 55.00
ISBN 978-3-88243-240-4

Dine, Jim
Hello Yellow Glove

€ 28.00 / £ 20.00 / US$ 35.00
ISBN 978-3-86930-484-7

Dine, Jim
A Printmaker's Document

€ 30.00 / £ 25.00 / US$ 40.00
ISBN 978-3-86930-644-5

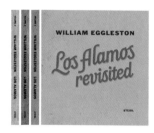

Eggleston, William
Los Alamos revisited

€ 950.00 / £ 900.00 / US$ 1200.00
ISBN 978-3-86930-532-5

Dine, Jim
Jewish Fate

€ 18.00 / £ 15.00 / US$ 20.00
ISBN 978-3-95829-322-9

Eggleston, William
At Zenith

€ 48.00 / £ 55.00 / US$ 65.00
ISBN 978-3-86930-710-7

Dine, Jim
My Letter to the Troops

€ 18.00 / £ 15.00 / US$ 20.00
ISBN 978-3-95829-339-7

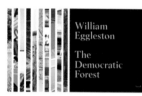

Eggleston, William
The Democratic Forest

€ 650.00 / £ 580.00 / US$ 680.00
ISBN 978-3-86930-792-3

Dine, Jim
Hot Dream (52 Books)

€ 150.00 / £ 140.00 / US$ 180.00
ISBN 978-3-95829-132-7

Eggleston, William
Election Eve

€ 85.00 / £ 80.00 / US$ 98.00
ISBN 978-3-95829-266-6

Dupont, Stephen
Generation AK

€ 78.00 / £ 70.00 / US$ 85.00
ISBN 978-3-86930-727-5

Eggleston, William
Flowers

€ 75.00 / £ 70.00 / US$ 80.00
ISBN 978-3-95829-389-2

Edgerton, Harold
Seeing the Unseen

€ 48.00 / £ 44.00 / US$ 50.00
ISBN 978-3-95829-308-3

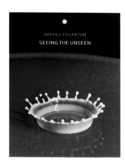

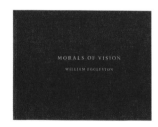

Eggleston, William
Morals of Vision

€ 75.00 / £ 70.00 / US$ 80.00
ISBN 978-3-95829-390-8

Eggleston, William
Polaroid SX-70

€ 75.00 / £ 70.00 / US$ 80.00
ISBN 978-3-95829-503-2

Epstein, Mitch
Rocks and Clouds

€ 65.00 / £ 58.00 / US$ 75.00
ISBN 978-3-95829-160-7

Elgort, Arthur
The Big Picture

€ 78.00 / £ 68.00 / US$ 85.00
ISBN 978-3-86930-543-1

Epstein, Mitch
Sunshine Hotel

€ 68.00 / £ 65.00 / US$ 75.00
ISBN 978-3-95829-609-1

Englander, Caryl
Through the Lens of Faith

€ 20.00 / £ 18.00 / US$ 20.00
ISBN 978-3-95829-654-1

Eskildsen, Joakim
American Realities

€ 32.00 / £ 28.00 / US$ 40.00
ISBN 978-3-86930-734-3

Ehrlich, Richard
Face the Music

€ 50.00 / £ 45.00 / US$ 55.00
ISBN 978-3-86930-966-8

Faurer, Louis
Louis Faurer

€ 34.00 / £ 29,80 / US$ 40.00
ISBN 978-3-95829-247-5

Epstein, Mitch
Berlin

€ 45.00 / £ 40.00 / US$ 55.00
ISBN 978-3-86930-224-9

Fernandes, Walter / Hurst, Miguel
Angola Cinemas

€ 45.00 / £ 40.00 / US$ 55.00
ISBN 978-3-86930-794-7

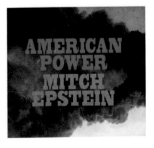

Epstein, Mitch
American Power

€ 65.00 / £ 60.00 / US$ 75.00
ISBN 978-3-86521-924-4

Ferrez, Marc / Polidori, Robert
Rio

€ 125.00 / £ 110.00 / US$ 150.00
ISBN 978-3-86930-910-1

Fougeron, Martine
Nicolas & Adrien

€ 40.00 / £ 35.00 / US$ 45.00
ISBN 978-3-95829-685-5

Frank, Robert
The Americans

€ 35.00 / £ 30.00 / US$ 40.00
ISBN 978-3-86521-584-0

Frank, Robert
Come Again

€ 35.00 / £ 30.00 / US$ 40.00
ISBN 978-3-86521-261-0

Frank, Robert
Frank Films

€ 45.00 / £ 40.00 / US$ 50.00
ISBN 978-3-86521-815-5

Frank, Henry
Father Photographer

€ 24.00 / £ 20.00 / US$ 25.00
ISBN 978-3-86521-814-8

ROBERT FRANK
FILM WORKS

STEIDL

Frank, Robert
Film Works

€ 150.00 / £ 120.00 / US$ 175.00
ISBN 978-3-95829-036-5

Frank, Robert
HOLD STILL – keep going

€ 40.00 / £ 35.00 / US$ 45.00
ISBN 978-3-86930-904-0

Frank, Robert
Household Inventory Record

€ 30.00 / £ 25.00 / US$ 35.00
ISBN 978-3-86930-660-5

Frank, Robert
Me and My Brother

€ 38.00 / £ 34.00 / US$ 45.00
ISBN 978-3-86521-363-1

Frank, Robert
New York to Nova Scotia

€ 35.00 / £ 30.00 / US$ 40.00
ISBN 978-3-86521-013-5

ONE
HOUR

Frank, Robert
One Hour

€ 10.00 / £ 8.00 / US$ 12.00
ISBN 978-3-86521-364-8

Frank, Robert
Pangnirtung

€ 35.00 / £ 30.00 / US$ 40.00
ISBN 978-3-86930-198-3

Frank, Robert
Paris

€ 35.00 / £ 30.00 / US$ 40.00
ISBN 978-3-86521-524-6

Frank, Robert
Valencia

€ 35.00 / £ 30.00 / US$ 40.00
ISBN 978-3-86930-502-8

Frank, Robert
Park/Sleep

€ 27.00 / £ 24.00 / US$ 30.00
ISBN 978-3-86930-585-1

Frank, Robert
Was haben wir gesehen /
What we have seen

€ 27.00 / £ 24.00 / US$ 30.00
ISBN 978-3-95829-095-2

Frank, Robert
Partida

€ 27.00 / £ 24.00 / US$ 30.00
ISBN 978-3-86930-795-4

Frank, Robert
You Would

€ 27.00 / £ 24.00 / US$ 30.00
ISBN 978-3-86930-418-2

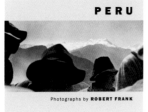

Frank, Robert
Peru

€ 30.00 / £ 25.00 / US$ 35.00
ISBN 978-3-86521-692-2

Frank, Robert
Zero Mostel Reads a Book

€ 15.00 / £ 10.00 / US$ 18.00
ISBN 978-3-86521-586-4

Frank, Robert
Pull My Daisy

€ 10.00 / £ 8.00 / US$ 12.00
ISBN 978-3-86521-673-1

Frank, Robert
Leon of Juda

€ 27.00 / £ 24.00 / US$ 30.00
ISBN 978-3-95829-311-3

Frank, Robert
Tal Uf Tal Ab

€ 27.00 / £ 24.00 / US$ 30.00
ISBN 978-3-86930-101-3

Frank, Robert
The Lines of My Hand

€ 30.00 / £ 28.00 / US$ 35.00
ISBN 978-3-95829-320-5

Frank, Robert
London/Wales

€ 38.00 / £ 34.00 / US$ 45.00
ISBN 978-3-86521-362-4

Goldblatt, David
Particulars

€ 58.00 / £ 42.00 / US$ 70.00
ISBN 978-3-86930-777-0

Frank, Robert
Good days quiet

€ 35.00 / £ 30.00 / US$ 40.00
ISBN 978-3-95829-550-6

Goldblatt, David
The Transported of Kwandebele

€ 65.00 / £ 48.00 / US$ 80.00
ISBN 978-3-86930-586-8

Freund, David
Gas Stop

€ 98.00 / £ 89.00 / US$ 125.00
ISBN 978-3-95829-173-7

Goldblatt, David
Structures of Dominion
and Democracy

€ 48.00 / £ 45.00 / US$ 65.00
ISBN 978-3-95829-391-5

Friedlander, Lee
Chain Link

€ 38.00 / £ 34.00 / US$ 40.00
ISBN 978-3-95829-259-8

Goldblatt, David
The Last Interview

€ 28.00 / £ 35.00 / US$ 35.00
ISBN 978-3-95829-559-9

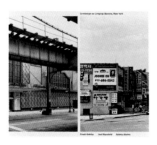

Gohlke, Frank / Sternfeld, Joel
Landscape as Longing: Queens,
New York

€ 75.00 / £ 70.00 / US$ 85.00
ISBN 978-3-95829-032-7

Goldblatt, David
Some Afrikaners Photographed

€ 58.00 / £ 55.00 / US$ 65.00
ISBN 978-3-95829-551-3

Goldblatt, David
On the Mines

€ 58.00 / £ 48.00 / US$ 65.00
ISBN 978-3-86930-491-5

Felix Gonzalez-Torres

€ 58.00 / £ 48.00 / US$ 65.00
ISBN 978-3-86930-921-7

Gossage, John
The Thirty-Two Inch Ruler /
Map of Babylon

€ 58.00 / £ 52.00 / US$ 60.00
ISBN 978-3-86521-710-3

Grass, Günter
Catalogue Raisonné 1
The Etchings

€ 98.00 / £ 90.00 / US$ 125.00
ISBN 978-3-86521-565-9

Gossage, John
Looking up Ben James - A Fable

€ 65.00 / £ 60.00 / US$ 75.00
ISBN 978-3-86930-589-9

Grass, Günter
Catalogue Raisonné 2
The Lithographs

€ 98.00 / £ 90.00 / US$ 125.00
ISBN 978-3-86521-566-6

Gossage, John
Should Nature Change

€ 45.00 / £ 45.00 / US$ 50.00
ISBN 978-3-95829-546-9

Angela Grauerholz

€ 58.00 / £ 48.00 / US$ 65.00
ISBN 978-3-95829-122-5

Gossage, John
Jack Wilson's Waltz

€ 45.00 / £ 45.00 / US$ 50.00
ISBN 978-3-95829-547-6

Grossman, Sid
The Life and Work of Sid Grossman

€ 48.00 / £ 45.00 / US$ 55.00
ISBN 978-3-95829-125-6

Gossage, John
The Nicknames of Citizens

€ 45.00 / £ 45.00 / US$ 50.00
ISBN 978-3-95829-548-3

Gudzowaty, Tomasz
Beyond the Body

€ 38.00 / £ 32.00 / US$ 45.00
ISBN 978-3-95829-040-2

Grätz, Roland / Neubauer,
Hans-Joachim (eds.)
Human Rights Watch
Ed Kashi

€ 30.00 / £ 24.00 / US$ 35.00
ISBN 978-3-95829-167-6

Gudzowaty, Tomasz
Photography as a New Kind of
Love Poem

€ 78.00 / £ 65.00 / US$ 85.00
ISBN 978-3-95829-041-9

Gudzowaty, Tomasz
Closer

€ 88.00 / £ 78.00 / US$ 95.00
ISBN 978-3-95829-044-0

Gudzowaty, Tomasz
Proof

€ 30.00 / £ 25.00 / US$ 35.00
ISBN 978-3-95829-164-5

Gundlach, F.C.
The Photographic Work

€ 75.00 / £ 70.00 / US$ 85.00
ISBN 978-3-86521-594-9

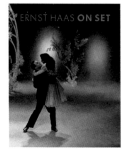

Haas, Ernst
On Set

€ 58.00 / £ 48.00 / US$ 70.00
ISBN 978-3-86930-587-5

Hanzlova, Jitka
Cotton Rose

€ 35.00 / £ 30.00 / US$ 40.00
ISBN 978-3-86930-127-3

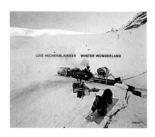

Hechenblaikner, Lois
Winter Wonderland

€ 38.00 / £ 30.00 / US$ 40.00
ISBN 978-3-86930-284-3

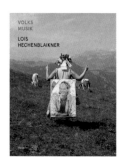

Hechenblaikner, Lois
Volksmusik

€ 38.00 / £ 35.00 / US$ 40.00
ISBN 978-3-95829-175-1

Heiting, Manfred (ed.)
Czech and Slovak Photo
Publications, 1918–1989

€ 125.00 / £ 98.00 / US$ 145.00
ISBN 978-3-95829-497-4

Hine, Lewis
When Innovation Was King

€ 40.00 / £ 38.00 / US$ 45.00
ISBN 978-3-95829-189-8

Hofer, Evelyn
Begegnungen/Encounters

€ 58.00 / £ 55.00 / US$ 65.00
ISBN 978-3-95829-563-6

Hoppé, E.O.
The German Work

€ 58.00 / £ 48.00 / US$ 65.00
ISBN 978-3-86930-937-8

Horn, Roni
Another Water

€ 38.00 / £ 35.00 / US$ 45.00
ISBN 978-3-86930-318-5

Horn, Roni
Haraldsdóttir, Part Two

€ 85.00 / £ 70.00 / US$ 95.00
ISBN 978-3-86930-317-8

Horn, Roni
Roni Horn aka Roni Horn

€ 50.00 / £ 45.00 / US$ 60.00
ISBN 978-3-86521-831-5

Horn, Roni
Cabinet of

€ 65.00 / £ 55.00 / US$ 75.00
ISBN 978-3-88243-864-2

Horn, Roni
Herdubreid at Home

€ 20.00 / £ 13.00 / US$ 20.00
ISBN 978-3-86521-457-7

Horn, Roni
Her, Her, Her, & Her

€ 35.00 / £ 24.00 / US$ 40.00
ISBN 978-3-86521-035-7

Horn, Roni
AKA

€ 38.00 / £ 35.00 / US$ 45.00
ISBN 978-3-86930-133-4

Horn, Roni
Index Cixous

€ 22.50 / £ 15.00 / US$ 20.00
ISBN 978-3-86521-135-4

Horn, Roni
Hack Wit

€ 38.00 / £ 35.00 / US$ 45.00
ISBN 97-3-86930-982-8

Horn, Roni
This is Me, This is You

€ 28.00 / £ 25.00 / US$ 30.00
ISBN 978-3-88243-798-0

Horn, Roni
The Selected Gifts, 1974-2015

€ 38.00 / £ 35.00 / US$ 45.00
ISBN 978-3-95829-162-1

Horn, Roni
bird

€ 38.00 / £ 35.00 / US$ 45.00
ISBN 978-3-86521-669-4

Horn, Roni
Th Rose Prblm

€ 38.00 / £ 35.00 / US$ 45.00
ISBN 978-3-95829-271-0

Horn, Roni
Dogs' Chorus

€ 50.00 / £ 45.00 / US$ 60.00
ISBN 978-3-95829-536-0

Horn, Roni
Remembered Words
A Specimen Concordance

€ 18.00 / £ 15.00 / US$ 25.00
ISBN 978-3-95829-564-3

Huyck, Willard / Katz, Gloria
Views of Japan

€ 80.00 / £ 75.00 / US$ 85.00
ISBN 978-3-95829-177-5

James Karales

€ 58.00 / £ 45.00 / US$ 64.00
ISBN 978-3-86930-444-1

Izu, Kenro
Eternal Light

€ 40.00 / £ 38.00 / US$ 45.00
ISBN 978-3-95829-190-4

Jedlicka, Jan
200 m

€ 48.00 / £ 45.00 / US$ 55.00
ISBN 978-3-95829-101-0

Kander, Nadav
The Meeting

€ 85.00 / £ 80.00 / US$ 95.00
ISBN 978-3-95829-615-2

Karasik, Mikhail
The Soviet Photobook

€ 125.00 / £ 98.00 / US$ 150.00
ISBN 978-3-95829-031-0

Karel, Betsy
America's Stage: Times Square

€ 40.00 / £ 35.00 / US$ 45.00
ISBN 978-3-95829-227-7

Keel, Philipp
Splash

€ 48.00 / £ 38.00 / US$ 65.00
ISBN 978-3-86930-799-2

Kia Henda, Kiluanji
Travelling to the Sun through the Night

€ 40.00 / £ 35.00 / US$ 45.00
ISBN 978-3-86930-800-5

Killip, Chris
In Flagrante Two

€ 65.00 / £ 58.00 / US$ 75.00
ISBN 978-3-86930-960-6

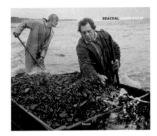

Killip, Chris
Seacoal

€ 48.00 / £ 38.00 / US$ 60.00
ISBN 978-3-86930-256-0

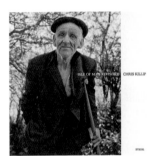

Killip, Chris
Pirelli Work

€ 45.00 / £ 38.00 / US$ 50.00
ISBN 978-3-86930-961-3

Killip, Chris
Isle of Man Revisited

€ 48.00 / £ 40.00 / US$ 60.00
ISBN 978-3-86930-959-0

Killip, Chris
The Station

€ 75.00 / £ 70.00 / US$ 85.00
ISBN 978-3-95829-616-9

Kosorukov, Gleb
Heroes of Labour

€ 58.00 / £ 54.00 / US$ 65.00
ISBN 978-3-86930-689-6

Kuhn, Mona
Bordeaux Series

€ 58.00 / £ 50.00 / US$ 65.00
ISBN 978-3-86930-308-6

Kuhn, Mona
Photographs

€ 40.00 / £ 35.00 / US$ 45.00
ISBN 978-3-86521-008-1

Kuhn, Mona
She Disappeared into
Complete Silence

€ 45,00 / £ 40.00 / US$ 50.00
ISBN 978-3-95829-180-5

Lagerfeld, Karl
Byzantine Fragments

€ 125.00 / £ 100.00 / US$ 140.00
ISBN 978-3-86930-246-1

Lagerfeld, Karl
Metamorphoses of an American

€ 98.00 / £ 80.00 / US$ 110.00
ISBN 978-3-86521-522-2

Lagerfeld, Karl
The Glory of Water

€ 200.00 / £ 170.00 / US$ 220.00
ISBN 978-3-86930-708-4

Lagerfeld, Karl
Villa Noailles
Hyères - Été 1995

€ 48.00 / £ 40.00 / US$ 60.00
ISBN 978-3-95829-037-2

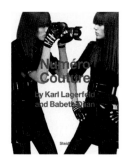

Lagerfeld, Karl / Djian, Babeth
Numéro Couture by Karl Lagerfeld

€ 85.00 / £ 75.00 / US$ 95.00
ISBN 978-3-95829-057-0

Leaf, June
Thought is Infinite

€ 35.00 / £ 28.00 / US$ 40.00
ISBN 978-3-95829-102-7

Lagerfeld, Karl
Paris Photo

€ 40.00 / £ 35.00 / US$ 45.00
ISBN 978-3-95829-354-0

Lebeck, Robert
1968

€ 45.00 / £ 40.00 / US$ 50.00
ISBN 978-3-95829-419-6

Lagerfeld, Karl
Choupette

€ 24.00 / £ 20.00 / US$ 30.00
ISBN 978-3-86930-897-5

Lechner, Alf
Sculpture Park

€ 48.00 / £ 40.00 / US$ 50.00
ISBN 978-3-95829-710-4

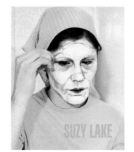

Lake, Suzy

€ 58.00 / £ 48.00 / US$ 65.00
ISBN 978-3-95829-282-6

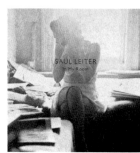

Leiter, Saul
In My Room

€ 38.00 / £ 32.00 / US$ 45.00
ISBN 978-3-95829-103-4

Laval, Karine
Poolscapes

€ 38.00 / £ 35.00 / US$ 45.00
ISBN 978-3-95829-261-1

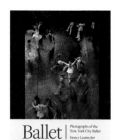

Leutwyler, Henry
Ballet

€ 65.00 / £ 55.00 / US$ 75.00
ISBN 978-3-86930-906-4

Leaf, June
Record 1974/75

€ 40.00 / £ 35.00 / US$ 45.00
ISBN 978-3-86930-045-0

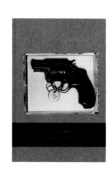

Leutwyler, Henry
Document

€ 65.00 / £ 58.00 / US$ 75.00
ISBN 978-3-86930-969-9

Leutwyler, Henry
Hi there!

€ 38.00 / £ 34.00 / US$ 40.00
ISBN 978-3-95829-534-6

Löffelbein, Kai
Ctrl-X
A topography of e-waste

€ 38.00 / £ 34.00 / US$ 45.00
ISBN 978-3-86930-970-5

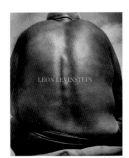

Leon Levinstein

€ 68.00 / £ 58.00 / US$ 85.00
ISBN 978-3-86930-443-4

McMillan, David
Growth and Decay

€ 65.00 / £ 58.00 / US$ 75.00
ISBN 978-3-95829-397-7

The Photographs of Abraham Lincoln

€ 58.00 / £ 48.00 / US$ 55.00
ISBN 978-3-86930-917-0

Maisel, David
Black Maps

€ 65.00 / £ 55.00 / US$ 85.00
ISBN 978-3-86930-537-0

Lifshitz, Sébastien
Amateur

€ 75.00 / £ 58.00 / US$ 90.00
ISBN 978-3-86930-739-8

Marchand, Yves / Meffre, Romain
Gunkanjima

€ 65.00 / £ 50.00 / US$ 85.00
ISBN 978-3-86930-546-2

Lim, Broy
and now they know

€ 35.00 / £ 30.00 / US$ 40.00
ISBN 978-3-95829-312-0

Michener, Diana
A Song of Life

€ 38.00 / £ 35.00 / US$ 40.00
ISBN 978-3-95829-326-7

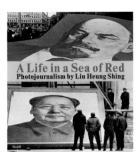

Liu, Heung Shing
A Life in a Sea of Red

€ 85.00 / £ 80.00 / US$ 95.00
ISBN 978-3-95829-545-2

Milella, Domingo

€ 58.00 / £ 48.00 / US$ 55.00
ISBN 978-3-86930-487-8

Mocafico, Guido
Mocafico Numéro

€ 145.00 / £ 135.00 / US$ 195.00
ISBN 978-3-86930-907-1

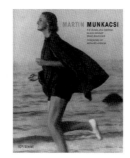

Martin Munkacsi

€ 65.00 / £ 58.00 / US$ 75.00
ISBN 978-3-86521-269-6

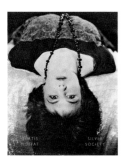

Moffat, Curtis
Silver Society

€ 44.00 / £ 38.00 / US$ 50.00
ISBN 978-3-95829-027-3

Müller-Westernhagen, Romney
Portraits

€ 42.00 / £ 35.00 / US$ 50.00
ISBN 978-3-86930-817-3

Mofokeng, Santu
The Black Photo Album

€ 34.00 / £ 28.00 / US$ 45.00
ISBN 978-3-86930-310-9

Nádas, Péter
Own Death

€ 40.00 / £ 28.00 / US$ 50.00
ISBN 978-3-86521-010-4

Mofokeng, Santu
Stories

€ 385.00 / £ 320.00 / US$ 450.00
ISBN 978-3-95829-515-5

Näder, Hans Georg
Futuring Human Mobility

€ 25.00 / £ 20.00 / US$ 30.00
ISBN 978-3-95829-635-0

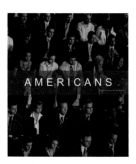

Morris, Christopher
Americans

€ 35.00 / £ 27.00 / US$ 40.00
ISBN 978-3-86930-448-9

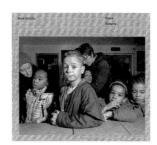

Neville, Mark
Fancy Pictures

€ 48.00 / £ 40.00 / US$ 55.00
ISBN 978-3-86930-908-8

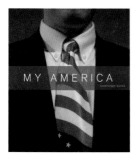

Morris, Christopher
My America

€ 35.00 / £ 27.00 / US$ 40.00
ISBN 978-3-86521-201-6

Nozolino, Paulo
bone lonely

€ 34.00 / £ 32.00 / US$ 35.00
ISBN 978-3-86521-861-2

Nozolino, Paulo
Far Cry

€ 45.00 / £ 30.00 / US$ 50.00
ISBN 978-3-86521-122-4

Odermatt, Arnold
After Work

€ 65.00 / £ 55.00 / US$ 75.00
ISBN 978-3-86930-973-6

Nozolino, Paulo
Makulatur

€ 25.00 / £ 20.00 / US$ 30.00
ISBN 978-3-86930-327-7

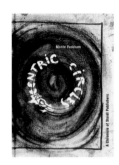

Packham, Monte
Concentric Circles

€ 20.00 / £ 17.00 / US$ 27.50
ISBN 978-3-86930-024-5

Nozolino, Paulo
Loaded Shine

€ 25.00 / £ 20.00 / US$ 30.00
ISBN 978-3-86930-972-9

Pamuk, Orhan
Balkon

€ 34,00 / £ 30.00/ US$ 40.00
ISBN 978-3-95829-399-1

O'Neal, Hank (ed.)
A Vision Shared
A Portrait of America 1935-1943

€ 68.00 / £ 60.00 / US$ 75.00
ISBN 978-3-95829-181-2

Papageorge, Tod
Dr. Blankman's New York

€ 40.00 / £ 35.00 / US$ 45.00
ISBN 978-3-95829-108-9

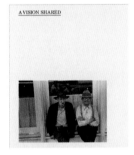

Odermatt, Arnold
On Duty

€ 65.00 / £ 55.00 / US$ 75.00
ISBN 978-3-86521-336-5

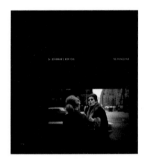

Park, Jongwoo
DMZ

€ 35.00 / £ 30.00 / US$ 40.00
ISBN 978-3-95829-315-1

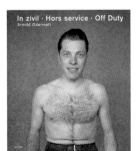

Odermatt, Arnold
Off Duty

€ 65.00 / £ 55.00 / US$ 75.00
ISBN 978-3-86521-796-7

Parke, Trent
Minutes to Midnight

€ 38.00 / £ 30.00 / US$ 45.00
ISBN 978-3-86930-205-8

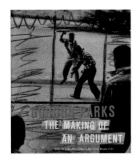

Parks, Gordon
The Making of an Argument

€ 38.00 / £ 30.00 / US$ 45.00
ISBN 978-3-86930-721-3

Parks, Gordon
Collected Works

€ 200.00 / £ 180.00 / US$ 225.00
ISBN 978-3-86930-530-1

Parks, Gordon
Collected Works – Study Edition

€ 125.00 / £ 115.00 / US$ 145.00
ISBN 978-3-95829-262-8

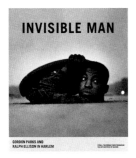

Parks, Gordon
Invisible Man

€ 38.00 / £ 30.00 / US$ 45.00
ISBN 978-3-95829-109-6

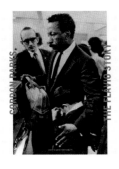

Parks, Gordon
The Flavio Story

€ 58.00 / £ 54.00 / US$ 65.00
ISBN 978-3-95829-344-1

Parks, Gordon
The New Tide, Early Work 1940-1950

€ 58.00 / £ 54.00 / US$ 65.00
ISBN 978-3-95829-488-2

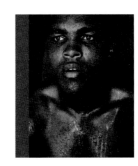

Parks, Gordon
Muhammad Ali

€ 48.00 / £ 45.00 / US$ 55.00
ISBN 978-3-95829-619-0

Parr, Martin (ed.)
The Protest Box

€ 225.00 / £ 185.00 / US$ 250.00
ISBN 978-3-86930-124-2

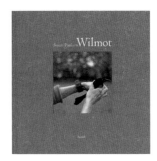

Paulsen, Susan
Wilmot

€ 48.00 / £ 35.00 / US$ 60.00
ISBN 978-3-86930-565-3

Paulsen, Susan
Sarah Rhymes with Clara

€ 34.00 / £ 40.00 / US$ 50.00
ISBN 978-3-86930-244-7

Peterson, Mark
Political Theatre

€ 35.00 / £ 28.00 / US$ 40.00
ISBN 978-3-95829-183-6

Phillips, Christopher /
Hung, Wu (eds.)
Life and Dreams: Contemporary
Chinese Photography and Media Art

€ 58.00 / £ 55.00 / US$ 60.00
ISBN 978-3-95829-490-5

Polidori, Robert
60 Feet Road

€ 98.00 / £ 88.00 / US$ 125.00
ISBN 978-3-95829-111-9

Polidori, Robert
Topographical Histories

€ 35,00 / £ 30.00 / US$ 50.00
ISBN 978-3-95829-549-0

Polidori, Robert
After the Flood

€ 85.00 / £ 75.00 / US$ 95.00
ISBN 978-3-86521-277-1

Polidori, Robert
Synchrony and Diachrony
Photographs of the J.P. Getty
Museum 1997

€ 38.00 / £ 35.00 / US$ 45.00
ISBN 978-3-95829-383-0

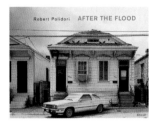

Polidori, Robert
Parcours Muséologique Revisité

€ 125.00 / £ 100.00 / US$ 150.00
ISBN 978-3-86521-702-8

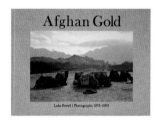

Powell, Luke
Afghan Gold

€ 98.00 / £ 95.00 / US$ 125.00
ISBN 978-3-86930-648-3

Polidori, Robert
Chronophagia

€ 48.00 / £ 40.00 / US$ 55.00
ISBN 978-3-86930-698-8

Prickett, Ivor
End of the Caliphate

€ 45.00 / £ 40.00 / US$ 55.00
ISBN 978-3-95829-493-6

Polidori, Robert
Eye and I

€ 48.00 / £ 40.00 / US$ 65.00
ISBN 978-3-86930-592-9

Purifoy, Noah
High Desert

€ 40.00 / £ 38.00 / US$ 60.00
ISBN 978-3-86930-595-0

Polidori, Robert
Hotel Petra

€ 48.00 / £ 42.00 / US$ 55.00
ISBN 978-3-95829-184-3

Rautert, Timm
No Photographing

€ 38.00 / £ 32.00 / US$ 45.00
ISBN 978-3-86930-322-2

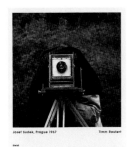

Rautert, Timm
Josef Sudek, Prague 1967

€ 40.00 / £ 35.00 / US$ 50.00
ISBN 978-3-95829-118-8

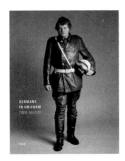

Rautert, Timm
Germans in Uniform

€ 34.00 / £ 30.00 / US$ 45.00
ISBN 978-3-95829-287-1

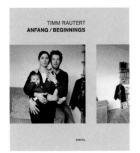

Rautert, Timm
Anfang / Beginnings

€ 58.00 / £ 70.00 / US$ 75.00
ISBN 978-3-95829-528-5

Renhui, Robert Zhao
A Guide to the Flora and Fauna
of the World

€ 58.00 / £ 55.00 / US$ 60.00
ISBN 978-3-95829-319-9

Riddy, John
Photographs

€ 75.00 / £ 70.00 / US$ 85.00
ISBN 978-3-95829-566-7

RongRong
RongRong's Diary

€ 48.00 / £ 45.00 / US$ 55.00
ISBN 978-3-95829-592-6

Ruetz, Michael
Eye on Infinity

€ 48.00 / £ 45.00 / US$ 55.00
ISBN 978-3-86521-766-0

Ruetz, Michael
The Family of Dog

€ 38.00 / £ 30.00 / US$ 45.00
ISBN 978-3-86930-575-2

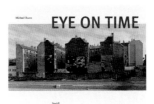

Ruetz, Michael
Eye on Time

€ 48.00 / £ 45.00 / US$ 55.00
ISBN 978-3-86521-577-2

Ruscha, Ed
THEN & NOW

€ 195.00 / £ 185.00 / US$ 250.00
ISBN 978-3-86521-105-7

Ruscha, Ed
Catalogue Raisonné of the
Paintings, Volume 2: 1971-1982

€ 165.00 / £ 155.00 / US$ 200.00
ISBN 978-3-86521-138-5

Ruscha, Ed
Catalogue Raisonné of the
Paintings, Volume 3: 1983-1987

€ 165.00 / £ 155.00 / US$ 200.00
ISBN 978-3-86521-368-6

Ruscha, Ed
Catalogue Raisonné of the
Paintings, Volume 4: 1988–1992

€ 165.00 / £ 155.00 / US$ 200.00
ISBN 978-3-86521-833-9

Samoylova, Anastasia
FloodZone

€ 38.00 / £ 35.00 / US$ 45.00
ISBN 978-3-95829-633-6

Ruscha, Ed
Catalogue Raisonné of the
Paintings, Volume 5: 1993–1997

€ 165.00 / £ 155.00 / US$ 200.00
ISBN 978-3-86930-251-5

Saura, Carlos
Vanished Spain

€ 65.00 / £ 58.00 / US$ 80.00
ISBN 978-3-86930-911-8

Ruscha, Ed
Catalogue Raisonné of the
Paintings, Volume 6: 1998–2003

€ 165.00 / £ 155.00 / US$ 200.00
ISBN 978-3-86930-740-4

Savulich, Andrew
The City

€ 38.00 / £ 30.00 / US$ 45.00
ISBN 978-3-86930-690-2

Ruscha, Ed
Catalogue Raisonné of the
Paintings. Volume 7: 2004–2011

€ 165.00 / £ 155.00 / US$ 200.00
ISBN 978-3-95829-186-7

Schles, Ken
Invisible City

€ 34.00 / £ 28.00 / US$ 40.00
ISBN 978-3-86930-691-9

Ruscha, Ed
Los Angeles Apartments

€ 38.00 / £ 30.00 / US$ 45.00
ISBN 978-3-869630-596-7

Schles, Ken
Night Walk

€ 38.00 / £ 30.00 / US$ 45.00
ISBN 978-3-86930-692-6

Ryan, Liza
The Unreal Real

€ 38,00 / £ 35.00 / US$ 45.00
ISBN 978-3-95829-351-9

Schmidt, Jason
Artists II

€ 58.00 / £ 48.00 / US$ 70.00
ISBN 978-3-86930-632-2

Schoeller, Martin
Works

€ 28.00 / £ 25.00 / US$ 40.00
ISBN 978-3-95829-707-4

Schoeller, Martin
Close

€ 75.00 / £ 68.00 / US$ 85.00
ISBN 978-3-95829-491-2

Schoeller, Martin
Survivors

€ 28.00 / £ 25.00 / US$ 40.00
ISBN 978-3-95829-621-3

Schulze / Ruelfs (eds.)
ReVision

€ 48.00 / £ 45.00 / US$ 58.00
ISBN 978-3-95829-185-0

Schwartzwald, Lawrence
The Art of Reading

€ 28.00 / £ 25.00 / US$ 30.00
ISBN 978-3-95829-508-7

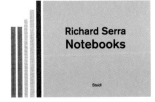

Serra, Richard
Notebooks, Vol. 1

€ 380.00 / £ 325.00 / US$ 400.00
ISBN 978-3-86930-253-9

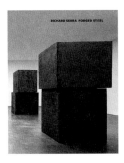

Serra, Richard
Forged Steel

€ 38.00 / £ 32.00
ISBN 978-3-95829-188-1
[Distributed in the USA by David
Zwirner (D.A.P.)]

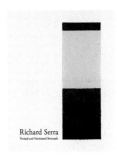

Serra, Richard
Vertical and Horizontal Reversals

€ 58.00 / £ 52.00
ISBN 978-3-86930-978-1
[Distributed in the USA by David
Zwirner (D.A.P.)]

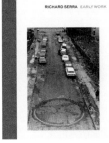

Serra, Richard
Early Work

€ 68.00 / £ 54.00 / US$ 85.00
ISBN 978-3-86930-716-9

Sheikh, Fazal
Portraits

€ 48.00 / £ 42.00 / US$ 55.00
ISBN 978-3-86521-819-3

Sheikh, Fazal
Moksha

€ 65.00 / £ 55.00 / US$ 70.00
ISBN 978-3-86521-125-5

Sheikh, Fazal
The Circle

€ 30.00 / £ 20.00 / US$ 40.00
ISBN 978-3-86521-599-4

Sheikh, Fazal
Ether

€ 38.00 / £ 30.00 / US$ 45.00
ISBN 978-3-86930-653-7

Sheikh, Fazal
The Erasure Trilogy

€ 98.00 / £ 85.00 / US$ 125.00
ISBN 978-3-86930-805-0

Singh, Dayanita
Museum of Chance

€ 48.00 / £ 40.00 / US$ 55.00
ISBN 978-3-86930-693-3

Singh, Dayanita
Dream Villa

€ 28.00 / £ 24.00 / US$ 35.00
ISBN 978-3-86521-985-5

Singh, Dayanita
Zakir Hussain Maquette

€ 40.00 / £ 35.00 / US$ 45.00
ISBN 978-3-95829-623-7

Sory, Sanlé
Volta Photo

€ 38.00 / £ 35.00 / US$ 40.00
ISBN 978-3-95829-400-4

Spagnoli, Jerry
Regard

€ 48.00 / £ 45.00 / US$ 55.00
ISBN 978-3-95829-239-0

Spero, Nancy
Acts of Rebellion

€ 30.00 / £ 25.00 / US$ 35.00
ISBN 978-3-95829-624-4

Staeck, Klaus / Steidl, Gerhard
Beuys Book

€ 45.00 / £ 40.00 / US$ 50.00
ISBN 978-3-86521-914-5

Stillings, Jamey
The Evolution of Ivanpah Solar

€ 65.00 / £ 58.00 / US$ 70.00
ISBN 978-3-86930-913-2

Sternfeld, Joel
On This Site

€ 48.00 / £ 42.00 / US$ 55.00
ISBN 978-3-86930-434-2

Sternfeld, Joel
First Pictures

€ 48.00 / £ 42.00 / US$ 55.00
ISBN 978-3-86930-309-3

Sternfeld, Joel
iDubai

€ 28.00 / £ 24.00 / US$ 30.00
ISBN 978-3-86521-916-9

Sternfeld, Joel
When it Changed

€ 25.00 / £ 20.00 / US$ 30.00
ISBN 978-3-86521-278-8

Sternfeld, Joel
Stranger Passing

€ 65.00 / £ 50.00 / US$ 75.00
ISBN 978-3-86930-499-1

Sternfeld, Joel
American Prospects

€ 95.00 / £ 85.00 / US$ 125.00
ISBN 978-3-95829-669-5

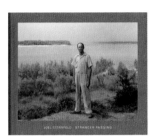

Sternfeld, Joel
Rome after Rome

€ 95.00 / £ 95.00 / US$ 100.00
ISBN 978-3-95829-263-5

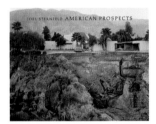

Sternfeld, Joel
Our Loss

€ 45.00 / £ 40.00 / US$ 50.00
ISBN 978-3-95829-658-9

Sturges, Jock
Fanny

€ 78.00 / £ 65.00 / US$ 90.00
ISBN 978-3-86930-694-0

Subotzky, Mikhael
Retinal Shift

€ 38.00 / £ 30.00 / US$ 45.00
ISBN 978-3-86930-539-4

Sutkus, Antanas
Pro Memoria

€ 35.00 / £ 30.00 / US$ 40.00
ISBN 978-3-95829-640-4

Taylor-Johnson, Sam
Birth of a Clown

€ 34.00 / £ 28.00 / US$ 40.00
ISBN 978-3-86521-853-7

Taylor-Johnson, Sam
Second Floor

€ 50.00 / £ 45.00 / US$ 60.00
ISBN 978-3-86930-264-5

Teller, Juergen
Nackig auf dem Fußballplatz

€ 25.00 / £ 18.00 / US$ 30.00
ISBN 978-3-88243-963-2

Teller, Juergen
Nürnberg

€ 75.00 / £ 65.00 / US$ 80.00
ISBN 978-3-86521-132-3

Teller, Juergen
The Keys to the House

€ 45.00 / £ 39.00 / US$ 50.00
ISBN 978-3-86930-383-3

Teller, Juergen
Woo!

€ 40.00 / £ 30.00 / US$ 45.00
ISBN 978-3-86930-652-0

Teller, Juergen
Siegerflieger

€ 29.80 / £ 25.00 / US$ 35.00
ISBN 978-3-86930-914-9

Teller, Juergen
Märchenstüberl

€ 22.00 / £ 14.00 / US$ 30.00
ISBN 978-3-88243-863-5

Teller, Juergen
Handbags

€ 95.00 / £ 85.00 / US$ 125.00
ISBN 978-3-95829-634-3

Tillim, Guy
O Futuro Certo

€ 45.00 / £ 40.00 / US$ 50.00
ISBN 978-3-86930-649-0

Trager, Philip
Photographing Ina

€ 38.00 / £ 34.00 / US$ 45.00
ISBN 978-3-86930-977-4

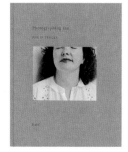

Trager, Philip
New York in the 1970s

€ 48.00 / £ 40.00 / US$ 55.00
ISBN 978-3-86930-806-7

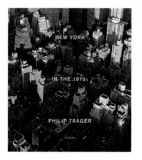

Tuggener, Jakob
Fabrik

€ 65.00 / £ 55.00 / US$ 75.00
ISBN 978-3-86521-493-5

Tuggener, Jakob
Books and Films

€ 700.00 / £ 650.00 / US$ 800.00
ISBN 978-3-95829-328-1

Verzosa, Jake
The Last Tattooed Women of Kalinga

€ 35.00 / £ 30.00 / US$ 40.00
ISBN 978-3-95829-317-5

Vitali, Massimo
Short Stories

€ 125.00 / £ 105.00 / US$ 135.00
ISBN 978-3-95829-496-7

Vitali, Massimo
Entering a New World
€ 95.00 / £ 85.00 / US$ 125.00
ISBN 978-3-95829-626-8

Voit, Robert
New Trees

€ 58.00 / £ 45.00 / US$ 65.00
ISBN 978-3-86521-825-4

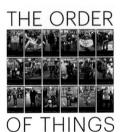

Wallis, Brian (ed.)
The Order of Things

€ 85.00 / £ 78.00 / US$ 95.00
ISBN 978-3-86930-994-1

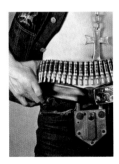

Weinberger, Karlheinz
Swiss Rebels

€ 65.00 / £ 58.00 / US$ 68.00
ISBN 978-3-95829-329-8

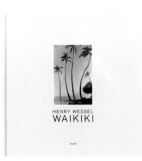

Wessel, Henry
Waikiki

€ 58.00 / £ 50.00 / US$ 65.00
ISBN 978-3-89630-300-0

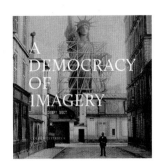

Westerbeck, Colin
A Democracy of Imagery

€ 45.00 / £ 40.00 / US$ 50.00
ISBN 978-3-95829-116-4

Wettre, Jonas
Once there were Polaroids

€ 30.00 / £ 25.00 / US$ 35.00
ISBN 978-3-86930-963-7

Wetzel, Gereon / Adolph, Jörg
How to Make a Book with Steidl

€ 15.00 / £ 12.00 / US$ 20.00
ISBN 978-3-86930-119-8

Wetzel, Gereon / Adolph, Jörg
How to Make a Book with Carlos
Saura & Steidl

€ 15.00 / £ 12.00 / US$ 20.00
ISBN 978-3-95829-353-3

Wiedenhöfer, Kai
The Book of Destruction

€ 34.00 / £ 30.00 / US$ 40.00
ISBN 978-3-86930-207-2

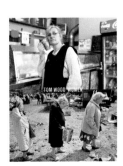

Wood, Tom
Men and Women

€ 68.00 / £ 58.00 / US$ 70.00
ISBN 978-3-86930-570-7

Soak Teng, Woong
Ways to Tie Trees

€ 50.00 / £ 45.00 / US$ 55.00
ISBN 978-3-95829-316-8

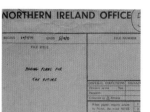

Wylie, Donovan
Housing Plans for the Future

€ 35.00 / £ 30.00 / US$ 40.00
ISBN 978-3-95829-488-2

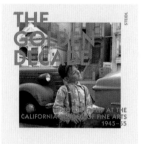

Whyte-Ball, Ken and
Victoria (eds.)
The Golden Decade

€ 58.00 / £ 50.00 / US$ 65.00
ISBN 978-3-86930-902-6

Zimmermann, Harf
Brand Wand

€ 78.00 / £ 65.00 / US$ 90.00
ISBN 978-3-86930-628-5

Zimmermann, Harf
The Sad-Eyed Lady

€ 58.00 / £ 50.00 / US$ 65.00
ISBN 978-3-95829-605-3